2001

NIGHT AND DAY

NIGHT AND DAY

The Double Lives of Artists in America

Gloria Klaiman

Westport, Connecticut
London

Library of Congress Cataloging-in-Publication Data

Klaiman, Gloria, 1953–
 Night and day : the double lives of artists in America / Gloria Klaiman.
 p. cm.
 Includes bibliographical references and index.
 ISBN 0–275–97029–9 (alk. paper)
 1. Arts—United States—Economic aspects. 2. Artists—United States—Interviews. I.
Title.
 NX634.K58 2001
 702'.3'73—dc21 00–026385

British Library Cataloguing in Publication Data is available.

Library of Congress Catalog Card Number: 00–026385
ISBN: 0–275–97029–9

First published in 2001

Praeger Publishers, 88 Post Road West, Westport, CT 06881
An imprint of Greenwood Publishing Group, Inc.
www.praeger.com

Printed in the United States of America

The paper used in this book complies with the
Permanent Paper Standard issued by the National
Information Standards Organization (Z39.48–1984).

10 9 8 7 6 5 4 3 2 1

In memory of my father
and
In honor of my mother
and for
Tamar, Danielle, and David

Contents

Preface

My motivation for writing *Night and Day: The Double Lives of Artists in America* was to gain insight into how artists in the United States balance the making of art with their need to earn a living. Over the years I have had many artist friends who tried to find the time and energy to create art while juggling part time work, freelance assignments, full-time employment, or some combination of these to pay the bills. My perceptions were not merely anecdotal. Among other reports and studies, the final report of the Ninety-Second American Assembly entitled *The Arts and the Public Purpose,* from a meeting held at Arden House in Harriman New York, May 29 through June 1, 1997, noted that the average annual income for professional artists is $24,000, several thousand dollars below that for other professionals. It noted that most of that money is not earned directly from artwork but from nonartistic jobs in the private and not-for-profit sectors. The report also stated that most artists lack health and retirement benefits.

The question about how one balances art and a day job has many dimensions. There are the practical ones, concerning logistics, access to health insurance, and finding enough time and energy to create; and the more esoteric ones, about making compromises, finding one's place in the community, setting aside time and space for contemplation and experimentation, and grappling with the effects that creating art has on one's spirituality and emotions.

The first chapter of this book is a brief overview of the current environment for the arts in the United States; subsequent chapters present interviews with twenty-one artists from many disciplines who are at various stages of their careers. I was acquainted with a few of these artists before undertaking this project, but most were strangers whom I met through word of mouth, mutual friends, the Internet, or postings at artists' colonies

and arts organizations. Except for a handful of face-to-face meetings, the conversations took place on the telephone. The artists interviewed graciously gave of their time, frequently late at night or on weekends in order to accommodate both of our outside work schedules. They generously shared their thoughts and feelings with great candor, often divulging very personal passions and vulnerabilities. I am exceedingly grateful to every one of them, as well as to all those artists whose words could not be included here due to space considerations.

This book could not have been written without the help and encouragement of many people. I am very grateful to my editor at Greenwood Publishing Group, Pamela St. Clair, for her extreme patience, and for recognizing the importance of this subject and giving me the chance to explore it. One of the most under-appreciated and overlooked jobs is that of the copyeditor, and therefore I want to express my gratitude to Marcia Havens for her valuable contribution. Andrew Hudak, my production editor at Greenwood, contributed much good advice, patience, and hard work in bringing this book to press. Michele Drivon and Tom Conville did an excellent job of proofreading on a tight schedule, despite their many other obligations.

I had the good fortune to receive encouragement from the fine writers Tally Brennan, Ellie Sullivan, Lisa Meritz, Priscilla Estes, Liz Soltan, and Janice Jakubowitcz, the wonderful artists in the Thursday evening printmaking class, and many other friends and colleagues too numerous to list here. I thank all of them for their criticism, support, sense of humor, and above all, their friendship.

There are some special people for whose encouragement and un-wavering affection mere words of gratitude are quite insufficient. Among these are Rita Cohen, Mark Cohen, Rebecca Cohen, Karen Wexler, Cliff Wexler, Kara Wexler, Alexandra Wexler, Ariana Wexler, Buddy Rosoff, Nancy Rosoff, Fred Cohen, Daniele Cohen, Seth Cohen, Philip Cohen, Jackie Fagan, Bernie Fagan, Audrey and Frank Fagan-Miranda and their families, Gary Fagan and his family, Bela Shmid, Abraham Shmid, Vered Friedman, Devin Friedman, Barry Friedman, Lopek Klaiman, Mala Jaskowicz, Sharon and Tal and their families, Zipporah Rosenfeld, Moshe Rosenfeld, Inbar Rosenfeld, Charlotte Mangold, and Maurice Clearfield.

Most of all, thanks to my daughters, Tamar and Danielle, for their beauty, strength, and wisdom; and to my husband David, good and ancient soul, for finding me.

1

The Artists among Us

They are librarians, insurance clerks, teachers, IRS bureaucrats, lawyers, workshop leaders, cocktail servers, and real estate agents— the poets, painters, musicians, performers, dancers, and writers among us. It is not a revelation that artists often need to earn a living by working at something other than their art. As one of the artists interviewed in this book said, "I know so many creators, but there are only a rare few, maybe three, who make their living at their art. That's why whenever I meet anyone in my art context, and they ask if that's what I do for a living, I'm taken aback. Because while I like that I occupy that moment so fully that that's the only self they see, the other part of me wants to ask, 'Do you actually know someone who only writes poetry for a living? Have you ever heard of that? Am I missing something?' "

In some cases the juggling of a job and artistic work causes artists to become more focused on their creative endeavors, to plan time in the studio or at the writing desk more efficiently, and to take skills and approaches learned at the day job and use them to enhance their art. However, there are also situations in which the exhaustion, boredom, or frustrations of the nine-to-five world sap energy, time, and attention from the creative process.

During the late 1980s and through most of the 1990s the culture wars that were waged against the arts by the Reagan administration, the conservative Congress, and the far right deeply wounded arts organizations and individual artists. Many scars still remain. The political attacks succeeded in slashing the annual budget of the National Endowment for the Arts (NEA) from almost $176 million in 1992 to funding for fiscal year 2000 of $97.6 million. Grants to individual artists were eliminated, except for those to writers, folk artists, and jazz musicians. Although only a minute number of artists nationwide ever actually received individual grants (for

example, in 1998 forty literature fellowships for $20,000 each were bestowed), the psychological importance of NEA grants and the prestige attached to them gave artists at least the illusion that art was important and valued by American society.

It seems that underlying much of the vitriol that was spewed from the far right during the culture wars was the perception that artists are lazy moochers lolling around waiting for handouts from hard-working taxpayers. This is a grave misconception. Some artists who have no family obligations have chosen to cherish time over money. They live frugally, forgoing many material comforts, and sometimes personal relationships, in exchange for the freedom to practice their art. An even greater number of artists display a work ethic that would be the envy of corporate America. This latter group often puts in eighty or more hours a week running from the office or the classroom to audition, practice, perform, edit, write, photograph, film, paint, or sculpt.

It is ironic that many in the business world who applaud the issuing of sales and signing bonuses, commissions, company cars, stock options, and "golden parachutes"— all perquisites that are showered on employees to acknowledge that their work, or their anticipated work, is valuable— often balk at small stipends given to nurture work in the arts, as if that work is not to be valued.

American society has a contradictory attitude toward artists. On one hand, the romantic myth of the starving artist still exists. Even many well educated and enlightened people hold fast to the belief that artists *should* be starving. The thinking is that it is the price they must pay to perfect their craft and connect with their muse. Why this same sacrifice is not necessary for lawyers, physicians, banking executives, auto technicians, or systems analysts is never made clear. On the other hand, because they do not make large amounts of money, by which success is largely measured in the United States, artists are looked down upon as capricious, unstable, childish, and nonconforming individuals. The late theater director Alan Schneider, who also taught at Julliard Theater Center and the University of California at San Diego, once said, "When I want to buy life insurance, I have to tell people I rob banks rather than that I'm a theater director. Or if I'm looking for an apartment, I have to pretend that I'm not an artist. . . ."[1]

Another very American approach to the arts is the tendency not to distinguish between art and entertainment. As one of the musicians in these pages observed, the success of artistic endeavors is judged on the money they generate and the fame that surrounds their practitioners. But much in art is difficult and not amenable to the adoration of large crowds. There is certainly a place in our lives for the blockbuster film, the best-selling book, and the hit show. However, our culture is in grave danger if profitability

and notoriety become the only measures of artistic worth. The experimental music composition, the thought-provoking poem, the painting that is different from what we are used to seeing, the book of quirky short stories, these will not garner fame and fortune, but that does not mean they are not essential to the enrichment and enlightenment of our society.

The firestorm of accusations and criticisms that raged around the Robert Mapplethorpe and Andres Serrano controversies in 1989 forced the art world to adopt a defensive, siege mentality. Panels were formed and meetings and hearings were convened. There were excruciating discussions about government support versus corporate support versus private patronage, arguments over the roles of state and federal government, and comparisons of European governments' subsidies for the arts with U.S. tax policies that encourage corporate sponsorships.

Despite this, little attention was paid to the actual makers of art themselves. No one sat down and quietly asked them what their lives were like, what encouraged them and what drained their enthusiasm, or what it felt like to be poorer than most of their peers who were succeeding in the boardroom and the marketplace. No one posed the questions: How are you able to switch from the often noisy world of commerce to the quiet, introspective state that is needed to compose a symphony or a poem or a painting? What are the things that haunt you in the wee hours— health insurance? mortgage payments? rivalries with other artists? fear of not having enough time, tenacity, or talent to create what you envision?

The interviews in the following pages are a modest attempt to initiate such listening. They represent the thoughts and experiences of twenty-one artists from several disciplines about how they balance the making of art with their day jobs, or how they have managed to free themselves from the need for outside work. Many also express their opinions on American society's view of the arts, funding for the arts, arts education, and how the creative process affects them emotionally and spiritually.

The importance of understanding how artists in the United States live and work has begun to become apparent to others as well. William Ivey, chairman of the NEA, commissioned a study to examine what percentage of artists hold second jobs, in which fields outside the arts they are employed, the unemployment rate among artists, and how their earnings compare with those of other professionals. The study, *More Than Once in a Blue Moon: Multiple Jobholdings by American Artists,* by Neil O. Alper and Gregory H. Wassall, reviewed more than thirty years of Census Bureau data. The report was published in August 2000.

The good news is that some of the funding gaps created by the NEA's decimation and the trickle down effect it had on arts funding in general have begun to be filled by other initiatives. In the spring of 1999, two dozen

foundations established the Creative Capital Foundation to directly fund artists in the performing, media, and visual arts. What is unique about the foundation's approach is that in addition to underwriting projects, the staff will work with artists on an ongoing basis to help them develop an audience and market their work.

There are also large foundations that present well-publicized grants to individual artists. Some of these more high-profile organizations include the Guggenheim Foundation, the MacArthur Foundation, the Ford Foundation, the Lannon Poetry Prize, and the Pew Fellowships in the Arts. Many other organizations, artists colonies, and state arts councils provide smaller grants; fellowships that offer stipends, time, and space in which to create; and emergency loans to artists.

Only a handful of these grants provide enough income to support an artist, even modestly, for a year. What a grant or fellowship does allow is some breathing room for artists— to pay off a few hounding bill collectors, buy materials or studio time, subscribe to publications related to their field, or take a short break from a second job, temporary work, or additional freelance assignments. More than anything, the recognition such an award affords is at least as important as any money received. Sometimes it leads to commissions, teaching assignments, invitations to speak, etcetera. It is an acknowledgment and affirmation that the artist's work is of high quality, well crafted, and admired by knowledgeable peers.

Another positive outcome of the culture wars was that artists redoubled their efforts to publicize their long-standing contributions to the communities in which they live and work. Artists have refuted the charges of elitism and insularity that were lodged against them. They have made greater efforts to demystify the rituals of their craft, to chase away the "scary, hairy monster" fear that many people associate with art.

Creative people also began to explore innovative ways to make and market their work. The simultaneous burgeoning of accessible and affordable technology aided them in this endeavor. Artists have found ways to produce art more cheaply, for example, using less expensive digital cameras to make films and videos. And a revolution has occurred in marketing, distribution, and communication with the advent of the Internet.

Perhaps most importantly, people in the arts and their advocates and patrons began to rethink the funding models that were used in the past and to conceive of additional, nontraditional ways to support the arts. Many of these initiatives cost very little and can help artists to create and disseminate their work quickly and easily. The following are just a few examples.

In Philadelphia the Artfront Partnership slated twelve empty storefronts to display the work of visual artists. Instead of passing by soaped-over windows or dark cavernous spaces, pedestrians can view the works of local

artists. The Artfront Partnership is a joint venture of city government and private foundations, and also enjoys corporate support.

In 1998, Public Radio International's show "Marketplace" reported on a Portland, Oregon, firm, BORRA Architects, Inc., which was able to simultaneously provide creative inspiration for its staff and a tax break for its bottom line by helping two arts groups. It did this by offering free office space and access to the company's administrative resources, such as copying machines, computers, and secretarial support, to the Portland Institute of Contemporary Art (PICA) and a literary arts group. In conjunction with PICA, the company sponsored brown bag lunches at which such individuals as composer Philip Glass and performance artists Spalding Gray and Karen Finley were invited to speak about their work and their creative process. The literary arts group presented readings by established writers and those who had received writing fellowships. The arts groups also invited the architectural firm's staff to performances, exhibitions, and readings outside the office. Both the architects and the artists reported that they were inspired and motivated by each other's work.

The tax break it received was another incentive for BORRA to initiate this program. Although the company had been donating money to the arts for years, the Internal Revenue Service only allows a corporation to deduct 10 percent of its taxable income for the year for charitable donations. Contributions of space and resources, however, are considered part of the cost of doing business, and all business expenses are tax deductible. The firm's financial officer explained that BORRA chose to enhance its environment by adding creative people instead of purchasing pieces of art or new furniture, for which other companies might opt.

In the same year, National Public Radio's "Morning Edition" also did a story about a collaboration between the business and arts communities at the World Trade Center in Manhattan. At the imposing twin towers that comprise the World Trade Center rent is at a premium, and therefore empty office space is not difficult to find. Similar high prices for real estate are found all over New York, leaving artists desperately scrambling for studio space. Thus, the New York and New Jersey Port Authority, which runs the World Trade Center, and the Lower Manhattan Cultural Council, which produces public art in that part of the city, joined forces to sponsor a project called "World View."

They initially invited nineteen painters to occupy vacant office space on various floors of the World Trade Center. The artists understood that they might have to leave at a moment's notice if their area became rented and that potential tenants would be coming through from time to time to see the space.

The painters reported that working next to other artists often inspired and strengthened their own work, and their perceptions about light and

space changed as they observed the constantly shifting shapes of clouds and angles of sunlight outside their windows high above Manhattan.

The Port Authority and Lower Manhattan Cultural Council sponsored a public tour of the "studios" and contemplated having a show of the work created in the building. Every few months they rotate artists, bringing in people from different disciplines.

Finally, in a setting far removed from Manhattan's skyscrapers, the small borough of Langhorne in southeastern Pennsylvania also found a way to encourage local artists. The Langhorne Council of the Arts awards selected artists a $200 stipend toward renovation of workspace on an abandoned eight-acre farm the borough purchased as part of its Open Space initiative. The artists contribute sweat and elbow grease to repair and refurbish the farm's dilapidated outbuildings into quiet, light-filled studios.

As many supporters of the arts have repeatedly pointed out, there are sound practical reasons for communities to underwrite and boost the work of artists. An investment in the arts can bring in excellent financial returns. Art museums, theaters, dance companies, orchestras, galleries, and performance groups entice large numbers of cultural tourists.

In Philadelphia, for example, the Philadelphia Museum of Art's three-month-long Cézanne exhibit in 1996 was attended by 777,810 people, many from out of town, who spent $122.6 million in the city.[2]

A 1994 Eagleton Institute of Politics study found that in New Jersey, 15 million people attend cultural events each year, infusing $300 million into the economy. Likewise, in 1999 the Pennsylvania Economy League reported that the arts enriched the tri-state Pennsylvania, Delaware, and New Jersey region by $600 million annually, created 11,000 jobs, and generated $16 million in taxes.

In towns and cities across the United States artists have also been pioneers in helping to revitalize downtown areas. This occurs when they flock to marginal neighborhoods for the cheap living and studio space, which then spurs the development of new housing and retail establishments.

Ultimately though, we should be nurturing, respecting, and cherishing artists because of the precious natural resource that they are in our society. As one of the artists in this book said, "Maybe if we're not afraid to say we're artists strong enough and loud enough, they'll realize that we're worthy, that society should support our efforts. Not for charity or a handout, but that what we contribute is valuable, like working for the department of power and water. It's just a different kind of energy, a different kind of service we're providing."

Artists will always find a way to create. Some of the artists in this book described this compulsion in the following ways: "I'd have to choose my painting, because that's my life force and that's what keeps me alive." "I

can't help myself. There is a compulsion to create art, and it doesn't go away." "But that need to create is like a dagger." "It's hard to explain to people who aren't artists that if I weren't doing this, I'd probably be dead."

But it is becoming more difficult, even for those artists who are willing to "sacrifice" for their art. If you are an artist, part time work or work taken at a low-paying, unstressful job to conserve your energy sends you home with barely enough to sustain yourself and no health insurance should your child break her arm or you discover a lump in your breast. You may willingly do without a luxury car or an executive home in the suburbs, but still, how do you send your son or daughter to college? You may make your peace with giving up a large bank account and a prestigious title to pursue your creativity, but then how do you respond to the barbs and snickers of parents, friends, and former classmates who consider you a failure or a fool?

In an article in *Civilization*, Robert Storr, a curator in the Department of Painting and Sculpture at the Museum of Modern Art, wrote about the plight of the artist in New York City today. His comments can be taken as a metaphor for artists everywhere in this country. "In a market where food, rent, and all other expenses are increasingly geared to upscale consumers, New York artists must pay an additional premium for the 'luxury' they create. Up to a point, we may count on their resourcefulness to overcome this challenge, but after that, the price to the city—the quiet exodus of gifted people, the refusal of others to take their chances and come here, the art unmade by those who stay but never get to devote themselves wholeheartedly to their work—will begin to show."[3]

And it is not only the actual cost of sustaining oneself that challenges the artist, but also the lack of opportunity for daydreaming, contemplation, or experimenting. Paul LeClerc, the president of the New York Public Library, said, "In the late twentieth century, we are a society that values output, speed, and productivity, whereas art requires time, reflection, tranquility, and space—all commodities that are in limited supply these days."[4]

It is incumbent upon us as a society to nurture our artists. In addition to the kinds of initiatives outlined above, we can begin to accomplish this by granting educational leave to attend workshops and artists' colonies; making universal, affordable healthcare available; and inviting artists and their work into our schools, community centers, prisons, nursing homes, corporations, and public spaces. If we do not find ways to encourage and appreciate our artists, then surely some will feel frustration and disappointment, and some may even drop out altogether, bitter and resigned. But it is we who will truly be impoverished. For artists have a unique focus—it is elsewhere, off center, different from where the general attention is aimed. Thus they notice things others overlook, attend to details others ignore. As we race about plugged into our cell phones, our laptops, and our fax machines, it is they

who block our paths, tug on our sleeves, and ask, "Where are you going? How are you getting there? and Why?"

The essayist and critic Tómas Ybarra-Frausto wrote: "In ancient times it was the task of the artist to 'deify things,' to reveal through form, color and line the inherent divinity in all earthly things. Across time and space, the moral dimension of the artist has been maintained. Today, an aesthetic obligation and major duty of the artist continues to be to produce art with a heartfelt intuition—*hacer las cosas con corazon.* While the artistic mind explores and depicts the deep structures of social reality, it is the higher task of the heart to intuit and express the boundless horizons of the imagination."[5]

Indeed, we need the artists in our midst, reminding us that we are all creating every day—whether it be a loving home for a child, a computer program, a garden, or a body of law—and that in that creating there is cause for much celebration and great responsibility. The artists circulate among us, entreating us not to base that which we make solely on the practical and profitable, but to infuse it also with the deepest passions of our hearts and the most vivid visions of our dreams.

NOTES

1. W. McNeil Lowry, ed., *The Arts and Public Policy in the United States* (Englewood Cliffs, NJ: Prentice-Hall, 1984), p. 103.

2. Peter Dobrin, "How Mayoral Hopefuls Would Cultivate City's Arts," *Philadelphia Inquirer,* May 11, 1999, p. A6.

3. Robert Storr, "Nice Work If You Can Get It," *Civilization,* February/March 1999, p. 78.

4. John Seabrook, "The Big Sellout," *The New Yorker,* October 20 and 27, 1997, p. 185.

5. Tómas Ybarra-Frausto, *Lo del Corazon: Heartbeat of a Culture* (San Francisco: The Mexican Museum, 1986), p. 13.

2

Bridging Communities:
Lenny Seidman

Lenny Seidman is a percussionist who specializes in playing the classical Indian tabla drums. He performs with Atzilut, a nine-member ensemble that performs non-Western Hebrew music derived from the widely dispersed Jewish diaspora, and is featured on the group's CD Souls on Fire. *Seidman is also co-director of Spoken Hand, a sixteen-piece traditional hand-drumming orchestra. He was awarded a three-month residency at Headlands Center for the Arts in California and an APPEX Fellowship at the University of California at Los Angeles.*

When he was twenty-six years old and on his way to establishing a lucrative career as an accountant, Lenny Seidman literally ran away from his job to become a musician. Now, almost thirty years later, he is a percussionist, a teacher, a performer, and a curator of world music and jazz at the Painted Bride, a thriving community-based arts center in downtown Philadelphia.

Over the years, as his life in music evolved, he began to focus more and more on the tabla, which are ancient, classical drums from northern India. Seidman explained what brought him to this concentration: "I used to play many kinds of drums in performance as well as electronics, analog electronics, so I used to be involved in the so-called avant-garde of music, very improvisational, very abstract, but I tried to add a breath to the electronics to make it human, that was always my approach. But in the last eight or nine years, I've concluded that the center of where all my musicality comes from is the tabla, and that takes several lifetimes to learn; it's such a tradition.

"I still do some other things, but that's my main discipline about which I study and investigate and teach and practice and give lecture demonstrations. I'm ending up more of a specialist, although I don't really think

of it as a specialist. I just like to think of having a powerful voice on one thing rather than not such a strong voice on a lot of things."

Seidman was studying classical and jazz piano before he was introduced to the tabla drum in 1970. "I discovered it through a friend. I was taking a walk with a friend down Pine Street in Philly, taking a break. At that time I was practicing classical piano eight or ten hours a day. We bumped into some people we knew who invited us in to listen to some music. They were studying Indian music at the University of Pennsylvania; there was an excellent program at that time. I heard this music and it had such a profound impact on me. I knew I had to learn the drums; it was particularly the drumming that moved me. It just so happened that a friend of mine had just come back from India with a pair of tabla, which I didn't know anything about. And they told me about a great teacher who was in residence at the University of Pennsylvania and introduced me to him. He said he could teach me. It started like that, a diversion from Western classical music, and within three years I had burned the classical piano bridge. From then on I've been performing."

In addition to performing solo, Seidman is co-director of Spoken Hand, a sixteen-piece traditional hand-drumming orchestra. The ensemble, which has been in existence for four years and is beginning to receive grants and recognition, represents many diverse cultures and drumming traditions.

He is also a charter member of an eight-piece ensemble, Atzilut, which was founded in 1971 and plays music of the Jewish diaspora rooted in Middle Eastern and Balkan modes and rhythms. The group is led by a *hazan* (cantor) named Jack Kessler, who is also a music scholar and composer. Atzilut has produced two CDs and recently played concerts of Jewish music in Berlin, Germany.

Seidman, who is himself Jewish, had performed in Germany twenty years earlier with the dance troupe Group Motion, which is based in Philadelphia. At that time he was able to come to terms with many of the difficult emotions that being in Germany for the first time aroused. Atzilut was very well received in Berlin. Seidman had this assessment of why this was so: "Yiddish culture is very big there. I think it's more than a guilty reaction, which was my first thought. Germans are very smart people, and I think that they're genuinely missing what was wiped out. Culture is the most powerful thing in society, and after fifty years there's a collective consciousness saying that something is missing."

It is an interesting story how in his mid-twenties, Seidman's life took such a radically different direction from the path he was on— aspiring to a successful, middle-class existence. He related how it transpired: "I had started studying classical piano as a way of just finding some meaning in my life, and that changed my life. I was 26 when I started. All through my

childhood I was into sports. I was just being pushed into a very ordinary life. It was clear to me that something was wrong, but I didn't know what, I didn't know about the arts. I just started playing the piano; I got goose bumps, and that was that. Little by little I became possessed.

"My accounting job at the time involved going to clients' offices to do audits, etcetera. When I was in Center City, where I lived, instead of going out to lunch, I'd practically run home, practice as much as I could, and then go back. But it started that I'd say to myself, another ten minutes, another ten minutes. It got to the point where I was taking two- or three-hour breaks, and finally, one of the clients told my boss. At that point they asked me to leave. Things had already been changing, I had stopped cutting my hair, I stopped getting my clothes ironed; it didn't matter. I started seeing life in a whole different way. I was pretty much a liability to the firm. They did me a big favor by letting me go. Because I was pondering, how am I going to survive, I can't do this anymore, I've got to just work on music. From that point on I felt liberated. Of course I didn't have an alternative way of making a living."

So Seidman filed for unemployment, which provided him with a minimum income for the next six months. He also sold his car and completely changed his lifestyle. "From eating steaks I went to oatmeal and eggs. I didn't have any health insurance, but who thought about that in my twenties? I was still immortal then. I was living very bare bones. I lived the art of frugality. It still haunts me, I still think that way sometimes, even though I don't need to. I learned to live on what I needed rather than on what I wanted or thought I wanted."

When the unemployment ran out, he went on welfare for about seven years, receiving $200 a month. "During that period," he said, "there weren't many people on welfare, and it was easier; it was the seventies and times were different. But still it wasn't enough money and I was still determined that I would never work in a regular job. That was a promise I made to myself."

He started to sell a little marijuana. It was a small-time operation; instead of the over-sized Cadillacs and Lincolns favored by drug dealers at the time, he made deliveries to customers on his bicycle. He made enough money to take some trips abroad to Eastern Europe and India, which he had become interested in through his study of the tabla drums.

"India had a strong influence on me," he said. "I knew I couldn't be in this illegal world anymore, it was seedy, I didn't like it. I started disliking the relationships I had developed through it. What I got from that trip was seeing that most of the world does not live like we do. My senses were just overloaded; during the whole trip I was like a sponge, I absorbed, listened, smelled. It took me a long time to synthesize it all. It changed my outlook on things. Things started becoming more meaningful to me. I saw so

many hungry people. And I thought it was totally ludicrous for me to be selling dope."

It was shortly after he returned from India that Seidman received a call from the administrators of the Painted Bride Art Center, who knew him from his performances there, asking if he would like to do some part time accounting work. It was a compromise for him to agree, because he dreaded the work so. But the need for some income and the fact that he would be doing the work for an arts organization convinced him to take it on. He discovered that he liked the people and the atmosphere at the Painted Bride, and eventually became more involved in the programs being presented there.

"One thing led to another and I started getting more aware of what was going on there," he said. "Jazz was a big thing for me, and I felt that the jazz series at the time was very weak, and I started voicing my opinion. Finally, the program director said he was going to give me some dates and see what I could do with them. That's how it started. I changed the jazz program. I brought in some hip stuff. The guy before me was very conservative; what he was booking was like lounge music almost. They liked what was happening, and I started programming Indian classical music for the first time there and filling the place with a whole different culture of people."

From that beginning, Seidman developed a well-attended world culture music series. He is now the curator for all the jazz and world music. Over the years his involvement with the center's bookkeeping became more involved and time consuming, particularly as the budget grew to a million dollars and the accounting system became computerized. Seidman began to feel like a slave to the work from which he had so desperately liberated himself. Eventually, he turned the accounting duties over to someone else.

Because Seidman was involved at a major urban arts center through the 1980s and 1990s, he was able to see firsthand the effect of the cuts made to arts funding during the culture wars of the Reagan administration, when the National Endowment for the Arts was under attack by congressional conservatives, such as Jesse Helms, and the religious right. "About seven or eight years ago we never had to think about budgetary things. If an artist cost $2,000 to bring in, and we only had forty people come and only took in $400, we wouldn't think about it. So I guess we were getting enough support to cover this stuff; I wasn't involved in the finances at the time. But even five or six years ago, we found ourselves in a crisis. A huge deficit. We were in danger of closing the doors. And then some big foundation bailed us out, a one-time bail out. Now we're very fiscally conscious. There's a meeting every week to make sure that that never happens again.

"The budget went from a high of $1.2 million to the current $700,000. So that's a big cut. And we lost half of the staff. Everyone's overworked, and there's so much stress. Now we have to consider if we can sell enough tickets for any given performance. Also, the curators have to take more responsibility for marketing. Now the questions being asked are 'How many people do you think will come, and how will we find these people?' We have to be involved in every aspect, whereas seven or eight years ago my job was just to program and stay in communication with the artist, be the emcee, and make sure everything was okay for the performance. Now I'm part of the process at every step. Now for every artist I bring in, I have to work on that performance for a minimum of six months. And if I do twenty concerts a year. . . . So, it gets us more involved.

"That process of getting more involved in all these aspects makes me understand the relationship between places like the Bride and the arts, and the Brides of the world are very important. Otherwise what we're going to be left with is the Avenue of the Arts [a major initiative to promote the arts on south Broad Street in Philadelphia, funded by government, private, and corporate donations, which includes the construction of a new performing arts center]. This is to bring in tourists and is very elitist stuff. Some good happens there too, but it's very mainstream; there's no involvement of various communities. The Bride reaches out to the many communities in Philadelphia and bridges them."

One of the reasons that Seidman feels so strongly about the involvement of different communities and the cultures they represent is that he views the arts as a vehicle for social change. He elaborated, "At one time I used to think of art for art's sake; that was when I was doing a lot of avant-garde stuff, which now I see as a problem. Because I feel in hindsight that I was very self-absorbed. I didn't necessarily care how the audience felt, although I wanted to please them, since I wanted the applause and wanted the recognition. But the audience wasn't even considered. I wasn't conscious of the impact it could have on the audience. At one time I became very political, and I had a major attitude, and the music I was playing then had lots of attitude also. Now I consider playing music with attitude but much differently. Now I feel that we do have to go out there with attitude, but an energized attitude, not a philosophical or in-your-face attitude.

"But in the last ten years, when I started doing the world music and bridging communities is when I started to see the power, the potential power, of strong art that does bridge communities at the same time. That just increases the dimension of what art can do. It wasn't something I created in my mind, it was through experience that I saw this. As a curator at the Bride I started creating these situations by bringing diverse cultures together on the stage and working things out. I was very naïve when I first

started doing that. I'm now at the point where I'm not so naïve and I know the pitfalls, and I know the obstacles, and I know the rewards.

"There was a certain amount of excitement about it, the artists were into it, but they were also very tense. The Japanese guy who's very disciplined and comes to work is playing next to a Puerto Rican drummer and West Indian drummer whose work habits are totally different and whose approach is totally different. These differences in attitudes and work habits, even though they're basically going for the same thing, caused a monumental struggle. There were misunderstandings and stereotyping.

"I've brought Jews and Palestinians together, Arabs and Jews, and tried to make things happen, Afro-Cuban and West African, Indian, Brazilian, all these traditions, artists working together. So it's been a fascinating experience learning, understanding that cultures all have their own idiosyncratic ways of doing things, coming from either spiritual practices or other areas of the culture. It's work to understand the next culture, and appreciate it, and see that it's great that it's different. It's wonderful that there are so many great cultures out there, and you have to take time and give up some ego to really get to know a person from a different one."

Being that Seidman sees how important the creative life is to society, he is frustrated with the lack of support for the arts in the United States. "It's an American phenomenon that we don't support the arts. In Europe they do support the artists over the long run. I think you do have to show some results, but people do get supported there, and you don't necessarily have to perform immediately. There are pockets here of support such as the Painted Bride. But the Painted Bride's resources aren't such that they can make a ten-year commitment to an artist or a group. They'll make a year commitment to a group, as they did with Spoken Hand. Now it's in its third year. So I figure as long as we keep working hard, and evolving and adding dimensions to our work, and creating new works, we do enough in the community and for the community so that the Bride can continue to support us."

There are grants available, but Seidman isn't certain that they stretch very far. He feels very fortunate that Spoken Hand has received a Rockefeller Foundation grant. Called a Rockefeller Multi-Arts Production (MAP) Grant, it provides money to create new works and to rehearse. "Even though we aren't at the point where we are real polished yet, they saw real value in what we were doing. That has already made us better. It provided paid rehearsals, there's a whole different attitude, and we're getting stronger. The grant doesn't sustain the group. No one gets rich. But it's about a half-a-year project, and hopefully we can use that to get more support, because

it's a very prestigious grant. So I hope that other foundations will jump on the bandwagon."

Seidman also credits the Painted Bride with providing support by offering rehearsal space. "Where else can sixteen drummers rehearse? They provide the infrastructure for us. And they do that for a lot of people. That never gets publicized. There are other places like the Bride. Compared to McDonald's there aren't a lot, but there may be a place like the Bride in every city— community arts centers on a smaller scale."

Seidman also feels lucky that everything he does to earn money is related to music, which had been his goal since engineering his own demise as an accountant. "I keep my schedule working at the Bride, but if a tour comes up for me, they say, 'Go, we'll take care of it.' My music is always top priority. Now my income is probably more than it's been in a long time. I don't make much at the Bride, it's part time, I'm supposed to be working ten hours a week, but that's a joke; it's always much more. I'm also teaching and giving guest lectures and demonstrations. I teach tabla privately, and I'll be working at Swarthmore College, working with their percussion ensemble and teaching, and then there are my gigs with Atzilut.

"But the percentage of artists who survive from their art is small, so, so small. If I just think about Spoken Hand— one of the guys is a fireman, one of the guys was assistant managing director of Philadelphia, another guy supervises the implosions of buildings, another guy delivers blood for the Red Cross, there are quite a few teachers, one works in a health food store, one has a recording business. Ninety-five percent of people have to do other things; they have families, they have kids.

"In Atzilut, one guy does telemarketing, another is an audio-visual guy at a hospital. Some of the guys were able to succeed as musicians in the commercial world— doing studio work, playing in bar mitzvah and wedding bands. Of course that can be problematic because that work is on weekends and that's when our gigs are."

Seidman believes that he can continue to sustain himself by patching together the kind of paying work he has described here. However, it is a fragile construct he has made for himself, one that provides little security. "I try not to think about it, the only times it comes up is when other people bring it up. It's hard to explain to people who aren't artists that if I weren't doing this, I'd probably be dead. I just see that right now all my energy is going into Spoken Hand and Atzilut and the Bride, and trying to be out there and get calls to do more college things. I can't complain.

"If I think about what's going to happen in ten years— I could have arthritis in my hands— I can get myself in trouble. I prefer to be in denial. I have a health insurance plan through the Bride, to which I contribute 50 percent. It even pays for me to regularly go to alternative healing for preventive care.

"But then I have to worry, if, say, certain dental things come up, I'm screwed. It happened to me two years ago. It cost me $8,000. I had enough savings to make it work. But if something catastrophic were to happen, I'm screwed. But I'm not going to worry about it. They can't put you in jail for owing money. I've gone through enough on this journey to realize that to spend energy worrying about things I have no control over is not productive. It's not that I only live in the moment, but partially I do. I think I have the psychological tools to cope. When I was twenty-six and was asked to quit the accounting thing, I said to myself, 'I'll give it two years; I have to be playing music professionally in two years.' Which is ridiculous, but I didn't know any better. Well I'm still saying that. No, seriously, I've learned since then that it's ridiculous to set a limit on anything. This kind of world, the creative world, has no limitations. You just have to be willing to deal with the roadblocks. And if I am worried a little, I sit down with my drums and start working on something new, and I realize that this is what's important. If someone starts talking to me about stocks and insurance, I don't want to listen, I don't want to listen to them talk about it. Because that will take me off my center, and I've got to keep my center."

3

Creating in the Community:
Fawn Potash

Fawn Potash is a photographer whose work has been displayed in many galleries throughout the United States, including the Boston Art Institute; the Center for Photography, Kodak Gallery, in Woodstock, New York; and Gallery 292, in New York City. Her photographs are in the collections of Dow Jones, in New York City; the New York State Bridge Authority, in New Paltz, New York; and the Bibliotec National, in Paris. Potash was the recipient of a New York State Decentralization Grant.

It was only a year and a half before she was to graduate from the Art Institute of Chicago that Fawn Potash enrolled in her first photography class. She wanted to learn how to take slides of her paintings. "However," she said, "I became more interested in photography than in anything else I was doing. So I started focusing more and more on photography the last year and a half I was there."

Today her work is shown at Gallery 292 in New York. The *Library Series,* a group of photographs of books and magazines piled in sculptural configurations and lit by moonlight and lamps, is selling well. This series was also featured in a Savannah gallery. "I love those pictures," Potash said, "but I'm a little tired of printing them, which is good, because that means I'm selling them. I had never had a series sell like this. I had understood the idea of editions, but it never occurred to me that an edition would sell out." She is also working on some garden pictures and another, unrelated series from Mexico.

Despite this success, Potash can not support herself on the profits from the prints, so she makes a living from several other jobs. She teaches a photography class for third-year photography majors at the School of Visual Arts in New York every Friday. The six-hour class begins at nine

o'clock in the morning, so she travels to the city the day before, spends the night at a friend's house, then teaches and returns home. For several weeks in the summer she teaches photography at a camp for two to four year olds that is run by the Arts Council in Catskill, the town in New York State's Hudson Valley in which she lives.

"I'm also a woodworker. Over the summer I built a computer desk for someone, and I did some renovation work. I'm a good plasterer. I do that kind of work when things are dry. I have some friends who are contractors, and I let them know when I'm free. I have done arts administration, and occasionally I'll get an arts consulting job. But the pay for arts administration around here is really low. It's $10.00 an hour no matter what. I can get twice that for plastering. It makes it really hard to do the work that I love. I like to be involved in exhibits going on and grant writing and all that, but not at that rate of pay."

Even when she was in college, Potash never had any grandiose expectations about her future as an artist. "When I was in school, I never imagined I would be able to make even a portion of my income from my work. I never once thought that I'd have a gallery in New York showing my work. I just thought I'd better have a whole bunch of other skills. So I worked for museums and galleries and not-for-profits; those were my main money-making endeavors, or else I worked in restaurants or did carpentry or cabinetmaking. I had all these other skills, and perhaps there's a down side to that, because if I didn't have them I would have been forced to just figure out how to make a living from my art. But I do have them, and thank God I have them, because I can build a house. And it's so great to not be an isolated 'dumb' artist; I have all these other cool things I can do too."

Because Potash is employed part time and is an independent contractor, the organizations and companies for which she works do not offer health insurance. Before her divorce, she was covered under her husband's policy, but now similar coverage would cost $2,500 a year. She calculated, "I could go on two vacations or have health insurance. I'll probably be much healthier if I go on two vacations. I could buy a whole new camera system or have health insurance. I don't want to do it. I'll only have it if someone else pays for it. I don't want to pay."

In her class at the School of Visual Arts, Potash explores with her students the art of photography— the creative process itself, and the practical aspects of earning a living as a photographer. During the first half of each class, Potash and her students critique and analyze students' work in progress. The second half of the class is based on a modified version of the book *The Artist's Way: A Spiritual Path to Higher Creativity* by Julia Cameron, which helps readers overcome the stumbling blocks to realizing their creativity.

"The first half of the class you're using sort of the yin side of yourself and the second half of the class is sort of the yang side. It's working very well, and the students like it very much. They're keeping journals, recording dreams, all these different sorts of soft things that contribute to their creative selves. I tell them to take themselves on dates, so they are connected with the things they love and that they enjoy; we're having a blast."

Potash also believes that students should have as many practical skills as possible. She thinks that it is an anachronism to think of the academy as a pure place, removed from the everyday mundane world in which rents have to be paid and food purchased. When she finishes writing a grant proposal, she brings it to class with her support materials and slides. Then she answers any related questions her students may have. She also shows them resource material that may be helpful, such as arts calendars, the New York Foundation for the Arts newsletter, and five or six different resources artists can use for getting shows. "My students seem to be really concerned about how they're going to make a living and pay off their student loans. Because they're photographers they have the option of commercial applications. Many of them are tuning their work to having one foot in each world. What I'm trying to do is turn them toward tuning it so that what they're doing is really creative but has a commercial application. If that's how they're built. Some of them aren't built that way. Some of them are going to be fashion photographers, some will be photo illustrators, and some will pretty much be like me— in a fine arts career. I try to gear it for who's in my class.

"We'll go to museums and galleries and artists' studios. I bring artists in. To get the conversation rolling, I'll ask very direct questions, such as 'What percentage of your annual income comes from fine art?' The students get a sense of how that varies."

Potash views her creativity as an artist as directly connected to her life in the community. She explained, "I'm a volunteer firefighter, and that's a way that I can be useful to the community, but I also want to be useful as an artist. People get to know you through what you do. I didn't want to be known as a firefighter or an arts administrator. I want them to know that I'm an artist. And I want them to know that other artists in the community have skills and talents to contribute. So, in a way I feel that it's good public relations for the arts community for us to be involved and engaged in meaningful ways so that the community can understand what we do."

One of the ways Potash became engaged with the people around her was to create the Local Hero Awards. Her town of Catskill is tiny. There is Main Street with a few restaurants and shops and many vacant storefronts. Being that it is the county seat, there are several government offices,

including those that provide welfare services. As has happened in many other small towns, the Main Street district suffered when shopkeepers and customers were drawn to a nearby mall. When the Catskill merchants decided to revive their downtown, Potash, who had already been involved in the local Arts Council's gallery on Main Street, increased her participation.

The Local Hero Awards featured people who had contributed to the life of the community, often in very quiet and unobtrusive ways. Photographic portraits and stories about these individuals' lives were displayed in the vacant storefronts in town and then in the Community Center. In a neighboring village they were accompanied with behind-the-scenes sketches and public relations pieces that displayed the evolution of community art. When the exhibit was dismantled, the portraits and stories were presented to the local heroes themselves.

In another effort, Potash applied for a grant for community children to produce self-portraits. She proposed that they create postcards to be sold in Catskill. The money raised would be used to maintain and supply a darkroom in the Community Center. There currently is a darkroom, but it has never been used. This fact itself provided a lesson for Potash, who explained, "I donated an enlarger about eight years ago. But then I finally realized that you can't just donate equipment, you have to donate some expertise to go with it."

The subject of grants, which often can give artists time for the creation of their art, is one on which Potash has many thoughts. Her impression is that there are many good grants available, but that the nature of the grants, the review process, and those who are selected as recipients have changed during recent years. "The seeds of the grants are changing. It used to be there was money to do your own thing. There were a fair number of grants out there to continue your body of work, or create a body of work. Now many of the grants want you to be involved in the community, or to cross cultural lines, or to create art work for communities that have no other access to art. There are a lot of social mandates attached. It's always been true that there were many criteria for artists that were weird and esoteric. But now there are a lot of partnerships. These might be, for instance, among the hospital and a government agency and a chamber of commerce, or between a school, a church, and some other organization.

"With the money that's available, they want whatever your program is, whatever your artwork is, to reach a broader range of people. And so, they want to ensure that there is a broader base of support for your work in the place where it's going to happen. Whether you're writing a grant for an individual artist or an arts organization, it's the same thing. They want to be into your program, signed off on it.

"I pick the art for the context. I have a few different subjects that I've used in my work and a few different ways of photographing. When I'm applying for a local community grant, I wouldn't send art work that is not accessible to the panel. I think it's the artist's job— if you want the money, if you want to do the program— to do the homework about the panel. Are they artists or people from the PTA? If you're planning a project that's not going to be accessible to the community in which it's going to be shown, then you shouldn't get the money.

"I'm all for stretching the community's boundaries, but it better have enough interpretive material to help the community understand what's going on. There's got to be a lecture, or lots of signage, or pamphlets. As a great example, here's what happened when a friend and I wrote a grant together for some Hudson River Foundation money. Those grants are not usually awarded to artists; they're normally awarded to cultural or environmental organizations.

"Our proposal was to build hiking paths with artist-designed things, like benches and signage. We proposed it as administrators not as artists. The concept that was developed with our artist team was too challenging for the community. It got all the way through the design stage, with some really cool designs— stuff like monoliths with artifacts from the riverfront embedded in them, windows cut into the monoliths that would look out on different scenes that have historical significance, and interpretive pamphlets that hikers could take. It was just too out there for people on the community panel who were reviewing it, and they killed it. They fired the team of artists after they had designed all this really great stuff.

"There was a dirt bridge. These artists had figured out how to build a bridge out of dirt. Some of it was really cool earthwork stuff, signs like you've never seen before— it was too weird, too weird. I was so excited about it, I stopped thinking about how the people on the greenway committee would be relating to it. I was just thinking, 'This is great because I love it,' and I know better. That is a perfect example. I have a feeling that eventually we'll get to build just one of the components that the artists designed. That will serve as an introduction to the next wild project we come up with."

One of the grants that Potash admires the most is the Special Opportunity Stipend (SOS), which was initiated after one of the New York Foundation for the Arts' yearly conferences. During the conference, administrators asked artists what kind of grants they really wanted. Potash and her colleagues requested fast grants that are easy to write and have a quick turnaround. Within a few months the foundation had created such grants. Potash acknowledged that they're only for $500, but it's $500 when an artist really needs it.

"I sat on the grants panel three times, and the panel was adamant about not awarding money to people just because they can write a grant well, but to award it to those people for whom 500 bucks at that time was going to mean something important for their career."

Despite her relative success at making art, Potash has no illusions about the place of the artist in contemporary American society. "They don't really trust artists right now. And I don't think it's unique to a small town or a small community. I don't think people see artists' skills as practical skills or important skills. They don't value what we do as integral to the society. I think it's a matter of showing them. If my Local Hero Awards actually did raise morale in the town and contribute to the Chamber of Commerce's efforts to make it a better place for businesses to move into, then I helped. That's a real skill, and I could actually point to that. Maybe a real estate agent could point to that and say, 'Look at the cool thing they have going on here,' when they're showing a vacant property to a potential tenant.

"People thought that the economic impact of the arts was a spurious argument for a long time, but it's just not true, it's a fact. If I could get every artist in the Hudson Valley into five acres, and put numbers on our T-shirts showing how much we paid in taxes, just taxes, it would be amazing. Just taxes, I'm not even talking about how many groceries we buy. We're a huge population around here. But we're new at letting the community know how we can be useful to the rest of the community, and they have to see it."

Potash believes that this awareness of the creative community's contribution will take time. Even in New York City, where artists are fairly well respected, she thinks that they are perceived as solo people who sporadically make a small impact. However, she is excited by the climate for art that exists in New York. Potash described the sensation of walking into her gallery: "I feel so great when I walk in there with a box of prints. There's a real market. It's a totally different feeling than walking around Catskill with my box of prints, knowing I'm just going to show them to somebody. Nobody's going to buy them. Well, it's good to have both."

What does exist in the Hudson Valley though, as Potash alluded to, is a thriving and nurturing artists' community. "There are a lot of artists here because of the proximity to New York City. In the town of Woodstock, there's a density of artists. Although many artists can't afford to live there anymore, there are still a lot of creative people there. But most artists who move here from somewhere else, usually from the City, opt for not being in town but having a few acres and maybe a barn or a house with lots of rooms, so they can have space to work or to raise a family and work. So you don't usually have people right next to you. But there is a good community through arts councils and galleries. There are some fairly great arts organiza-

tions around here. People get together at exhibits and performances, that sort of thing, so we know each other. The main activity is eating dinner at each other's houses. Then we see each other at shows. The nicest thing about this arts community is that artists are very supportive of each other. So if I have a show someplace, and if I think one of my friend's work would be good there, I'll push for that work to get shown. I didn't feel that in New York City as much."

At this point in her life, Potash is genuinely surprised at the success she has enjoyed as a photographer. "I thought that I would be the kind of artist who would do my art and have a job, and at some point in my life maybe I would get a grant so I could work for two years on only my art. I didn't have it figured out. Ambition has come to me very late in life. Most people when they come out of art school, or when they're in their twenties, they have this feeling that they're going to be an artist, become famous, make a lot of money. Something is motivating them forward. I didn't have any of that. It's only lately that I've been thinking, oh, maybe I can make some money at this. Fame and fortune never occurred to me, and now I'm thinking, well maybe. I almost had to be knocked on the head with the possibility."

The idea of doing commercial photography that would pay more than her fine art work is not an anathema to Potash. She said, "I wouldn't feel conflicted about doing commercial photography, I just stink at it. I'd love to do it. I'm going to try. I wish I could be a travel photographer; the problem is I don't shoot color. I have an idea that I want to go down the Mississippi, from St. Louis to New Orleans. My boyfriend wants to put a steam engine in a John boat. And I'm thinking I could sell this idea to an out-door adventure magazine. And it's such an esoteric idea that why couldn't the pictures be really esoteric—journal entries written right on the photo-graphs? I'm thinking I could do something really wild. It's still art, but maybe it could find some place in the world."

Recently, Potash hired an intern, a photography student from the local junior college, to help with printing her *Library Series*. She mused that per-haps he can stay home and print her pictures while she goes out into the world and has adventures. But on a more serious note, she points to this small act of enlisting a helper as an example of how she is seeking to find more time to work on the conceptual part of her art. "Getting this intern in my life is great. It just lately occurred to me that I could have someone else do some of this. I think it takes a long time to value balance, and then it takes a long time to achieve it. It seems that every little move I make toward balance makes me happier."

4

New Languages, New Connections: A. Madison Cario

A. Madison Cario is a performance artist and writer who has written and produced more than a dozen multimedia performances. Among these were **CYAN Presents Blue, a Safe Place,** *a thirty-person work about war crimes against women; and* **Disputed Territory: Sexploration,** *which focused on the experiences of sex workers in the San Francisco area.*

A. Madison Cario likens herself to a mix-master, a disc jockey who takes existing music and combines and integrates it into new and original combinations and juxtapositions. In the creation of her performance pieces she employs dance, writing, video, photographs, music, and narrative.

Cario explained how she evolved into a performance artist: "Basically I started out as a writer, I guess at my core that's what I am. But I never actually ever verbalized that to anyone until I met Myra, a former lover of mine. She asked me what I did, and I said, 'I'm a writer.' That was the first time I ever self-acknowledged myself as an artist."

She felt it was presumptuous to identify herself as a writer. "I was an English major in college, I was a writer, but it wasn't anything I shared; I was in the closet about being a writer. At least if you're a dancer or in the theater, you're an actor. If you say you're a writer, then people ask, 'Well, what have you published? Who are you writing for?' "

Cario was drawn to the art world but had no idea how to enter it and had no practical plan for how to make a life or a living for herself in that world. So she left school, went to New York for a short time, and then joined the Marine Corps. After she was discharged she returned to school, completed her English degree, and worked in the permissions departments of various medical publishers in Philadelphia, where she settled.

Her performance career began as the result of a momentary whim. "I

happened to be in a coffee shop and I saw an application for a grant from a theater that has since burned to the ground. I picked it up and filled it out, thinking I'd never get it. I sent it in and forgot about it. I got a phone call; the man said, 'Congratulations, you've received this grant.' I was so stunned I said, 'She's not here right now, can I take a message and have her get back to you?' I hadn't even made a copy of the application, I didn't even remember everything I had written."

After that initial success, Cario became adept at writing proposals and received other local grants that enabled her to produce and perform additional pieces at community arts centers.

A few years ago, Cario moved to San Francisco, where she has produced and performed in over a dozen shows. To earn a living, she has a full-time job working for the Conservation Corps, which services at-risk youths in West Oakland, California. She described the program, "We teach things like job responsibility, punctuality, and some job skills. They do recycling or clear brush, do trail maintenance, stencil storm pipes with warnings like 'Don't dump here, it goes straight to the Bay.' They're in the community four days a week, and two nights a week they go to school in our building. We are a charter school. When they go to work, we count that as school. We get funding from the school district because we found a way to translate the work into the equivalent of school learning. On Fridays they go to job training or drivers' education, or learn how to do their taxes, or they come to me. I'm teaching public speaking and art. I'm also trying to work with them in conjunction with a local theater company. Basically, they can stay in the program for a year and then they can go work for UPS, or FedEx, or the state, or go back to the 'hood if they don't make it.

"I'd like to present another option for them of staying in art if they do like it, like doing lighting design, stage design, graphic arts. They don't have access to computers and probably most of them have only just seen them. But some of these kids are amazing artists; they just don't know it. That's kind of like what happened to me when I was growing up, I didn't have anyone ever encouraging that in me. I didn't even know it was an option to be an artist. I didn't have piano lessons. Art was never something that anyone talked about or that I ever saw, except in books in art history class when I was a freshman in college, and I hated that.

"I don't think that these kids even considered art as a possibility. Some of them could be amazing DJs or mix-masters like King Brit in Philly, who is internationally known and quite a success. Not that money is the end-all, but from their point of view, for something to be considered, there has to be some money involved.

"If they're hanging with the boys, no one's going to say, 'Well I'm going to be a writer.' Even if they're thinking about it, it's just not going to

happen. So I have to think of new words for these different art forms so
they'll get into it. And once they get into it, they'll find words to say it
themselves. For myself, now I have no problem saying what I do, but for
the longest time I couldn't say anything because it was embarrassing. It's
also embarrassing in the world of, say, lawyers— 'Oh, really?' chuckle,
chuckle, 'Honey? How are you going to make it, marry rich?' "

Besides working at the Conservation Corps, Cario earns extra money by
filling in as a lighting designer for other people's shows. "People have asked
me to tech their shows. That's something I learned because I had no
money. It's a good kind of Catch-22— I learned how to do lighting because
I couldn't pay a lighting designer, I didn't have money for someone to do
slides for me, I couldn't hire a graphic designer to do my flyers; so I learned
how to do it myself.

"In San Francisco, I first produced the festival, *Dancing to Your Emotions,*
and from that I got more festivals. Work comes in, and people call and ask
if I want to tech this or that show that they can't make. I've become the
last-minute girl. People in this town are not the most reliable. So there are a
lot of holes. There are a lot of local shows in theaters and bars where peo-
ple don't show up. I have the reputation as someone who *will* show up. So
they call me the night before and ask me to come. It's not a lot of money,
but hey, $50 pays for the flyers for my next show."

Cario is an energetic woman, with a puckish grin and a shaved head,
who exudes energy when she enters a room. But the schedule she keeps
exhausts even her. She said, "Sometimes I think, when I'm working hard
and having rehearsals, 'Why can't I be a normal person and just have a job
and come home. Because literally, I come home from my job, and there's
job number two. I'm running. I leave for my job at 7:30 in the morning; I
get home around 5:30 or 6:00. I sit down and eat for fifteen minutes, then I
usually have a meeting or rehearsal at 6:30. That runs until 10:00. Then I get
up the next morning and start all over again. I hate that, but then as soon as
the next opportunity comes along to squeeze another gig in there, I'm like
yeah, sure, I'll do it.

"I'm moving to the point in my life where there's no distinction between
life and work and art. I want them all to become one. I think that's where
I'll be the happiest. It's what makes the most sense, physically, energywise,
financially— have everything be one. Even if you're at a job that's making
you money but taking your energy, you're going to run out of one or the
other, it's inevitable. I'd rather run out of money than energy.

"And this job, really I'm going to turn it into something that will work
for me. I've always enjoyed working with people who are 'nonartists,' be-
cause I find them the most honest and they get the most out of the kind
of performances I put together. These kids in the Conservation Corps are

great, and my official job technically has nothing to do with doing these workshops. But I figure, I'm here, I'm going to do these things. Because this is for me. It's for them, but it's for me too."

Cario views her financial situation as a handicap— not an insurmountable obstacle that keeps her from writing, producing, dancing, and performing, but a hindrance that makes the ability to do these things more difficult. "I didn't get a $30,000 grant out here that I applied for. I was kind of shocked. Half of me was 'You're never going to get it,' the other half was 'It's a damn good idea, and it's written well,' and I had it all spent in my head. Money's not the most important thing, but not having it is a handicap. It's a handicap to my life in art. I have to go to work and I have to pay bills. If I didn't spend eight and a half or nine hours at work, I could do much more.

"Even for artists who are fortunate enough to work within the medium, who, say, work either dancing or teaching dance, most of them can't make a living just from their art. Even for many people who dance in the theater, in *Phantom of the Opera* or *Cats,* I mean they probably have got to have a certain level of frustration.

"I don't have a real big conflict though. A lot of artists say, 'I have to work, I don't have any time.' To me, I've always had to work, period. Since I was a wee tot. That's maybe an issue of class. I've always had to work, and I don't see any time soon when I won't have to work. So it's not something that I'm particularly angry about. It's like I have to do the wash every week; it's just something that I have to do. It's just that when I'm in the middle of like twelve shows, I think if I just didn't have to go to work today. . . . But for the most part it's just part of the things that I have to do.

"It's not like I'm saying that if I didn't have to work I could do my art, because I am doing it, without the money and with a full-time job. As I mentioned, I've applied for grants. I'd like to start my own nonprofit and apply for grants, and I need to really get on that because there is money out there. There's no reason why I shouldn't be able to get some. There's no money for individual artists. Well, there is a little money, but it's really hard to get it, and there are lots of strings attached, and I'll be really old by the time I would get any.

"Plus, for a foundation it's risky sponsoring an individual artist. Usually with a nonprofit organization they'd prefer to grant money to say a theater group that has some kind of history, some proof of whatever they're looking for. Maybe some day I can get enough grants so that I won't have to work full-time. But that would entail many hours of research and writing, so it's work of another kind. I don't see that my art in and of itself will ever pay for itself— maybe if I ever get to big theaters, but my art doesn't really lend itself to that. Maybe I say I don't want the big theaters because I know

I can't have them, or maybe there is some truth that they're pretty unacceptable, and I want my art to remain true to my history. I don't want the yearly subscription holders, for the most part I want people who don't think they're interested in art."

Much of Cario's initial lack of confidence about her creative abilities was self-imposed. However, she did encounter some snobbery and cliquishness in the art world from other artists. She related her experiences, "I think I was a lot more closed in Philly. I was struggling with, well, I'm not a trained dancer, or a trained director, and I think it limited me. Most of that I created. But it was suggested to me by others at a few crucial points in my beginning out-art career, and it did a lot of damage. It made me not want to be around most of the art community.

"After I did my first show, *Backward*, I went to a dance workshop. They started out by doing a round robin asking each person to say who you are and whom you studied with. There was this real attitude of one-upmanship about who your mentor was and where you had studied. That was intimidating to me, and I went to the bathroom right before it was my turn to speak. It felt to me like the thing that the rest of the world does to the arts community, like when they say, 'When are you going to grow up and get a real job?' The arts community does that to its own. They co-opt that attitude. They can't beat up on the lawyers, except to make fun that the lawyers are on the train at 8:00 in the morning while they're still sleeping. I think a little of that gets passed along. It's the one-upmanship— well, I studied with so and so, who did you study with? My point of view and my point of reference is the here and now. If you came to my show and you liked it, why isn't that enough? Why do you have to always go back there? There isn't much back there that's pretty, and I'm sure that everything I've done has culminated in the person I am today. But I think the most important thing is the person I am today and the person I can be tomorrow.

"The second time I went, I actually stayed in the workshop; I stayed for the whole thing. The only reason I went back, because they really hurt my feelings the first time, was because the workshop was called Movement for Writers. The woman teaching it was a dance critic from the *New York Times*. So all the dancers from the Philadelphia community came, because you never know—you could make a good contact. In the workshop we wrote for a little while, which was good for me. Then we had to move. First we moved individually, then they put us all in groups while the other groups sat and watched.

"This woman Amy came up to me and said very snidely that my movement was very pedestrian. I never went back to another dance class ever. It can be harsh. Especially when you're fragile. When I think about it, we're all

artists. When you were little you were dancing, singing, drawing, and then somewhere along the line an Amy came into your life. More than likely someone just came up and said, 'Maybe you ought not to do that.' Or they were all shushing you when you were singing or stopping you when you were dancing, and now we're all stifled, and I struggle with that. Training or not, you need to encourage everyone to express themselves freely. It shouldn't need to take fourteen years of training to learn how to express yourself. In a lot of ways, that's crazy.

"I think it gets lost sometimes, the loving the art and wanting to encourage others to participate and enjoy it. It's really hard for me to confront an Amy, because it's personal. But when I see it happening around me to others, I do question people as to why they would do that. Sometimes the response is, 'I can't work with people who aren't trained.' But I also hear the exact opposite, 'Well, I'd rather work with people who aren't trained, because then I don't have to deal with all this training, you don't have to undo things.' My art ego is fragile, more fragile than all my other egos. It's still a child and I need to nourish it. I need to maintain my integrity and develop my identity before I start really putting it out there for people who have a really strong identity. They have twenty years under their belt with this identity, whether they hate it or love it, so don't crush my little baby. I don't want to have that happen to me, it's part of what happened to me in Philly. Art is work, it's hard work, and I don't need to be around people that might influence me in that way.

"Mostly I think I started doing art because I wasn't seeing anything I wanted to see out there. I felt so isolated. That's why I didn't want to identify myself as an artist. Even going to art shows, I felt they really did not relate to me, as if the artists had their own trips. What about art for those who aren't artists? Because I didn't come from that. I didn't go to art school, I didn't have that kind of background. Every artist has a different background. But I think what's unfortunate is that those who make it onto main stages above ground in the United States are the ones who have gone to school with someone who has the big name.

"I couldn't relate to that. That's one reason it took me so long. I had this big chip on my shoulder because I didn't go to art school. Finally, I just got to a point in my life when I just said to myself, 'It doesn't matter, because I have something to say that I have never seen up there, so that must be important.' I still struggle with that.

"I feel that some people are looking at me and saying I don't have the right credentials. I'm not sure how much of that is projection and how much is coming from them. I think a lot of that is still my little tantrum. I would love to go to art school. I love school. But I could never afford art school."

Cario loves writing and creating her productions. But she is also interested in how the process spirals out, how it affects both the performers and those who witness the work. "Art can bring cultures together. It's sort of a sneak attack. I worked on a festival focusing on the exploitation of sex workers. Even in this town, it's not all 'Oh yea, happy sex workers.' People are still getting arrested. There's still pimping. It's one of the few jobs where you have to pay to work. You have the academics, you have the feminists who are talking about prostitution forever, but I'm not sure they're doing such nice things for the people who are in it. Then you have the politicians, and the 'concerned community,' and all this rhetoric, but nothing has really changed. It's still a pretty horrible and at the same time a pretty wonderful, empowering place to be when you're in it. I tried to think about another way to discuss it, and I thought about art."

In her art Cario strives to change people's perspectives and assumptions. She said, "In my last piece I said to people, 'I don't like it that as soon as you get here you try to call me "butch" or "femme," and you're unhappy because I won't stick to a tie or a dress, one or the other. I won't make up my mind.' In the beginning of the show I came out naked, and then I got dressed. First in a dress and a wig, and then in a suit and tie, and they loved both, but I don't think they wanted to.

"They're pretty hard-core about their lines here. You can have a place, as long as you stay in your place. They're pretty harsh, even in this liberal place. I think there's a big resurgence of redefining lines. They want to define a place so they know where they fit in. That piece worked. I spoke to a woman afterwards. She's been a lesbian all her life; she's in her mid-forties, old school. I was in a workshop with her a month or so earlier and we were talking about who we're attracted to, and she said she's butch and she's only attracted to femme girls. She was telling me because whatever I happened to be wearing that day she figured that I was butch and with her in that.

"When she saw the show, she said to me, 'You know, you look good in a dress. I know I told you I don't like butches, but you know, with your body you look good in a dress.' And she had to really think about it for awhile. She left shaking her head. She was just confused.

"I want to just keep people thinking. You don't have to agree with me, but just keep thinking. That's what's unique about art. You can get to an audience on so many levels, because I have music, and dance, and spoken word, and video. Whatever I can possibly afford. Because everyone reacts differently and thinks differently. With some people, the music gets them, some people are visually inclined, so it depends on your history. I like to give them lots of different options and I say things on different levels.

"One thing I've been thinking of doing for years is adding smell. That's the limbic system; that's the closest thing to your memory in your brain. I'd like to do a simple thing and have a potpourri of smells, like Mom's apple

pie or a locker room smell, maybe a little container with a smell under each person's chair. It'd be interesting to see what kind of feedback I'd get. Maybe I'd tell them I'd done it, and maybe I wouldn't.

"I learned that about light too, that low blue light makes people irritable if they have to sit in it or look at it for any period of time because they have to keep straining their eyes. There was some truth to the psychobabble of the fifties when they talked about painting this room this color and that room another."

Ultimately, what Cario is striving for is the creation of new languages that contain fresh connections and the integration of new ways of communicating. She models her ideas on what she has learned from her brother, who is severely disabled from cerebral palsy. She explained, "Thinking about my brother has helped my art career more than anything else. There is sadness about it for me and frustration when I think about how I walked out of dance class because I couldn't get over my little ego, and he has to struggle just to eat. My brother can't speak properly, but if he wants something on the TV, he shakes his arm in a certain way, and those who are used to being around him know what he wants. He has created his own language."

Cario bases her art on this concept of using alternate means of expression and being creative even within the confines and restrictions of available time and money. "I once created a performance piece by asking a composer to write some music. Then I took that and gave it to a filmmaker and asked the filmmaker to make a short film based only on that music, and so forth with other artists down the line. And it came all the way around, and they each got to see how the other person had translated it. That's what art is, being able to translate and understand and communicate within the confines that you have; that's where the power is."

5

The Political Act of Creating: Steven Verdad

Steven Verdad is a composer and musician who plays his avant-garde music on the recorder and penny whistle. He performs independently and also as a member of an experimental music ensemble and in a musical ministry. His performances and compositions have been recorded on several CDs. Steven Verdad is a pseudonym that the musician requested be used so that he could speak candidly about his day job and his possible plans for the future.

When Steven Verdad performs, he employs an unusual combination of recorder and electronics in his music. And he performs in many different venues for varied audiences— as a member of an experimental ensemble; as an independent performer; and as part of the musical ministry at an Episcopal church in the nation's capital, whose repertoire stretches from Gospel hymns to Gregorian chants. He composes as well, working recently on a large dance work that premiered in New York City, and teaches recorder and penny whistle at a neighborhood arts workshop.

Verdad's day job is as a librarian at a federal agency. Before his schooling in library science, Verdad's academic training was in music theory and musicology. He explained how his experience in music segued naturally into his work as a librarian: "I had the experience that a lot of people in the library field have, of having been trained in one particular research field and somewhere along the line realizing that I could make steady income if I had the credentials. So I went ahead and got the library degree while I was actually working in a library.

"I find that many people don't have a sense of what librarians do. What I'm doing is searching for information that agency staffers need for me to get. I purchase books, I keep track of lots of journals that are subscribed to, and I apportion the budget that I'm given to pay for these things. It's a

pretty wide range of things to do in one job. Unfortunately, we don't sit around and read books all day. That's the job I'd be happy to do. It's a forty-hour-a-week job."

Verdad has found parallels between his work as a musician on a stage and the tasks he performs in the library. "There are ways in which I am performing at the day job. I've found that I find it pleasurable to perform for people. And I find that with reference work, the same thing can happen as with teaching or giving a concert, in that you feel a connection, a communication. I certainly get that in my job, if I didn't, I don't think I could do it with the pace that I do. The science fiction writer Octavia Butler talks about having always taken only blue-collar jobs because she wanted absolutely no commitment to the job. I can imagine that, although at this point, not having worked too many blue-collar jobs, but some low-level white-collar ones, I think it's much nicer to have a mid-level white-collar job.

"My colleagues at work know I'm a musician and their reaction is positive. It's interesting, because actually many people where I work were trained in the arts, as a singer, or a painter, or something. I'm in a minority in that I'm actively engaged in my art. So I think for most people this isn't a day job, it's what they do. And there's nothing wrong with that; it's just different."

Before becoming a librarian, Verdad once worked for several months as a guard in an art museum, an experience he enjoyed. "I found it possibly the most wonderful steady job I ever had. I was doing it four days a week, not five. For the most part I was just in the background, occasionally stepping forward to say, 'Please don't get so close to the painting,' or occasionally answering a question. But most people I think didn't even know I was there. And I would come home and find I had enough energy for composing, and it felt wonderful. It was almost as if I was in prayer for eight hours and then came out of it and did other things. But it was also really a chance to watch and observe. It wasn't the same thing as frying hamburgers or entering the same string of numbers 500 times in an hour, which might be really problematic.

"The problem with the guard job was that it paid $5.00 an hour. I realized at some point that if somebody's going to buy my time, I want to be compensated for it. I did the guard job for a few months and then decided that it was time to move back to Washington. Actually I was following my spouse back here. I don't want to be in a regret mode, but in some ways I think maybe I should have stayed in that guard job for a while longer.

"The other thing about the guard job was that I didn't have health care insurance because it was part time and considered contract labor. I guess

most of the other jobs I've had did have health care benefits. One of my major disappointments about the Clinton administration was that that just got stomped on and dropped. Our chances for getting a decent health care system are very poor now. And it's probably not only artists who are suffering, but it's one of the ways that we are disenfranchised by society.

"I think about a number of musician friends I have in the UK. A lot of them may be 'on the dole,' as they say, but they have national health care—they could get checked, they could go to a doctor. They certainly would not go to the best hospitals, but they would get care.

"This is definitely an issue with musicians I know here in the States. It's a horrible Catch-22; it's ludicrous. We don't get health care provided. Except if you're a member of the musician's union you can buy health care coverage through that, but for the most part it's still far more expensive than what you'd pay through any employment coverage. The phrase 'adding insult to injury' seems to be quite appropriate, the insult to preventive medicine too."

Verdad's friends and colleagues marvel at his ability to succeed at what are in essence two full-time jobs. He is often asked how he does it—the seventy to seventy-five hours of work most weeks, the running from the office, to the studio, to the rehearsal hall. He explained that it does take its toll in several ways: "I think I'm still able to produce worthwhile work; there's a strong enough pull that that seems to be flowing. But here's a classic example: While working on this dance piece, we were moving through the rehearsal and finally had enough of the collaborative aspects worked out that I knew what I wanted to do. But the time that I had to do it was starting in here in my studio at 9 PM and continuing on until four or five the next morning. Then I went to sleep for forty-five minutes, got up, and was at my desk by 9 AM.

"It doesn't leave much time for experimentation or the kind of trial and error method that I find fruitful— Oh how does this work? Well, let's look at that for awhile. No I don't think I like that, let's try this. There's not much time for making mistakes or just trying something that may never see the light of day, which is something that all of us in the arts, any writer or any painter, does, ideally. And it's for the pleasure, much of art is play. There's the gaming aspect of it that's just wonderful, for which there's not much time.

"My frustration level varies, but at the moment it's pretty high. Because I feel that I'm doing good work, and that I could be doing a whole lot better work if I had more of my energy to focus on it. It affects me as a performer, too. I am in a nice position in the market, playing avant-garde music on recorder, which not many other people are doing. My technique on

the recorder could be enormously better if I could reliably do an hour and a half of practice every day. But that's almost impossible.

"The other side effect that I have discovered is that on those occasions when I *don't* have a rehearsal, or a lesson to teach, or some critical deadline that I have to push on that I tend to look at the open calendar and sort of stare at the wall. I feel like I have some free time, that I can do something refreshing instead of just doing work, and that's awful. I don't mean to sound like I'm chastising myself, but that is the shadow side of being so snowed under with other stuff. That's why it doesn't feel balanced. That's the problem with a really strong commitment to the art side and having the day job. That's why I don't know, if I didn't care about the day job, would the balance be better? Would I slack off? It doesn't seem that I would.

"Actually, here's the answer, how I do it is by running from one project to another and basically having no time for refreshment or evaluation. I mean I obviously evaluate things as I'm doing them, but in my studio there are stacks of paper. I come from one rehearsal, empty the case, pick up another stack, and then run off. I do it by the energy that I get from the music side of it, because I realize that it feels like such a calling to me that I cannot not commit. I mean I can certainly say no to a particular engagement, but I couldn't decide that I'm just going to retire from music or stop doing music. I spent years of my life in school learning art, and it feels like too much a part of who I am and for me, as someone engaged in a broadly speaking religious tradition, it feels like part of me, the universe calling me. I have to be engaged in the creative process. I'm not convinced that I have to do it in the out-of-balance manner in which I'm doing it though."

There are moments, too, when all the juggling takes its toll on Verdad. He related this anecdote about a moment of revelation on an ordinary workday: "I was once working in a medical library. I can remember standing at the copier one day thinking, 'Why did I get a degree in any of the things in which I got a degree, because except for the library credential, without which I wouldn't have landed the job, it's not doing a damn bit of good. I might as well not do anything.' For the most part it's a pretty unpleasant schizophrenia. It's the sense that you have to switch personalities and furthermore, it's not that it's bad, it's just that your deepest, truest self has no relevance to what you're doing. Your colleagues' attitude often is that it's well and good that you're composing, but we certainly don't want it impinging on what you're doing here for us."

Given these inner conflicts, at the age of forty-four, Verdad feels that he is poised for a shift in his life, though he is not certain what form that will take. "I really want time for more contemplation and to give more thought to what I'm doing," he said. He has come to realize that for an artist, the traditional model of teaching is not a bad one. He wishes he were in a

position to be part of a university faculty, but the market for teachers of music is very tight, particularly if one does not have a Ph.D. If he did have the chance to teach, he believes that his focus would not necessarily be on professionals who want to do art for a living, but more importantly, on connecting with students and the general population to encourage creativity.

He expounded on this idea. "I think nurturing creativity is one of our strongest social roles as artists. To me the ideal life would not be one in which I was handed a billion dollars and told to go off to a hut in the woods, where I would find every imaginable toy that I could use and every possible instrument that I could ever want, and they wouldn't ever want to see me again. To me the ideal would be, here's a billion dollars, take what you need to live on and use the rest to fund a concert series in the community, mount another teaching opportunity for yourself and other people, that would make more sense to me.

"What I'm after is using the arts to really be engaged in life; I think that's what they do. I guess my frustration in serious part grows out of feeling like I'm stymied in that. I feel like we have a culture now that relies on a pretty high level of dullness in the general population. The way that television functions most of the time is quite literally as an anesthetic. It's not that there's something intrinsically wrong with the medium, it's just strictly the social function that it plays right now. In fact most people experience the kinds of frustration that we in the arts do, but there's no encouragement for acting on aesthetics as a principle of life. There's such a strong social push to get a good job, which basically means one that is structured like it would have been in the early days of the Industrial Revolution, in which you were working as many hours as you could before you dropped. In exchange for your life they're willing to see that you have a lot of creature comforts.

"The more I ponder this, the more I wonder how we got to the concept that work was a single-employer, primary-energy focus, as opposed to the concept that people were simply people and that one of the things they needed to do was garner income. It's weird that we forget— well we Americans have no historical memory anyway— that this wasn't a problem in the 1600s, or for most of time in fact. And it's not the case all over the globe either. I keep hoping that this is an aberration; it sure feels like one. If someone feels deeply passionate about something and wants to work eighty hours a week for as long as their body can sustain it, then fine, but don't ask everyone else to do it.

"It's killing not only people in the arts, it's killing everyone. It's just that we in the arts have a lower tolerance for it. We're all fascinated by other people, obviously; we watch television to see the stories of other people, but it's some kind of awful substitute for actually participating. I know very few people who are not artists who are doing things that they really care

about. People just seem to be struggling along in life. Certainly there must be something they do to get pleasure, but it's not that because they're not artists that their day jobs are satisfying people. They're frustrated too.

"More and more people out there are beginning to ask the questions, but that's because the economic structure is beginning to fall apart. There's not the guaranteed lifelong employment that people of my parents' generation would have expected. And ultimately, for me, coming from a fairly leftist political perspective, that's probably not a bad thing. On a certain level we're not fighting the issues of class struggle. I think what people are really being forced to wrestle with is that the system isn't working, even for those of us who are employed full-time."

Verdad thinks that artists have a prophetic role in any culture. "I'm fond of what I believe was a Bertolt Brecht quote that 'art is not a mirror with which to reflect society, but a hammer with which to change it.' I think that's one reason that we're marginalized, because we're scary. We're a threat. Although we realize that being awake brings with it a lot of pain, it also brings a lot of pleasure. If you don't know about the pleasure part, why would you want to wake up?"

According to Verdad, we usually separate art from politics and narrow our definition of politics to refer to the maneuverings accomplished by those people who hold office. In Verdad's opinion, how one lives in the world and how one creates are very political acts. "Politics is what's in your tone of voice when you answer the phone. If you're meeting someone who's interested in collaborating with you, it's how you welcome them into your home. Do you respond to a letter? All of that is politics, and it's foolishness to say it's not. Politics are those things with power behind them. And by segregating them we act as though we don't have power and personal efficacy, but I think we do. I think that how one responds to another human being does change the world. That's my fantasy."

Straddling two worlds raises questions of identity within Verdad himself— about whether he is a "real" musician, about what sacrifices he should make, about where he belongs in each of the environments in which he finds himself. "I know it's important to me to own and define myself as a professional in the arts, as opposed to someone who says, 'Well, yeah I love music, and I have degrees in music, but I'm not a real composer,' or something like that. I'm always wanting to shout, 'I am a real composer, here's a CD I'm on.'

"A few years ago, I was moaning about the standard things, questioning if I am really a musician. This friend of mine said that it seems to be defined by what you are doing as opposed to what you aren't doing. In my case I could say, 'I'm out there, I'm listening, I'm sounding, I'm writing, I'm composing.'

"I must admit though, that I feel terrified, I feel totally insecure, when I'm around musicians who don't have a day job and who say that 'if you were a real musician you wouldn't work full-time.' It's awful that people could argue that you're not a real musician because you have a day job. In truth, I haven't encountered very much of that. I think that brings us into the area of double consciousness that W.E.B. Du Bois talked about for black people in America. The fact that most Americans of African descent always had a double consciousness of being one thing and at the same time being something else. I think in the music and arts world we have to develop our double consciousness better.

"It brings to mind kids in the ghetto saying you can't be authentically black and be good in school. 'What do you mean playing that clarinet? If you were a real homeboy, you'd be playing hip hop and not Souza marches.' Those are just incredibly destructive dichotomies. Of course it's not just in black culture that that happens. It happens in any group that's capable of beating itself, tearing into itself. I think musically we do that, we act as though so and so can't be a real musician if she has a nonmusic job. I think it's a question of commitment and the quality of the work being produced; I don't see how it could be judged on anything else. That's the only reason those with a day job should feel insecure, if the quality's not there; that's a legitimate reason.

"Sometimes I do think that maybe the person without the day job might be doing higher quality work because they do have more time to rehearse or experiment. That's a different matter, but it is an important issue. It can turn into really weird twists of thinking. If we're talking about funding, does this mean I shouldn't receive a grant for as much as someone else because I have this other source of income? But if I had more income, with a grant for music, I could work less. Is there a way out? I don't think so."

So his image of himself is something with which Verdad constantly finds himself grappling. "I feel increasingly that what I'm concerned about is getting some freedom to structure my time so that I can work more effectively. I don't anticipate ever not needing other sources of income. I am really looking to see if there is a way that I can get more into teaching, either more private lessons or actually diving into it somewhere, because then at least there would be blocks of time opened up."

Verdad also thinks that in trying to find a balance in their lives, artists have to set priorities for themselves. "I think in the arts world we have to look at questions of lifestyle, and not just in the denigrating humor of 'What do you say to a person with a Ph.D. in musical composition? Yes, I would like fries with that.' I think we have to ask, 'If I am serious about freeing my time and my energy to work on what feels like my life's calling, how important is it that I have clothes that are in a particular style? Is it

important that I go out to eat in a restaurant X number of times in a month?' "

This whole question of practical economics for those in the arts is one that Verdad feels should be discussed and addressed in music, art, and theater schools. He believes that it's an ethical bankruptcy on the part of academia that this is generally not done. "I don't think anyone will hire me to do a commercial gig, nor do I want to do that. There's a lot of wonderful music that happens in clubs, but it's not me. So I do think it's wonderful to have a sense of purity. But if someone is going to get a degree, then it has to be balanced, there has to be both purity and the practical application of the work, and that's what I feel is missing from most artistic curricula. If we're going to do it within a degree program then we have to really grapple with that.

"Some of the course work I envision would be to look at the economics of how we spend our money. And to do that is flying right in the face of the consumer culture. It's just one component that's important. I think it's important not to say you need to sacrifice for your art, but to say you could be liberated, you could unhook from some of this. And if you truly felt that you didn't need whatever, wow, that would mean that you don't need to earn those dollars. That's what I'm in a sense in the process of doing, figuring out how much in the middle do I want to be, how much under I can be.

"I think artists need to join forces with the various other parts of society who are struggling to have part-time employment with benefits. We're not the only ones who want that, and it would help a lot of people to push the world into the post-jobbed economic setting. I think that organizing is important. One of the good things that came out of the trauma with the NEA that we went through in the late eighties was that it mobilized people more than they had been.

"Maybe what we need to do is have fewer but stronger organizations. For example, there are a couple of music organizations such as the American Composers Forum and the American Music Center, and although they're not really in competition, I think in the minds of most of us in the composing world, they're kind of nebulously overlapping. It makes me wonder if we wouldn't really benefit from one of them saying, 'Here's our defined area,' and the other saying, 'Okay, here's our defined area,' and maybe one of those defined areas would be, say, health insurance coverage."

Grants are another source of income for artists that can free up some time, at least temporarily, for creative work. Verdad has received grants as part of a group, though not as an individual composer. His sense is that

money is much tighter now than in the past. "My main teacher, Pauline Oliveros, wrote an essay about fifteen years ago explaining how it's possible to earn a living as a composer because there are a lot of funding organizations out there, and you just have to really dig in and go for the money, and it should be possible to support yourself in these various manners. And she was also arguing, very appropriately, for young women who were interested in music to think that the idea of being a composer was an option to be taken seriously. That was a very worthy argument, but I don't think that Pauline could write that essay now; things are too tight."

In Verdad's opinion, the shortage in funding may change, if people in the arts can do a better job of informing the public about the general value of the arts to society. He does not think that focusing on cultural tourism is the right approach. He explained, "I don't think that that's a fruitful approach, it's the wrong motivation. I think that we have to be ready to point out that there are economic benefits from the arts. But I think we have to make it clear that those economic benefits grow from having a generally more awake population. By beating capitalism at his own game— more creative people will be doing things that they're more satisfied by doing and therefore will do them better. If one believes the capitalist model, then theoretically they'll be producing more goods or better goods or having a better market share. I think what's generally thought of as cultural tourism is a dead end in terms of making money; I don't think it's a useful approach ultimately. It might be fine for a year, until, for instance, some supposedly blockbuster art show doesn't become a blockbuster show, and then the whole idea gets turned on its head.

"Arts are not consumer productive, they're a completely different animal. Somebody said that doing artwork should be returning one's gift to the community. That's the crux of the matter. I think the reason that we as artists are frustrated is that we're not able to return the gift to the community, even though we'd like to.

"I like the idea of pointing out to people that the creativity that's inherent in their own lives is what is in the arts. That's the wake-up call again. It's hard for me to believe that there's a real difference, that my problem-solving as a composer is on a more high flown level than someone faced with rewiring an old house. I guess it might be fun to think that it was, but I don't really think that that's justifiable."

Verdad envisions that just as artists can help illuminate the creativity that permeates every person's life, they can also join with others who also seek a better equation between work and other aspects of their lives to effect change. "Maybe the only hope we have is the broad family rights movement for flexibility of time to do child care and elder care. At some point there's bound to be a switch. For instance, if a company got to the point where it could say, 'Let's see, we can let our vice president have a flex schedule

because she needs to take a four-day week for five months to do elder care, why couldn't we let Steve do that to do composing?' I think we'd all benefit from not having such strict lines. I can also see society breaking it down further into saying, 'Fred really likes to go trout fishing, okay, so let him go two days a week.' "

6

A Web of Art:
Joe Matuzak

Joe Matuzak is a poet. His poetry collection Eating Fire *was published in 1998, and his poems and essays have appeared in numerous journals and anthologies, among which are* The Georgia Review, Kansas Quarterly, Renegade, Contemporary Michigan Poets, Songs from Unsung Worlds, *and* Passages North Anthology. *Matuzak has won awards from the Michigan Poetry Festival and the Michigan Council for the Arts and received fellowships to Cranbrook Writers Conference and the Oakland Writers Conference.*

For poet Joe Matuzak, his job as director of the ArtsWire Web site represents the convergence of many long-standing interests. ArtsWire is a communications network for the arts community, and is a program of the New York Foundation for the Arts. It provides extensive information about individual artists, arts organizations, and events and news in the art world.

Before working for ArtsWire, Matuzak worked for a variety of nonprofit organizations such as the Red Cross and small galleries that received subsidies from government agencies. A five-year stint in a friend's computer store in the mid-1980s gave him a technical background and an introduction to managing information in an electronic environment. He ran one of the first electronic bulletin boards in the Midwest during those years.

Matuzak said, "Somehow I managed to get sucked into arts administration. I'm still not quite sure how. My wife, who is also a poet, and I— we met around poetry and that was one of our common interests forever— started running a community-based reading series for about thirteen years up in Flint, Michigan, where we grew up. It's not particularly a hot bed of cultural activity."

Several years ago, at a National Association of Artists Organization conference in Washington, D.C., Matuzak wandered into an ArtsWire organizing meeting. At the time he knew nothing about it. By the time he walked out of the meeting, he found himself on the technical steering committee, and as the project evolved the Web site's developer recruited him to serve as its director.

Running the Web site is time and labor intensive, and although he enjoys the work, it does bump up against his time to write poetry. Matuzak said, "I could work easily 100 hours a week without finishing things. So time is always an issue in terms of time to write. The balance tends to get skewed. I tend to self-identify with what I do. I look at it as my program, it's tied up with my identity. I'm not sure where one thing ends and the other begins, I'm not really good at making those kinds of separations. In addition to which, because I'm the director, there are always things that need to be done. If no one else has the energy, then I need to do it. Plus, everything about this is so hot right now. I don't think it will stay that way. But how often do you get a lever put in your hand and you can pull it and really make something happen? And when you're in a situation where that's there, how do you not take advantage of it?

"I would love to be able to sit around and write poetry all day. But the thing with poetry is that you can't really sell out because nobody's buying. It's kind of the nature of the beast that you're going to have to do something else. That's why you find so many writers in academia. It's a fairly controlled way of doing things, at least in theory, that can give you a degree of time to work on things. I'm not cut out to be an academic, I don't have the patience or the attention span. This job allows me contact with a lot of different things. One of the things I used to love about running the computer store was that I'm kind of an information junkie. I like to process information. It doesn't matter what the information is; I get a lot of pleasure out of the process. When I was there, so much was always changing, and that was good. And that part is definitely true with ArtsWire; it's constantly changing. I'm dealing with people who have wonderful ideas, very talented people who have vision. Who wouldn't love doing that?

"Of course that runs counter to the need for contemplation, the need to work on poetry. I try to do it by parceling time out and stealing time, but I don't get as much time as I want. It's not as simple as me saying, 'Okay I'm going to take a month and go to an artists' colony.' That's just not possible for me at this time.

"Occasionally I find it difficult to shift gears. For instance, the last time I went to a colony was about a year ago, and I found it immensely frustrating because the job wouldn't leave me alone while I was there. One of the things that suits me best in terms of writing is that I tend to be obsessive for a time. I like to dive down and disappear for awhile. Probably the best

semester I ever had in college was the one when I ignored my classes and stayed home and wrote, and I got some great work done. It wasn't really a smart thing to do academically. There were incompletes I had to deal with, but it was a very good thing for me to do in terms of my art. It's a balance. I'm constantly trying to find it.

"I do think my work with the computer stuff does help my art, although I can't say exactly how. Part of it is dealing with the people whom I end up dealing with. It has to have an effect simply because of who those people are. Doing this I come in contact with a lot of things that I wouldn't otherwise have come in contact with, in terms of being aware of what's going on in the arts. Simply traveling around, if nothing else, gets me in contact with things I otherwise wouldn't. I was able to go to the Bonnard show in New York because I was there for a meeting. There's no way that those things don't have a positive effect, clearly they do."

Another aspect of his ArtsWire job that Matuzak enjoys is that he can help other artists and arts organizations create the infrastructure and knowledge base that will enhance their abilities to disseminate art and information to their constituents. In workshops and seminars that Matuzak runs for arts organizations in many places, he teaches digital literacy and how to plan for and implement Web-related material. He is helping organizations deal with technology from a macro-perspective— managing and planning for technology. And he is also teaching a class on these topics at the School of the Arts in Chicago. He said, "The reason I agreed to teach the class is because I feel that I have a responsibility for seeding the field. We've done some projects in the past that weren't wholly successful because the basic skills weren't there in the organizations. There's a degree of positioning here where I have to take advantage of that and I have to give that back to the field."

Matuzak is very excited about the burgeoning of the Internet and what it promises for the arts and artists. "Part of the buzz about the whole Internet thing is the joy of possibilities," he said. "What's interesting to me is to have it happen on a couple of different levels. One is the straight new art form approach. This is a medium that's new and that will define its own new characteristics. The art forms that evolve from it, say in the same way that photography evolved, will be interesting and unique in and of themselves.

"At the same time, I think there are brilliant things that have been done using very traditional art forms that have increased their exposure and enhanced the actual experience for the user. I remember going to the *Paris Review*'s Web site and realizing that not only can I read a poem by Czeslaw Milosz, but I can also hear him read it, which is a wonderful addition.

"Since I come from a small press background, I can think of the history of literary magazines in America. Say I'll print 1,000 magazines. Maybe 100

will go to the contributors, and maybe 200 will go to subscribers, and 100 will go to libraries, and another 200 to bookstores on consignment, and the remainder will sit in the basement and sop up moisture. That is one of the things that's always been true. Now I can put something up online and potentially reach millions and millions of people.

"Obviously there are still the same aspects of getting people to look at it, but a lot of the barriers to putting together a good distribution system are gone. One of the things in the workshops I always say is that in the arts there are four pieces. We've always been good at two and lousy at two. We've always been great at content and design, we've always been bad at production and distribution. Now I don't have to worry about how many colors or how many copies I can afford to print in a Web context. There is a great deal of potential here, both in my own art form, which is poetry, and in all the other art forms that are out there. It's very interesting for me to work with different groups who have various approaches to that and help them both think about it and develop it.

"I don't mean to imply that it's all that simple. There are other issues involved with that though. For instance, who's going to pay for this? Doing it on the Web is not without cost. The people aspect of this is the part that is quite expensive. As the tools continue to change it will be less the case, and it's less the case now than it was. You don't have to be a code head to make a Web page. But these things do take a lot of work if you want to do them properly, and it still does take a degree of expertise to do it. We're moving more toward needing less and less specialization, but we're still a ways away from that.

"But I think clearly the future of academic publishing belongs online. When you're talking about journals that go to a specialized 1,000 people or libraries and then wind up being turned into microfiche in six to eight months, well why not just skip the middle process of actually printing the thing on paper and put it out on the Web, where it's instantly more searchable and more available."

Matuzak believes that the Web also offers hope for drawing young audiences back to the arts. "There's been a mad concern in the arts for the last decade and a half about the aging nature of the audience, which we've all yakked about until we're tired of hearing about it. But it still is a very valid issue, if you cut the arts out of education— well? If that's what's happening, it is an issue. Well, if you want to reach that next generation, where is that young audience?"

There is some resistance to the Web from traditionalists in the arts, and Matuzak understands their arguments and thinks they have some validity. "Seeing a painting online is not the same as seeing a painting in real life. There's no question about it. But I don't see why I have to have an either-or equation. The fact that I see a photograph of a painting in a book is not

the same as seeing it in person. You can go through and try to nail the Internet for just about everything negative in the universe if you really want to. The reality of it is that most of the sins that are wandering around were here before the Internet and will be here after the Internet.

"Yes, there are some specific issues regarding ease of use, regarding access. But it's like saying, 'TV is bad.' Yes, I don't disagree necessarily that there aren't issues involved with this. However, it's not something that exists in a vacuum. I do think that there are marvelous possibilities here. People don't have to use it, that's fine. There's nothing wrong with that decision. There are things that don't work well on the Internet. It's a tool, like a screwdriver, it's not a religious experience. It's not one of those things where you have to go one way or the other. If it works, it's useful, if not, then what's the point? Don't spend a lot of time worrying about it.

"It's more a point of having an understanding of what the issues are, simply saying let's go back and let's figure out what's really involved with this so that this is done from a base of knowledge rather than fear. There's nothing wrong with going through this and saying, 'I don't think this is a viable option for my purposes.' There's nothing wrong with that, if it's done from a position of knowledge, and you're aware of what the issues are.

"The younger generation coming up, this is their language. I'm from the TV generation. My initial experiences with computers were watching bad Japanese sci-fi, with room-size computers spinning tapes; and something goes wrong; and Godzilla starts talking. That's my generation's connection with computers. Now it's a normal thing to have in the house, and you presume it's there. The guy whose doing the cover of my book is a painter by the name of John Dempsey. He said to me once, 'My kids are the first generation who see it as their duty to escape from information as opposed to gain it.' There's a lot of depth to that observation, because when I grew up, it was about getting at the stuff. That tends to be true for most people. To go from that to overload, which is where we are at this point, is a very different way of dealing with the world. It's a very different way of thinking about the world. I'd like to do an essay or something about this because I think it's a very astute way of looking at things.

"It's not an issue of 'I can't get at the information,' it's a question of 'How do I filter out all the crap and get to what I really want? How do I determine what I really want?' Those are different baselines for dealing with the world. My advice for arts organizations for years has been to go find a few thirteen year olds. They don't understand that it's supposed to be difficult, and mystical, and problematic, and so they'll just do it. With my students at the art school I ask them what they know and what they do; what their background is; what their sense of themselves as computer users is. It's always very interesting to see what the differences in individuals are.

"Last year everybody in the class had e-mail, used e-mail, browsed the Web, and used the Web for research, and a few had Web sites. Most of them thought of themselves as computer neophytes. Context is everything. I tell them that two years ago you would have been geek city, a year ago you would have been geek city, for many of the people I deal with you're geek city. But for you contextually you think of yourself as someone who is pretty new at this and that you don't really know what you're doing.

"That is one of the things I find completely and totally fascinating as I go through this process, watching the baseline change. I don't have to, as I used to, explain to anyone what a modem is, I don't have to explain what a Web site is, or what the Internet is. That's what's in the *Zeitgeist*, that's what people know. That's fascinating to me."

As involved as Matuzak is in technology in his daily work, his poetry is not about technology. "I'm not a hypertext poet," he explained. "I understand what's involved with it, I've found it interesting, but it's not what I do, it's not appropriate for what I do. I'm not losing any sleep over it. It's interesting. If this is what you do, great. It's kind of like every painter worrying that they should also be a photographer."

Matuzak is constantly working on new poems. "I still do readings, and I despise going to readings without something new, if for no other reason than I don't want to bore my wife. She's a writer whom I respect, so the last thing I want to do is come in and say, 'I've done absolutely nothing and you've done all these wonderful things.' I always have notebooks with me and I'm always working on things. I don't get as much time as I'd like to do that, but that probably puts me in the majority. I recognize that. There were other things I've done where I didn't get as much time, so no big deal.

"Part of it is that I've adopted as my theme the words from a Warren Zevon song, 'I'll Sleep When I'm Dead.' That's not that different from most of the artists I know. My wife and I are always saying we can either have a life or a clean house, what's it going to be? You can apologize about that stuff and worry about that stuff, but ultimately, that's the way it is.

"One of the things I have gotten better at is trying to carve out time when I travel. I went through a period a few years ago when I realized that in the course of a year I'd been to New York and D.C. about a dozen times. I realized that despite the fact that I went there and sat in meetings all day with artists and arts organizations and talked about great issues, I hadn't actually been to see any art! When I realized that it shocked me. I realized, this is stupid, this is not why I got into this. I've gotten better at setting aside time during which I go to see art. I look around to see what shows are in the museums.

"I do a lot of conferences as well. It's easier for me to find time to write at those. There are only so many panels I want to attend on cultural tourism and so many tables I want to sit around. I can take my notebook and wander around a city I happen to be in. That can be a huge stimulus. This is a job that has taken me to some very interesting places, and I've gotten some good work done out of them. If it weren't for this job I wouldn't have been in Northern Ireland, and I wouldn't have gotten the poems that I got out of that. I wouldn't have been in Bogota, Colombia, and gotten the poems I got out of that. There are many opportunities that come out of this as well.

"The balance is always hard. It's like the lament of the workaholic— big deal, quit whining. I'd like to get to the point where I'm not apologizing all the time for being late with deadlines. You can sit around and whine about it or you can just do it. There are plenty of people who have barriers. There are two people on my staff with disabilities. They're able to work because of this medium. When I look at what they have to do to do some things that I take pretty much for granted, I think what am I whining about? Let's go back to that perspective of 'at least I have this opportunity.'

"The town in which I grew up was a pretty rough town overall. I looked at the school system there the last time I was there. More than 50 percent of the kids going there live below the poverty level. Those are my friends and neighbors who might never get a shot. I'm blessed with a degree of skill and a degree of knowledge and intelligence that allows me to have choices. I mean, how many people get to do what they really want to do on a daily basis? If I don't want to do what I do, I have options. I'm perfectly aware of how blessed I am, so I may do some whining, but at least there will be a ceremonious aspect to it.

"Right now I'm working on a book that's three years overdue, and it's all because I haven't let go of it. Part of it is because I've been doing the design on it as well. I did small press projects before. It's actually ready to go, and I hope it will even go to press by the end of this month and be out before the end of the year. I think I've managed to torture it as much as it needs to be. My publisher is at the point now where he says, 'You know, enough.' He, of course, is completely right. It's finally at that point— I waited a year to get blurbs for it, that kind of thing. It's one of those things where creating the artifact is a kind of an afterthought for me. But it's one of those things that I know I have to do.

"Thinking about my writing career— when I was twenty, I wrote a great deal; when I was thirty I wrote less; when I was forty I wrote very little; and when I'm sixty, I won't have written a damn thing. The more you know, the more you see the flaws in what you do.

"I remember doing an interview with Philip Levine, and I asked him about getting older. He said that when he hit forty he realized he didn't

have the energy that he had before, just in terms of pure volume of work. But on the other hand, he said he doesn't do as much bad work. It's a very good way of putting it. As I go on I kill the really ugly ones before they get out. Or I'll let them sit for a year.

Being that he works for the New York Foundation for the Arts and is in constant contact with hundreds of arts organizations and artists all over the country, Matuzak had a front row seat to the culture wars of the late eighties and early nineties, when Jesse Helms and the far right nearly succeeded in decimating the National Endowment for the Arts as well as the morale of most artists in the United States. His take on the current state of affairs in the arts is that they have improved greatly. "I hope we're at the latter stages of the 'bad dog' process of politics and the arts; you know— artists, go on the paper. I think everyone is tired of hearing it. And when you start combining that fact with things like recent studies on cultural tourism— these people might be wacky but they drop money in your community when they come in— those are some hopeful signs that we can get to a more positive perspective. I am starting to see things that are far more positive. At least it's not a state of constant antagonism, as it was for most of the nineties; not to say that that's still not there, and that there aren't still issues, and that we haven't sustained really bad losses in that process.

"The NEA process hurt us at the New York Foundation for the Arts as well, because we lost a lot. Not so much that we got direct funding from the NEA, because we never got any, but when money got tight among our constituents, we were a frill, particularly for a lot of state arts councils, who had sustained us at a pretty high level.

"We can just look to see what happened with the House this year, that they actually voted to fund the NEA. That doesn't sound like much, but at least it frees up some energy to do something else besides make the same case over and over again.

"Artists are still a little angry at having been made political pawns, because we have been. But honestly, we're at the point right now where pure anger can only sustain you for so long. If we're sitting around and being mobilized only around those issues, unless you happen to be the kind of artist who specifically makes art out of that, we're letting them win. I see artists and arts organizations being a good deal more savvy about the politics of it all right now. We know what the game is and we know how it's going to be played and what's going to be done. And we know we have to be aware of this. There are some positive things that came out of it. By and large, artists and arts organizations are interested in getting back to making art. A lot of them feel, rightfully so, that the best way to do this is by being involved in their local communities, mainstreaming art in their

communities. So that we're not just these things with fur and foreheads, alien monsters.

"In some ways, involvement with local communities is both a lesson that was learned from the political process and a natural curve that was occurring anyway. Small organizations, multicultural organizations all have tended to be heavily involved in their communities and in community arts. That's both something we're seeing a lot of and also a very positive construct for the future. But it's not strictly in reaction to the politics, although there's a degree of that, it's the direction that things were going anyway. Maybe there's a little more attention to it. We can sit around and ask how the American Family Association got political power. Well, they went after school boards. They did it locally. People can say that we decided we should do that too. But no, I'm sorry. We've always been working with youths at risk. We've always been working with a variety of things inside our communities, so this is not totally reactive.

"The whole culture wars argument about the arts being elitist and aimed at its own insular world— it's a wonderful misinformation tool because you have to react to it. It's like, 'Prove to me you weren't drunk your entire term, senator.' Like that's really easy to do. How do you go through and prove that you're not an alien? It's a distraction strategy, which is the politics of the 1990s, the politics of distraction. The reality of it is that community involvement is what arts and artists' organizations have always done.

"I think it's great that what we've always been doing, and what we intended to do from the beginning, happens to be extremely healthy for us. We have to do it because of who we are and what we do. I'm thinking of when I was running poetry readings in bars in Flint for thirteen years. I did it because that's where I lived and that's what I wanted to have happen in my community. And I did that long before there were any controversies of any kind whatsoever. Now that it happens to be good from a political standpoint doesn't make it any different from what I thought back then was good from a marketing and demystification standpoint. Then I thought, 'People are afraid of this, how do I make this normal?'

"I have a friend who comes from outside the arts. She used to say that it is the only area that doesn't think of itself as a sector. Agriculture thinks of itself as a sector, but the arts don't. We focus on the differences rather than the similarities. Yes, there's a spectrum. Yes, there are groups that are high-culture elitist groups. Yes, there are groups that are as far down the cultural ladder as you want to get, who work in their communities, and quality is not even a word that's an issue. And there are all things in between. The spectrum is what's important, not just this or that piece of it. It's important that it all be there and that it's possible to move throughout the spectrum according to what your needs and desires happen to be. That's both from

an artistic standpoint and an audience standpoint. Why does everything have to be brown, or why does everything have to be green, what's wrong with having all the colors? It's not like high culture is bad, low culture is good, or vice versa. Those are artificial and silly constructs.

"We can have good and important discussions about how resources should be allocated and so forth, but that's a different issue than what ought to exist. Why do I have to give up classic Western culture because I'm simply tired of hearing about it, because I've had it banged into my head for my entire life, as opposed to Latino culture because it's something I haven't been exposed to? Why either-or?

"The Internet does have the possibility of taking some of these divisions away. I remember that one of the first Web sites that made a strong impression on me was the Sandinista Web site. I thought, 'The Sandinistas have a Web site?' And I realized that here was the great possibility of having this alternative means of communication, and there was a degree of leveling that had occurred. Of course there's a negative side to that too, if you're going to talk about the neo-Nazi misinformation groups, the Aryan Nation–type stuff. But here again we get to that spectrum, what we need to do is try to help people learn how to make judgments and how to use these tools. That's no different than anything else.

"How do you make the choice of what your authority is going to be? I can choose to believe the *New York Times*, I can choose to believe *Soldier of Fortune* magazine. That's a choice I make based on my sense of the veracity of the source, or I can choose to disbelieve both of them. That's part of the American experience anyway, that we're not passive; we're participants in the process. I think that is the great thing about the Internet, the possibility of getting at information that might have been difficult to get at before, the possibility of putting up information that needs to get out. I'm not very concerned about the acid or base of the content. I believe in freedom of expression and the First Amendment. People are smart if you give them a chance; people will decide if they're given the chance; people are primarily reasonable if you go through that process. I'm not paranoid about that stuff. I think it's great that information is available and out there. Yes, there's no question that we in the arts should be thrilled at this possibility, because it is the possibility of reaching out, outside of our small constituencies."

The basic questions of how one juggles one's time, balances work and art, and remains accessible or unreachable still exist for Matuzak as they do for other artists. "I always used to make fun of the ads about faxing from the beach. No, I don't want to fax from the beach. Go away. But you think about what that says about the availability of contact for us. The idea that

we're all going to be instantly accessible I find frightening. I will never carry a cell phone. I want to assert the importance and the validity of sometimes being alone and unreachable. But look at cell phones, how ubiquitous they are. For some people they're essential for how they operate.

"I take my laptop on the road and I can get my e-mail anywhere, and that has huge advantages for me, but huge disadvantages as well. Then everyone expects me to get work done when I'm away. How do you go through and assert your ownership of the process? I always say I'm driving; the machine's not driving. It's my decision about when I'll work and not work. It's okay to say that, it's essential to say that.

"I got into a very spectacular public argument with someone in one of the news groups online. Someone sent me an e-mail, and horrors, I took three days to respond to it, so they trashed me online. I answered, 'You know, you just proposed ten years worth of work. If you really want me to say, "Yeah great idea, go for it," I can do that. If you want an actual cogent response, I'm sorry, I don't work as fast as the technology. I still need to think, I still need to go through and do, and I'm not going to apologize for setting my own priorities.' I think that's one of the issues that everyone is grappling with, how to assert a degree of control.

"I think being able to assert the need for personal time will become one of the skills we will take for granted in a couple of years. We have to figure out ways of doing it for survival. They're new skills, but they're skills that we can manage to come up with. We should be able to figure out how to do it."

7

The Value of Art:
Judith Sloan

Judith Sloan is a writer, actress, comedienne, and oral historian. Her shows, which include A Tattle Tale *and* Denial of the Fittest, Evacuations of Untold Truths and Other Outbursts, *have enjoyed critical acclaim in many theaters, festivals, and universities in New York, Tampa, Denver, Indianapolis, and Ann Arbor in the United States as well as Canada, Israel, Japan, and Scotland. Her commentaries and documentaries have been heard on New York Public Radio and National Public Radio. Sloan is the co-founder of Ear/Say, a multi-media arts organization committed to documenting and portraying the lives of uncelebrated Americans through theater, print, video, radio, and the Internet.*

For the last ten years, Judith Sloan has been able to make a living through her performance art, teaching related to that art at New York University, teaching teachers to use theater and juggling in the classroom curriculum, and grants. But she still has a license to do hair and wigs, because life in the arts is precarious, and as she said, "You just never know."

She did style wigs in the theater for a time. And although she was earning more than the actors, she hopes it is something she won't have to do again. She said, "It was frustrating, but I was doing it for a limited amount of time because I needed $5,000, and once I got the $5,000 I stopped. I teach now too, and I think a lot of artists do that also. Because either you hit a nerve and you have something that's a commercial success or a semicommercial success, or you somehow eke out a living. I think it's very hard for composers, musicians have a hard life, and I think for dancers it's even more difficult."

In her teenage years Sloan also worked stints as a waitress and a maid. But she said, "I couldn't do that for too long because it was too depressing, to clean someone else's mess when I can't even clean my own. But most of

these houses were usually clean before I got there anyway. I also made pizza once. That was kind of gross. I'm sure you could make them healthier than those I was making. Over the years I've done some commercials for products that I'd never recommend that anybody buy. I've done voice-overs for various things, for toys. I've never had a high tolerance for going to lots of auditions. I had grants. I lived on unemployment for a year."

While doing all these jobs, Sloan was still able to work on her own performances. There have been times when a conflict arose, when she was offered a high-paying job that fell on a day when she had a performance scheduled. "I've turned down some big money jobs because I was pursuing my art for no money. Those were all choices— good or bad. But it is a choice. Someone said to me you could work such and such a job and make $1,000 a week, but I already had two performances booked, and even though I wasn't making much money, that wasn't why I was doing the gigs. You get involved with doing a job as an artist and then taking on more and more of those jobs. Maybe at some point you will make some money. You may have ten things in the fire, and maybe one of them will work out.

"I've always lived part of the time trying to do something creative and part of the time trying to earn money, because my father died when I was twelve, and I started to be an adult from that point on. So I went to school, and I worked after school through high school and college; I had waitressing jobs. I once worked as a medical secretary, as a fundraiser for someone else's projects. I always had jobs so that I could do something else. I never had a job because I wanted that job. I think a lot of people are like that. They just work at their job so that they can have their house or whatever. For me it was having a job so I could spend $2,000 on a press packet, or spend six months interviewing people, or travel around so I could write six new characters. For me it was a way of funding my work."

Sloan wrote a novel with her husband, Warren Lehrer, and they are seeking a publisher for it. He is a visual artist who has a full-time college teaching position, and she has health insurance through his employer. "When I married, things changed, and all of a sudden— boom— I'm in a relationship and a marriage and I have health insurance that I used to have to pay for myself. Health insurance is such a big thing. Before I got married I had health insurance, catastrophe insurance, through the hairdressers' association.

In Sloan's opinion, there is a lack of support for the arts in the United States. However money, and often the lack thereof, pervades her experiences and thoughts about art and society in general. She said, "We have smaller budgets in the United States than in the city of Berlin for artists.

And now we have virtually no budget; there are virtually no more federal individual arts grants. Contrast this to the subsidies the government gives corporations. I did a project called *Muriel for President*, in which my character Muriel was looking at corporate wealthfare. What does it mean for corporations to get $300 million subsidies? They get money for advertising their products overseas. Murial says, 'Should Uncle Sam be giving $300 million to Uncle Ben's rice? Why not give it to Aunt Muriel or school lunch?'

"I also think there's a huge disparity of wealth in the United States and it's getting worse and worse. Rich people are getting richer and richer and everybody else is getting poorer or they're working twice as hard. I went to a high school that had federally funded programs, I went to city programs that were federally funded, and all that stuff stopped in 1987. In 1986 it started really getting rougher, by 1989 it was *bad*. I really think that Reagan was a terrible, horrible, destructive force in the United States. Reagan and Bush started it, and there was nothing Clinton could do if he was trying to please people. Of course, he should have just not cared about pleasing certain people so much. Even now, if the questions are asked without the words 'government spending' most Americans really want funding for education and believe their tax dollars should go to making our domestic life better for the general population.

"Money is a serious problem though. When you have no money you worry and you don't have any time to call your congressperson, and you don't have resources to lobby for your concerns. You are consumed with surviving.

"I don't think that any of us will be able to address money unless we address the huge disparity in wealth in this country and where that's leading us. It's criminal behavior. Unless we look at it as criminal behavior and morally vapid, we're never going to be able to address it. I don't think artists exist outside of society. We don't value our artists, we don't value our children, we don't give money to education, and instead we scream about crime. In fact, if artists were not challenging the status quo, there wouldn't be a political attack on the arts. And artists have always questioned the society and the nature of our existence. Rarely do you hear anyone besides Ralph Nader or Michael Moore talking about locking up corporate raiders who put thousands of people out of work so one person can end up with a $45 million bonus. Greed has to be curbed. It's like runaway feudalism.

"People in the arts have to spend an inordinate amount of time thinking about money, even if they don't care about money for its own sake. That's the position of everyone in America if they're not extremely wealthy. There's a big difference between rich people and the rest of us, because rich people don't worry like this.

"We're on the earth, we're in the country, why are we here? If I were going to run my character Muriel for president, she would run on increasing taxes on the wealthy. I don't care. I pay taxes. People complain that they pay taxes for things they don't get back. Well, I don't have children, but you can be damn sure I want to have kids in school, because I want to have someone to talk to in twenty years. There are other people besides ourselves out there; we do not exist in a selfish world. Pay more taxes and decrease the subway fare. Increase the luxury tax. If someone wants to buy twenty-five houses, go ahead, tax the hell out of them. Instead it's been going in the opposite direction. And while we're at it, Muriel wants to have a tax on the truly gaudy; call it a tax on the truly tasteless.

"I do find it kind of painful and frustrating to see how much in the last fifteen years or so, for many people in college and just getting out of college, all they care about is making money. And I think part of it is that money is valued and part of it is that it's considered the only value, not creating something or discovering some incredible moment, whatever it is that actors do on stage. Also because it's fear. People are afraid they're not going to have anything, because maybe that's true. It's a panic mentality."

Sloan acknowledges that it is sometimes difficult for artists to feel accomplished when their family and peers measure success only by how big one's house is, how fancy one's car is. But the competition and evaluation does not stop there, and artists are not so above the fray that they are not sucked into it. There is also, for example, the scrutinizing by other artists, "How prestigious was that poetry prize you received or that grant?" Sloan said, "Honestly, it's hard not to feel that pressure as an artist and not to judge yourself that way. There are certain people I don't tell what I'm doing or how I'm doing, because I don't want to be compared to the people they know who have million-dollar houses."

She cautioned, "It's important to think about what happens to people when they worship nothing but money and then what happens to your soul? As an artist you need to keep your soul intact, and your spirit, you need to be able to connect with the unconscious and to go deeper into someplace that has nothing to do with the reality that we're grounded in in everyday life. So there's a definite disconnect. Which is why grants and all of that funding and patrons are so important to artists. It funds the work, and the work funds the life."

Sloan bristles at the opinion of some policymakers that the arts should be wholly self-sustaining. "You get the Rush Limbaugh argument that if the art was any good it would be making money," she said. "I think the opposite is sometimes true, that what makes money is often the lowest common denominator. Because producers and marketers are not about art. And that is probably something that could be turned around in this country. Look at certain independent films and the favorable audience response. It doesn't

have to be the lowest common denominator. Producers can expect more out of the audience. Feed them sugar and they'll eat sugar. Feed them a well-seasoned salad and they'll eat that. Like in the book-publishing world, where you have all these market researchers saying, 'Well let's give such and such a celebrity millions of dollars as an advance.' Then they lose money on that book. If they do that enough with these big celebrity authors, then they'll lose their mid-list authors because they wasted all this money on books that lost millions of dollars. So, there goes the marketing research. No one thought *Angela's Ashes* was going to be the success that it is. So I think there is a lesson to be learned from all of that, which is that market researchers should get out of the business of making art. Just get rid of the market research people."

Sloan believes, particularly because of the paucity of grants and funding available for individual artists, that creative people have to use their ingenuity not only to produce their projects but to fund them as well. She related some of her own experiences, "There are people who get some help with support from their parents or friends. I know when I was starting out, a lot of people used to say, 'Well, why don't you just go to your family to back your projects?' That is something that a lot of people tell people to do. Well, if the people around you or who you were growing up with have no money or are working class, they're going to say, 'Why are you doing that, why don't you do something more real, why don't you get a real job? Why do you want to do that anyway?'

"I did do some fund-raising for projects. I did a project in which I interviewed old European Jews. I had a matching grant. I had a certain amount of money from the grant and I had to match it. So I went to everyone I knew and asked for $10 or $20, and I matched it. I got a state council grant when I was in Connecticut. I started to develop a support base from audiences. If you don't have patrons immediately at your side, then you have to develop them. People have supported my work at various points; every once in a while that will happen. But that's pretty unusual. I believe completely in patronage and supporting the arts."

On the other hand, Sloan sees no romance in the image of the ever-struggling, starving artist. "I don't believe that you have to keep working all the time and never become a success, and that this is the way life continues. I'm a step beyond that now and I hope to go beyond that even further."

Asked if she would continue performing her art if she knew she would never be financially successful, she jokingly suggested that were that the case she would shoot herself. But considering such a scenario more seriously, Sloan contemplated, "I'd perform anyway. I'd do it if I was locked in a cell. I am one of those people who just loves performing, and writing, and creating characters. I love doing what I'm doing. I'm directing other peo-

ple's work right now. I love the process of creating characters and mono-
logues and stories. I love the magic of making something from nothing.

"People ask artists all the time, 'Why do you do that? Why are you inter-
ested in fringe people? Why did you go interview an eighty-year-old woman
who nobody knows just because she survived the Holocaust and became a
psychologist? Or why are you interviewing that woman who was a runaway
and became a cop and then blew the whistle? Why'd you spend six years
doing that? That's such an obscure story.' I'm interested in people's lives.
I'm just fascinated about how people live on the earth."

Recently, Sloan and several other artists have formed a not-for-profit
arts organization, Ear/Say. They are developing a funding base, a business
plan, and are working on two multimedia projects: one on recent immi-
grants in Queens, New York, and one inspired by Sloan's mother's illness,
mistreatment, and death, which will focus on HMO's, care of the dying, and
healthcare as it affects older women.

As it does for most teachers of the arts, the practical subject of earning a
living has come up in Sloan's classes at New York University. "One class is
working passionately on oral history pieces. One student is doing a project
on single black mothers; another on growing up under a military dictator-
ship in Uruguay; another on young gay people who are making choices
about coming out or staying in the closet; another woman found the diary
of her mother, who as a young woman deferred her education during the
Depression and worked to support her parents. That was really interesting.
I think they're all worthy projects, and I'm encouraging them— fix that,
change that word, see how deep that is, see our reaction to that. One of my
students said her parents asked her why she was doing what she's doing.
Why are you getting a graduate degree in art and the public sector? She
wasn't just interested in becoming a performer, she wanted to look at how
art could change the society. And they thought that was crazy, like why are
you doing that? Why not just try to do something that will make money?

"So, what am I supposed to say as the professor? Yes, twenty years later
we will look at twelve students from Judith Sloan's 'Oral History and Cul-
tural Identity in the Arts' class and ask where are they now? They're poor,
but they're happy. I was making a joke and they all laughed. I said, 'Look
maybe I'm telling you the wrong thing to do. I'm not telling you to do this,
but I'm saying if you *do* do it, let's be passionate about making it good and
caring about what we're saying.' Some of them will be very successful, some
of them will be fine, some of them won't. Just like the percentages all over
the place."

Sloan predicts, though, that those who will be successful are the stu-
dents who have great tenacity, focus, and commitment. She said, "There's
a student of mine in an acting class who just doesn't have a passion

for acting, he really doesn't. For him a three-hour class is too long to concentrate. And I actually said to him, 'I don't think theater's the right thing for you. What are you going to do when you're in a ten-hour rehearsal, when you have to concentrate for that long? When you just have to keep at it because you're on a deadline?'

"I don't find it hard to concentrate for three hours or five hours, to rehearse something over and over until it's the way I need it to be. He didn't have that drive. It makes me wonder what people are learning in high school that they're in college and unable to concentrate for long periods of time. Because even in high school, I loved working on projects, finishing something until the wee hours of the night. Maybe there are some of us who just love it."

Even with the inroads being made by technology and the virtual world, Sloan believes that people will still always crave the tactile, the live, the real in their lives. "I don't think people will ever get sick of books. I know people say we'll have these little miniscreens that we can take to the beach with us— but you can't write in the margins! What will we do with the highlighters and the nifty little things you get at Staples?"

But on the other hand, she laments that there is less and less individuality, quirkiness, and uniqueness around us. As she said, "It's a shame that I can make a joke about Staples now. It's a chain, and it's all over the country. Years ago I couldn't have made a joke about Staples, because I went to the little stationery store on the corner, Greens or something, and I would have said that, and the audience wouldn't have known what I was talking about. But now we live in this incredibly uniform society."

8

Giving Voice to the Muted:
Keith Antar Mason

Keith Antar Mason is a writer and performance artist who has worked nationally and internationally in several media since 1979. His collection, **Gunge Tommorrows,** *won the Harvard Book Award for Poetry in 1974. Mason is founder of blackmadrid, a black poetry-jazz-rap-griot recording collective, and is the artistic director of the Hittite Empire, an ensemble that has produced more than 200 performances in Los Angeles, St. Louis, and other cities. In 1999, he performed his critically acclaimed* **Loss Soul** *in Austin, Texas, and elsewhere.*

Keith Antar Mason is developing a piece on fathers, sons, and brothers with his touring theater company, the Hittite Empire, an African American men's performance collective. As he explained, "We do letter-writing workshops between fathers and sons, in which we get them to write each other. And then we take the stories that they write about to each other, episodes from their personal lives, and create a performance piece with them. We're going to different cities to collect these letters and then create a work that will have impact on the cities we're going to and also, when the work becomes part of the touring roster, those stories will become representative of the relationship between fathers and sons nationally.

"We discovered that there are no first narrative voices between black men about interpersonal relationships; it's one of the angles we're exploring. We work with libraries and community centers to get these workshops set up."

This is just one of the projects that this busy writer and performer has percolating. He explained, "I'm also a playwright. The next piece I'm writing is for the Hittite Empire, which I'll be the sole playwright on; it's called *Cycle 8.* We are trying to get it ready to do for the London International Festival of Theatre.

Cycle 8 will be a series of images that will take us from the bottom of the slave ship, through history, all the way to a cell in a super-maximum security prison. It's kind of documenting how the black man's body in the New World has become a commodity again. Being sold into slavery in Africa, being sold on the auction block, and now being part of the fastest growing industry in America—the prisons.

"We found that there are a lot of comparative stories that are happening over in the United Kingdom. African and African diasporan people make up a smaller percentage in Great Britain, but they make up the same kind of number in the population of prison institutions. We definitely want to see about that story. We'll be working with British performers as well.

"I also have some plays that are being workshopped and stage-read at various theaters. The one that everyone's excited about is one that I didn't think people would be excited about. It's about intimate and terrible alone-ness, the Abner Louima case, the man from Haiti that got beaten up and sodomized by the New York cops in Brooklyn. They've done it in play labs in Minneapolis, and now they're reading it in Seattle. They read it in Louisville, and there's talk about them doing a reading of it in New York.

"I've also returned back to my early love of science fiction and short fiction. So I've been writing a lot of short fiction and getting rejected and getting published. I'm not getting rich, but at least they give you a copy of the book when you're published."

Mason's theater and writing work does not earn enough money to sustain him financially, but to earn a living he does stay in his chosen artistic field. He said, "What I do that's not directly related to my work is that I conduct workshops—writing workshops or performance residencies. I make a livable income. I'm able to at least pay rent by doing those workshops. Sometimes I'll set up my own workshops. I was doing a one-man show in Houston, and I set up my own series of workshops while I was doing the show. Sometimes I get hired by a university to come in and do a lecture or a presentation or an actual workshop.

"And there are places that give funding that want to give children's programs or young people's programs, and then they'll hire me to come in and do a series of workshops. I don't make a lot of money. I'm talking about a $75 workshop for three hours, that's $25 an hour. And if I'm negotiating with a community arts center administrator who got a grant, then he doesn't want to give me three hours, he wants to give me fifty-five minutes, and then he wants those guys back on the basketball court, because that's what they're there for; that's the reality.

"There are not a lot of grants or money out there. If I can extrapolate out to a more general picture—if you're not one of the commercial artists

in one of the popular cultural art forms— film, TV— and you are supplying arts education in a society that doesn't value the arts, well there may have been a time when there was lots of money for that kind of work and that kind of activity, at the time of the birth of the National Endowment for the Arts, but I became part of the field when the NEA was being dismantled; there is no money."

Mason figures that if his financial situation ever becomes really desperate, he can take a temporary job doing something completely unrelated to his art. He said, "At one point in my life I worked for Federal Express. So, if I was going to get a temp job, I could do shipping and receiving. I could do data entry if I had to, because I'm always using the computer, but I haven't had to do that.

"At those times in the past when I had to do that, it didn't zap my energy, it just made me get really focused. Out here in L.A. it could be temp heaven. For me, I have to not be tempted to get lazy and say that's what I'm going to do— take six months to do temp work and then six months to do my art. I don't want to get into that situation where I have to go and temp for six months, even though on the surface it would seemingly make life easier. But I would rather go to a temp agency only in a crunch time and find a little gig and do it until I found the next series of workshops that I could put together. I'd rather spend my time putting the next series of workshops together, on that track, as opposed to doing the temp stuff.

"I've always been a Maoist at heart— not to live beyond my means, to be really centered about what my goals were, not to believe in luck, not to believe that one day Hollywood was going to discover me, or TV was going to discover me, or that a book was going to get published. None of those things were the source of my joy. They would be steps along the way of a process of discovering my own inner self or developing my inner self. They weren't the goals, the goal is something higher, to be able to spend time within myself and to know on those days that are bad and I'm down that inside of myself is something that is good and that is worthy and that the bad thing I'm going through will pass as well. I'm working on that. I'm not a Buddhist or anything like that. People out here in California say that's why I came out here. It's not that I'm just satisfied and content, or that I don't strive for excellence; the things I do I need to strive for excellence, but the striving within is more important to me, and it's always been that way.

"I'm from St. Louis, Missouri, and when I was growing up there, there were no Buddhists. When I was growing up I was always the weird one, but now they have a term for that, *New Age*. I was way too conservative to have been an actual freak in those days. There were freaks, but I could point like a regular guy and say, 'You're a freak, man.' But I was what my friends called the 'spooky teenage poet.' I was drawn to poetry since I was nine

years old. I got my first poem published when I was nine.

"My father didn't encourage me, my mom did. My mother's still alive. Both my parents are the smartest people on the planet, I mean it. My mother's intellectual capabilities, it's like, how do you know all this stuff? My father continued to amaze me until he died. It wasn't just book knowledge, it was world knowledge and worldview. They encouraged me to read and write. As a matter of fact, before I was going to be 'on punishment,' my father would take me to the St. Louis Art Museum. 'Go around and browse,' he'd say, 'because you're not going to see it for a long time.' I always knew how serious it was if he'd take me to the art museum.

"But he didn't want me to be an artist. He didn't go out of his way to really discourage it, but he had plans for me to be a politician. And my mom just encouraged me to be the best at whatever I decided to be. My grandmother would come in and tell me a bedtime story, then at age nine she said I could tell a better story than she could. I just started writing poetry, which seemed like it was real simple because there weren't a lot of words on the page. I was trying to just do something that didn't have a lot of anything. I could write a page and it would be a poem, so that's how I got started. The first poem I got published was only one stanza, about six lines.

"I read everything. I went to the same library as the writer Ntozake Shange. In high school, I was just carrying around a journal all the time—the black-covered notebook with the blank pages inside. I never carried around a quill pen; it never got that outlandish. But there were some puff-sleeved shirts. I would always try to wrinkle my brow."

"All my friends say I don't celebrate my life," Mason said. "And when they look at my résumé they say, 'Wow I wish I had done that.' I do look at my résumé, and I am glad that I've done those things I've done; it's just that I keep asking myself, What is there to want that I don't already have? When push comes to shove I don't want the big fancy car, I definitely don't want an entourage of well-wishers who don't really know me. What is there to have? I want to be able to pay the phone bill consistently, that's my thing. Caviar or a filet of fish sandwich from McDonald's is still fish. It's not that I don't have taste or quality control in my life, or whatever it is. But I've seen other artist friends do that cycle, where they had to have something because now they had put themselves in the situation of wanting that thing, before that they wanted something else. They achieved that, and then they moved on to wanting something else. That's the big question, what is it that I want for? What I want for is for a lot of African American men not to commit crimes against each other, not to live in an oppressive world.

"I know why this teacher is having a hard time with this young man.

This man's coming to school three days having not eaten. You'd have a hard time teaching me too, if I hadn't eaten for three days. And he's too embarrassed to say, 'I can't concentrate because I haven't eaten.' That doesn't make him stupid, it makes him hungry.

"I don't have that religious dogma thing. I'm not a Jesus Christ, I'm not trying to save him that way. But at least maybe I can help him to be strong enough to say what's going on in his life, so that maybe people can help him."

Mason is literally immersed in the arts, surrounded by creative people and ideas where he works and lives. For his apartment is at the 18th Street Complex, which he described in this way: "It's a collection of artists and arts organizations that decided to take over some buildings on the west side of L.A., in Santa Monica actually, that would have intercultural dialogues and develop new multicultural relationships in the art world, and that would be a community of artists that would continue these dialogues as we traveled into the new millennium. It's evolved. Now everyone is their own separate entity but we still work together as a community. We still have the 18th Street Complex as the hub, but I go on tour most of the time and I'm not here. We have Cornerstone right next door, which is this theater company that travels throughout the country and puts projects together the way the Hittite Empire does."

Because the creative life is so integral to Mason's existence and the way he views the world, he has strong opinions about how the government and society in the United States should view the arts. "Maybe if we're not afraid to say we're artists strong enough and loud enough, they'll realize that we're worthy, that society should support our efforts. Not for charity or a handout, but that what we contribute is valuable, like working for the department of power and water. It's just a different kind of energy, a different kind of service we're providing. It's going to take a lot of argument and a lot of debate, but if we really think it's worthy— we're the creative people. A lot of our enemies are using the tools that we gave them, and we taught them how to use them. Okay, so we're now moving on to a new set of tools. I've been to other countries, and I know they do it. We have an artist from Finland visiting, and I was talking to him. They have socialized medicine. If he were to get sick, he doesn't worry about it; he can go to the doctor.

"I also think there's a double standard. The NEA was funding a certain kind of privileged art, elitist art. I'm not saying that it was a bad thing, but the structure itself was Eurocentric in nature, so they would pick those things that they valued. My work is about people, black people, poor people, working-class people, urban youth. And it's not taking those urban

youth to the symphony or a well-constructed play as a community outreach program. My work is one of the oldest art forms, it's storytelling, it's poetry and it's deeper than that, it's psychologically helping young African American men find their voices. I have seen it. If I can help a young African American man find his own voice, then he is more likely not to pick up a gun and kill another African American man.

"There's no funding for that, although they can say I can go to programs for at-risk youth, but I'm not a social worker. And I would prefer to work as a self-identified artist. I remember when I was seventeen, I was not a jazz musician, I was a poet, and I would have loved to be in the company of poets, but the only poets who were around were the jazz musicians.

"So now in my early forties, when I find young brothers who don't read and write period, but they have skills, if I can help them improve their communication skills, if I can help them learn to read and write, if I can help them nurture the talents that they have, that may be seen as at-risk work but that's not the reason that I'm doing it. I'm doing it because that brother is a hell of a poet, and he has all these obstacles in his way that are going to say, you can't even speak the President's English. He is going to have all these obstacles saying what he is doing, how he is contributing to language in this day and age, is not valid. And I say, no. My work is about saying, your voice is valid, the way that you speak, the way that you want to construct your worldview is important, and it needs to be propagated."

9

The Sound of People Working
Together: Joseph Zitt

Joseph Zitt is a musician and poet. He founded the avant-garde vocal ensemble Comma, which has released the CD Voices. *Zitt has written and presented performance poetry and music in Austin, Dallas, and Houston. His poetry chapbook,* Partial Requiem, *was published by Ded Poets Press, in Austin.*

For Joseph Zitt, creating music and poetry are not all that different from writing a good string of code. Now, most of his artistic efforts are spent on composing for and performing with the vocal ensemble Comma, based in Washington, D.C. The ensemble has produced a CD entitled *Voices,* and has performed in many venues in Washington, D.C., New York, and New Jersey. In addition to this work, Zitt is working on a book-length poetry project that he descibes as a hallucinatory view of a biblical epic. He also manages the online Silence mailing list for discussions of the music of John Cage.

The computer code comes in during his nine-to-five existence, in which Zitt is the Webmaster for the Intranet of the engineering division at Hughes Network Systems, in Gaithersburg, Maryland, an engineering firm that designs DirecTV™ and satellite communication equipment. What he finds most rewarding about this work is interacting closely with the people who are actually going to be using the system and then developing an interface that thinks the way they do. Zitt said, "The tool should be designed for the person, it's really hard to redesign people for the tool."

Zitt attended college at Yeshiva University, in New York, and Rutgers University, in New Jersey, where his major was electronic and ethnic music. When he left college he continued to compose, although he had little

opportunity to hear his work performed, except for the music he wrote for a small theater company in the Williamsburg section of New York.

In 1989, Zitt moved to Austin, Texas, and began writing poetry at the suggestion of some of his co-workers at IBM. The performances of his poetry evolved into dance-theater pieces. He said, "Poetry is a wonderfully efficient performance medium. So I got to perform a lot. Then I moved to Dallas and put together an ensemble of people doing sound poetry. My poetry was starting to shift from more conventionally content-based stuff to more sound-based stuff. I put together a performance ensemble called Question Authority, The. It still is somewhat in existence, with the other members performing together on occasion."

For several years Zitt had stopped creating poetry, but he has recently resumed writing it. He said, "I found that when I do write poetry, people like it, especially when I write the accessible stuff. I've written some poems that were derived from chants, and people just say, 'Oh that's interesting.' But when I write the content-driven thing, people really like it.

"So I've had this idea for this biblically based piece that I've been batting around in my head since college. I sat down and started to write it and it's flowing out, and I think people will like it, and that's cool. It's not avant-garde, it's not a humongous challenge to do, it's not going to stretch either me or the audience. But that's not necessarily a bad thing, and it will probably touch people much more than the other stuff I had been doing the last few years."

Zitt has been fortunate, because even though his job entails working with computers, many of his colleagues have also been involved in the arts. As he explained, "Although I'm a programmer now, up until the early 1990s, I was a technical writer. I was a writer at IBM, so I was hanging out and working with a whole lot of artistic people. My first encouragement to do a poetry reading came from a co-worker who did his own poetry and performance reading at a wonderful theater that is no longer in existence in Austin. He encouraged me to come out to the open-mike night and read some of the stuff I was writing.

"When I started putting together the first dance performance I did, it was written for another technical writer at IBM who was also a dancer. Then after a year at IBM, I moved on to a company called AIC Analysts International, which on the whole is kind of a body shop that places people in different companies. I became a support programmer for the technical writers. What happened was I got really annoyed at the tools we were using and decided to look under the hood and see if they could be improved. I learned enough programming to do some, and eventually got into programming. But on our team it was almost all writers. The art on the walls of the office was by members of the team. On the last Wednesday of

every month we would have a brown bag lunch where people would read their poetry. We had a bunch of musicians there. Working with a guitarist on my team, I did a score for a corporate film that ended up not being used. We did a video tape about people on the team. I did the music and produced it.

"When I did my biggest theater piece, *Shekhinah: The Presence*, the lead dancer was that same tech writer with whom I worked at IBM who was then at AIC also. There was also kind of an installation art piece as part of it, which was done by a member of the team. Some of the vocals on the soundtrack and the costumes were done by my boss. It was a wonderful job and a wonderful team to work with.

"My job as a support programmer there was basically to wander around, listen to what people were griping about, and figure out a solution. So by the time they came to me with a problem, I'd say, 'Oh, this program I just wrote will solve that.' It's the art of strategic eavesdropping. It was a wonderful working environment. I think from the level above my boss on up the company thought that we were a bunch of crackpots and wanted to get rid of us. But at least going up one level it worked.

"Among the people at that job there were different levels of artistic frustration. There were some people who would much rather have been out there doing their art who were quite frustrated at having to do a day job. Others felt as I did. I know that the kind of art I do for the most part is not terribly commercial. If I were to try to make a living at it, barring some amazing support from somewhere, I would either have to change it into something that is much more commercial, which is not in itself a bad thing, it's just not the direction I see myself going in, or I would have to spend so much time doing organization and fund-raising and all that that I wouldn't have time to do the art anyway."

Besides coming to grips with the reality of his situation, Zitt also is fortunate that his paying job in many ways nurtures his art. "To a great extent what I do when my work is going ideally is not all that different from what I do in my art," he said. "Programming and technical writing are very similar to composition and improvisation. In a composition you are in a sense writing a set of material and rules for people to follow in getting to a certain result. In programming you're doing a similar thing for a computer.

"There are several compositions that I've written first as computer programs to see what would come of them, and then I've looked at the programs I've written and abstracted the instructions so they'd be something that a human could follow. A lot of my composing is very much in the tradition of John Cage, and Pauline Oliveros, and John Zorn.

"It's been a long time since I've composed anything where I've written down an actual note on a staff. It's more verbal instructions for interactions among people producing music. This piece we're hoping to record soon,

called *feldMorph,* simply because it's music inspired by Morton Feldman and the sound is kind of morphing around, is a one-page verbal score. We're going to do it for about an hour and see what happens."

Zitt views the explosion of technology, particularly of the Internet in recent years, as a great boon to the arts. "It's very much a medium for bringing people together. The way that I met Matt and Tom, the other members of Comma, was through the Silence mailing list that I run online, and the ArtsWire communication system. Also every week on Wednesday evening we have at Diversity University a discussion on contemporary music, mostly by people who make it. Last year we had a Cage concert that came about because of the Web. I had just moved to the D.C. area, and somebody on the Silence mailing list said, 'Let's have a party since Joe's in town.' They started talking about when and where. And I said, 'September 5 would have been Cage's eighty-fifth birthday, how about we pull off a concert?'

"We managed to have about sixteen people doing a dozen pieces, 200 people in the audience, and the concert went for three or four hours. And most of us involved in the concert met for the first time the night of the concert. It was all done online.

"Another example— I'm on the mailing list for Austin Poets-at-Large, even though I'm no longer in Austin. They publish poems in their newsletter. I wrote a piece that was published in a newsletter. They were asking for pieces about Miles Davis and John Coltrane, and I wrote a piece about Miles. They e-mailed it out; it went to 700 people. If that had been a piece published in a hard-copy zine, for one thing it would take forever until it came out, and readership would probably not be much better. So a lot of the stuff I write is specifically to go online.

"For the CD we did for Comma we did this extensive Web site so you can get a lot more information about the CD. It would have been incredibly expensive to do as a CD booklet, whereas online it's relatively inexpensive.

"I hope Sun gets around to publishing their Java Sound specification, since I've been working on designing a Java-based, Web-based musical interaction system. It will make it possible for people on their computers to interact with this changing sound sculpture, and what you'll be hearing at any given time will be a result of what the people online right that minute are doing to change the sound in real time. That would be inconceivable without the Internet. Playing on my computer in the living room would be the real time interaction of people from all over the world. I could flip a few buttons and send in my interaction. It would be almost like listening to weather, but listening to the interaction of people, the sound of people working together."

Despite the creative co-workers Zitt has usually encountered, he did once have a job that was intolerable because of the people who worked there. He described the milieu in which he felt so uncomfortable. "These were people who would sit down at their computer at 9 AM, stop for lunch, walk away from the computer at 5 PM, and go home and just work on their lawns or watch football. They and I each wondered what planet the other was from. The majority of people it seems to me, do their jobs for eight hours a day or whatever, and then they go home and do something fairly passive in terms of entertainment, raise the kids, and worry about the house.

"When I was complaining about my job a few weeks ago, someone said, 'You know in my time and my parents' time, most people had a job, and granted it wasn't something they enjoyed doing, but they would go and do whatever they had to do and get the paycheck, and that was sufficient.' She was bringing this up in a sense as something worth emulating, this was how life was and people were fine with it. And I was sitting there thinking, isn't that a pathetic way to live, isn't it sad that people had to do that?

"For awhile, up until a few weeks ago, I was avidly trying to get out of my current job. I wasn't having the kind of interactions with people I wanted to have on the job, I was frustrated with a lot of stuff. I had the good luck, in a sense, of having the flu and being completely immobilized for a few days, to the point where I couldn't even read; I just had to sit there. Which gave me an opportunity for meditation, as it were. It struck me that one of the reasons I was looking for this in my work was that I didn't have it in my outside life.

"I go home alone. I spend a lot of time wandering around in CD stores to avoid being home alone. Which means I have about a-CD-a-day habit. I do have a wonderful collection though. I was trying to have the job fill these interpersonal things that I need. And maybe that's the wrong way to go about it, and I should start cultivating some outside stuff.

"I have a feeling that if I ever got around to getting into a relationship or anything like that, I might become a whole lot less creative, and that might not be a bad thing. There are other things I could be doing with my time besides writing and composing and all of that. To a certain extent, what all this is about is creating interpersonal interactions or simulations thereof. To a certain extent, no matter how good the art is it doesn't add up to the same thing. Why am I doing this art, what am I going for, and what else should be in my life?

"Here I am living in an apartment in the middle of the city. Although I love living in the city, I'm on my own. I'm doing music to a large extent that other people don't want to hear.

I would like to see myself settling down into a relationship and having a

nice house somewhere, things like that. When I was busy learning how to be a composer I sort of missed out on lessons on how to do that."

Zitt believes that when he is performing it is important to respect the audience and approach it with a desire to communicate. He said, "A few days ago I was reading an interview with Rob Zombie, former lead singer of the group White Zombie, and he was talking about doing performances and playing the few hits that he's had. He said that to a certain extent he'd rather do new stuff and move on, but when he's got an audience there before him, he's got to think like the audience. If he's got an audience, they're going to want to hear *Thunder Crash 69* or *More Human than Human*. So he'll do that in his concert. He said he will also do the more adventurous stuff, but he has a certain amount of respect for the audience.

"To a certain extent I do care if the audience listens. The audience is giving of their time and attention so I want something to reward them back. To a certain extent it hangs on the triple statement by the Jewish sage Hillel, 'If I am not for myself, who will be for me? If I am only for myself, what am I? and If not now, when?' If I didn't have that tattooed to the inside of my brain, I'd probably have it up on my wall. That's such an important statement.

"One cool thing with Comma is that Tom is an expert at church chant. He's a devout Christian, though not of the fundamentalist, obnoxious ilk. Matt is coming from a Taoist perspective and has also done a lot of church performances. And I'm coming from Cage's philosophy of anarchic harmony. So for each of us, in doing our music, we are not just making music, but creating an interaction. This is education; this is trying to make the world better. In a sense, we are trying to present what we do musically as a paradigm for how people might interact outside of music.

"On the other hand, I do appreciate that there are people who want to hear our music, and that there are people who don't. I do a certain amount of evangelism, trying to get people to hear these things. One thing that is very important to us in our performing, and it depends on where we're performing, is that the audience knows what's going on. If they look on stage and feel that what's going on is just utterly random and they don't have a clue, then it won't reach them as much. Explaining to some extent the process, the sources, gives people something to latch onto. That's an important thing. There are some composers and people in the arts who just feel that 'what I'm doing is too good for the bourgeoisie to get into and the hell with them; if they're not interested then they're not worthy.' If I can get anyone to listen to something in a new way, I enjoy that happening. In a sense coming from where Cage was coming from, one of my buzz phrases is that 'music is not a way of creating sound but of perceiving sound.' Yes, you can listen to what's happening over the course of a few minutes in the

park and listen to it with the attention with which you listen to music. That helps in listening to some of my stuff also.

"I know of experiences that I myself have had, going to a performance that I expected to hate and then liking it in a completely unexpected way. In fact, quite often when there's an area of art or music that I find myself really not liking, I start investigating it to figure out what it is that I don't like about it, and to see if there is a way that I could like it. For instance, Country and Western music, I really didn't like it. I listened, and granted the music isn't inventive, but it's working very much like folk music does; there are certain tropes that people use, and where things are happening is in the familiarity of people with the sound and with the story that the music is telling, they're people's stories. And that's what people are getting into. I'll listen to maybe two or three Country and Western CDs a year, but I'll find a way to enjoy them.

"Even elevator music— there are ways to enjoy that if you listen past the idea that this is pap music being imposed on you. There are often many odd little things happening in the orchestration and interesting decisions being made by the composers and arrangers— how they take something that was an aggressive rock song and make it so it maintains its identity but works here in this new genre. There are ways to make it interesting."

Zitt has given some thought to the direction in which he wants to take his art. "In a sense I would like to be able to do large theater pieces, films, and things like that. That involves things where you have a big budget. Having seen the amazing things that U2 or Peter Gabriel have done with rock shows in a stadium or arena, it makes me want to be able to do that. I also know that a vanishingly small group of people actually get to do that. I do a little pop music also.

"I would also like to see, and it's starting to happen a little bit, that the pieces I write get performed by other people. One of the things that's frustrating with non–pop music is that things tend to get performed exactly once. Very rarely do you hear of a second performance of an opera or symphony. Everyone wants to do premieres, which is frustrating. It would be nice to be able to get into the repertory and to be influential, in the same way that the people from whom I've learned have been influential.

"I want to put something back in. It's sort of like on the computer side, some of the systems I use, the Linux operating system, the Apache Web server, stuff like that, have been designed collaboratively by people. A lot of people have put in a lot of unpaid work so that we all can use these tools. They'll write the code and contribute it back in. The way the community stays alive is having people giving back into that from which they took. That's important to me."

10

The Imagination's Surprises:
David Estey

David Estey is a visual artist whose paintings, drawings, and prints have been widely exhibited. Some of the galleries that have displayed his work are the Woodmere Art Museum, Pennsylvania Academy of the Fine Arts, Third Street Gallery, and Manayunk Art Center, in Philadelphia; Jane Law Gallery, in Long Beach Island, New Jersey; the Cheltenham Center for the Arts, in Cheltenham, Pennsylvania; and the Foundry Gallery, in Washington, D.C. He has won juried awards from the Woodmere Art Museum, Pennsylvania Academy of the Fine Arts, and the Cheltenham Center for the Arts.

Paintings lined the walls of the Third Street Gallery, an artists' cooperative space in Old City Philadelphia, depicting symbols, bureaucrats, and emblems of the Internal Revenue Service (IRS). One of the paintings in the show, entitled *Inside the IRS,* portrayed a large seal of the IRS with this quote overprinting it: "IRS managers are overwhelmingly introverted, sensing, thinking, and judging. This means they are self-contained, detail-oriented, procedural, and decisive. This mind set permeates the organizational culture and stifles creativity."

A gallery filled with paintings focusing on one of the world's largest tax bureaucracies is an anomaly. But the artist, David Estey, who received a BFA from the Rhode Island School of Design, and studied drawing and painting in Rome during his senior year, spent twenty-six years employed by the IRS. The text he printed on his painting is derived from the actual results of psychological testing the IRS performs to determine the personality profile of its managers and executives. Their strengths lie in thinking rather than feeling, in judging rather than perceiving— qualities that contradict the intuitive, receptive nature associated with creative artists.

Estey said that when he himself was tested, his personality traits were right in the middle, "Which means I could slip one way or the other, which probably drove my co-workers a little crazy."

The artist found his way to the IRS by way of the military. Upon his graduation from the Rhode Island School of Design in 1964, he was drafted into the recruiting command in Fort Meade, Maryland, near Baltimore. These were the years during which the Vietnam War was raging, and he was fortunate to be given an assignment as an illustrator. When his tour of duty was over, he stayed on in a civilian capacity for another two years, teaching art in small classes to adults and children on the side, as well as working on his own art. In 1967 he had a solo exhibition at the National Security Agency.

Two years later, and now a husband with a young family to support, he took a job that had opened up at the IRS developing illustration and television workshops. Over the course of his long career, Estey worked as a visual information specialist and public affairs officer in Washington, D.C., Baltimore, and Philadelphia, while still continuing to teach and create art in his spare time. When he first accepted the job at the federal tax agency, he thought that it would provide financial stability for his young family. And over the years his employment did enable him to maintain a suburban middle-class lifestyle— making house and car payments, taking his son and daughter to football and soccer games, traveling to Europe a few times to visit his first wife's family. But it also turned out to engage him and, unexpectedly, in many ways to complement his art.

The early days that he spent in the Baltimore office, from 1973 to 1979, were heady ones. Watergate, the auditing of President Nixon's and Vice-President Agnew's tax returns, and investigations of price gouging by the gasoline and beef industries were underway at the IRS. Estey found himself on radio and television talk shows, fending off aggressive reporters, and planning strategies with colleagues about how to be honest with the press and public and yet not divulge classified information. Bob Woodward of the famous Woodward and Bernstein team at the *Washington Post* pumped him for information; Walter Cronkite once phoned to verify a story five minutes before his deadline; and a woman who was largely unknown at the time, Oprah Winfrey, interviewed him on a Baltimore television show.

During those years he earned a MSA in public administration from George Washington University and had a second child. Still, he painted. In 1984 when he transferred to the Philadelphia regional office of the IRS, he enrolled in noncredit night classes in painting and printmaking at the Pennsylvania Academy of the Fine Arts, Cheltenham Center for the Arts, and Abington Art Center, and studied art during some vacations at the Haystack Mountain School of Crafts, in Deer Isle, Maine.

After a divorce and marriage to his second wife in 1988, Estey moved to a semi-detached house in a residential neighborhood that had a small, light-filled studio adjacent to it. As he passed his weekends and vacations sketching and painting there, he began to fantasize about spending whole days in the studio, exploring conceptual and design ideas, and having the time and freedom to experiment and develop his talent further. In 1995, at the age of fifty-three, when the IRS, during a reorganization, offered him the chance to retire early with a nice pension, he was very ready to accept.

Since he has become a full-time artist, Estey has had five solo exhibitions of his work and won several awards at juried shows. He has also displayed his paintings and prints in over two dozen galleries, community art centers, libraries, art schools, colleges, and corporations. In 1998, he moved with his wife to a home and art studio they built in Cramerton, North Carolina.

Reflecting on how his long stint in the bureaucracy compares with life in the art studio, Estey finds that there are many parallels between the two. He said, "In both realms there is the need to solve problems and conceptualize. This is accomplished by thinking clearly; being initially open to all kinds of wild, crazy, and dissimilar ideas; and then being organized enough to distill them and discover those things that are meaningful and relate to each other.

"An artist makes hundreds of decisions in minutes and seconds—stroke? color? where? to what degree? These decisions are made intuitively. What I discovered at the IRS was that those who had difficulty solving problems were people who could not conceptualize possible scenarios and solutions in the abstract." Estey credits his own ability to visualize how disparate ideas relate to each other to his training at the Rhode Island School of Design. "The same thinking process can be applied to an artist, public relations or public information person, the manager of a corporation, or a writer. You have to be able to think, organize, conceptualize, and be open to new ideas."

He discovered a paradox that exists in a large bureaucracy. "They say they want creativity, but it's against the lock-step thinking that produces efficiency, and the IRS is very efficient, and has to be, so they need that, they need people to do it right, follow procedures, and do it the same way every time. That's totally against people who are free-thinkers and say let's do it differently even though we've done it this way forever. The bureaucracy says it wants creativity, but it doesn't take risks; you can't have creativity, so there's a difficulty there."

This contradiction came into sharp focus for Estey when he visited one of his retired professors from the Rhode Island School of Design. The professor, Robert Hamilton, lives in a small fishing village on the coast of

Maine and still paints every day, even though he has two buildings on his property overflowing with his art. When Estey asked him why he keeps at it, he told him it was for the surprise. "If I don't have a surprise each day, I've had a bad day."

That was like a revelation to Estey. In his career in public information he was repeatedly reminded that there should be "no surprises." He was supposed to anticipate any possible scenarios that could occur and brief his boss about them so that he wouldn't be sitting in a meeting and be blindsided by anything. "As an artist, when you're really free-thinking and letting the material speak to you, there is no better pleasure; it is a free fall. And if you don't happen on that, then you're not having much fun. That's when that happy accident occurs. That's why we keep going. But that happy accident is not happy when you run into it in a bureaucracy. Then it's 'oh my God, what happened?' "

The transition from his government office to the studio was seamless for Estey. He said, "I think it's important to have endings to things. I brought my stuff home and didn't miss the job after that. No trauma. I miss the people; I'm still in touch with people. But now I can do what I wanted to do and had been doing on a limited basis. I'm free, like when I was in school, for the first time in thirty years. I don't have to get on the train and run downtown every day. I can spend time in galleries, get into arts organizations, can use my skills to help them, and it's been very satisfying to help them."

Estey also doesn't see the two worlds he inhabited as totally separate. "A common thread runs through honest design, honest government, honest public relations, and honest writing— the desire to communicate and convey information and experience with integrity. The fact that other artists and people who have been to my shows respect and admire my work is very important to me, because it means I've been able to express something of what I'm feeling. If I make marks on the paper and find them exciting, I want other people to find them exciting. They can make their own stories up, and I want them to, they can see in it what they want, but I want them to be stimulated by it the way I am. Because there's so much pleasure in it for me that I want to be able to share it."

Estey has moved back and forth from abstract painting and printmaking to more realistic work such as the paintings in the IRS show. Some of these also included portraits of an executive he admired; a metaphorical organizational ant pyramid, in which the top ants defecate and the ants three levels below eat their waste; a collage of IRS workers; and a satirical 1040 tax form containing creative instructions, such as those under "Medical and Dental Deductions" stating "don't even bother unless you're a walking disaster." Now Estey has a vision of combining these abstract and realistic styles into

a more integrated approach to his art. He is moving in a direction "that doesn't have all the realism, does have narrative, is quite abstract and perhaps more primitive than I've done in my whole life. I think I can combine them into something that will be quite poetic."

He is experimenting with painting, printmaking, and collage and incorporating new techniques and media, including computer-generated images and photocopies, to express his creativity. Estey's formal art training emphasized the importance of a good sense of design, and "for better or worse" he has always been able to draw very well. But he has concluded that, although these skills are important, they are not enough. Part of his artist's statement reads, "I work for the sense of discovery experienced by a child. The pieces never totally reveal themselves, so I can relive the process each time I see them. That way, I can continue to create and recreate the possibilities in my mind and be freshly invigorated by the work and its origins."

Estey never wavered from the idea that there would be a time in his life when he would be able to get back to his art. He had a few opportunities during his career to move into executive positions. He said, "I gave them up but I don't regret it. My ego said, 'I'm as bright as others, I can do it.' But my heart said, 'That wouldn't be any fun, I don't want that.' I always knew that I would one day get back to art and do it full-time. My whole life I felt that I was special, that God gave me a talent that was special, and I would do something special with it. But now, the more I look at the practical side of it, and look at my age, I wonder if that's ever going to happen, and it doesn't matter anymore. I've always gotten tremendous pleasure out of my art. There's some reason for it; that's what has always driven me; it's enough to keep reaching."

11

A Hobby at the Core of One's Life:
Richard Grayson

Richard Grayson is a short story writer and journalist who has published eight short story collections, including Disjointed Fictions, With Hitler in New York and Other Stories, Lincoln's Doctor's Dog and Other Stories, I Brake for Delmore Schwartz, Eating at Arby's, The Greatest Short Story That Absolutely Ever Was, *and* I Survived Caracas Traffic. *His articles have appeared in such publications as the* New York Times *and* New Jersey Online.

The revelation that Richard Grayson had after his first book of short stories was published in 1979, when he was twenty-seven years old, was that it wasn't going to change his life. He was excited and proud of his accomplishment, as were his family and friends. The book was widely reviewed, but he experienced no fame and garnered no fortune. He found himself still going to his part time adjunct teaching job in the English department of a New York college and living his anonymous writer's life as if nothing had happened.

Grayson considers the publication of his first book a fluke—his publisher, who had just taken over a small commercial publishing company in New York, had read one of Grayson's stories in a literary magazine and become interested. Since then he has published about 200 short stories in magazines and anthologies as well as four hardcover collections of stories and four chapbooks. He has also done some journalism, primarily op-ed pieces on issues about which he felt strongly.

There is no doubt in Grayson's mind that it is impossible for him to earn a living solely from his writing. He explained, "If I didn't do anything except writing, I couldn't survive. I'm forty-six now. I grew up in Brooklyn where I lived with my family. I lived at home until I was twenty-six or

twenty-seven to save money. I went to Brooklyn College, which is a commuter school basically, and I got a master's in English for essay and creative writing there. The first jobs I had after graduate school tended to be adjunct teaching positions. Like a lot of people who have degrees in English, I was actually doing that while in grad school, not at the same school. I had a friend whose father was the chair of an English department, and he had an opening when a faculty member died. I taught at that school for a few years. I think I was making $2,700. Being that I was living with my parents, my expenses were pretty low."

When his parents moved to Florida, he followed shortly after and quickly landed an adjunct teaching job at a community college, which led to a full-time position. Grayson said, "I was teaching full-time on a temporary year-to-year basis. I had benefits and a salary. But on the other hand, I was teaching twelve classes a year of composition, and I really didn't have time to write.

"At the community college there was in-service training on how to use the computer. I had always been against computers. They were the things the technological people used. I remember in 1981 I got a grant from Florida and so did a poet. She said she was going to buy a word processor. At the time I thought, 'What does a poet need with a word processor?'

"But I really took to the computers right away. In our last session, the trainer couldn't do something, and she said, 'You do it, you understand this stuff really well.' Even though I wasn't that young, I was in a place where most of the faculty was pretty old. I started taking graduate courses that were offered in computer education. One thing sort of led to another, and I got a part time job teaching computers in the Broward County school system. It paid reasonably well, and there weren't all those papers to grade. I would drive all over Miami; I had no fear of ghetto neighborhoods. I still taught creative writing workshops at the community college."

Then for several years, Grayson made a living through a creative mix consisting of his teaching salary, unemployment benefits, and credit cards. "I'd be laid off for the summer; I would go on unemployment. I've been on unemployment maybe thirteen or fourteen times in my life. Whereas other people view it as a tragedy, to me it's great.

"I also found a way to live off credit cards. While I had a full-time job, I'd apply for credit cards. And they would also come in the mail, of course. I never bought much, but I'd use them for cash advances to live on, and then I'd be very scrupulous about paying them back. So this seemed like extra income to me. I understood that I owed this money and I'd pay it off with interest rates. But I also devised a scheme. I saw what was going on with the economy at the time. I said to myself, 'The government is acquiring all this debt, and it's all going to implode eventually, and I'll just declare

bankruptcy when it does. In the meantime, I'll just try to get as many credit cards as I can and live off them.' I developed a spread sheet program to keep track of them, so I paid them off, I would overpay on them.

"What I used the money for was to put it in the bank in a savings account. I showed at one point $50,000 in the bank, which was entirely money borrowed on credit cards. Keeping track of it all actually became very time consuming as well. At one point I had forty-six Visas, Master-Cards, American Expresses, Discovers, and Choices. I also became sort of an expert at the credit card business, because I would read about which ones were easy to get; I used to read *American Banker*. I had all this money that wasn't real. Actually, a lot of this is reflected in my writing.

"I could see by 1990 that everything was turning out just as I had predicted. Eventually, the credit card chaos was getting too weird. I knew I was going to have to go bankrupt. The problem was I didn't have anything, because I didn't buy anything with the money. If they asked me where it went, well I used to pay my rent with the credit cards, I'd buy groceries with credit cards, I'd use cash advances. I couldn't afford a car, but I once rented a car for four months. Another time I bought a used car for $2,000. I didn't have the money, but I took twenty credit cards to a cash machine. And I said to the guard, now watch this— here's $200, here's $200, here's $200."

During the next few years, Grayson split his time between New York, where he shared an apartment with a friend, and Florida. He continued to do adjunct teaching in English and worked for the Miami-Dade public school system as a computer trainer. He also enrolled in law school at the University of Florida, making ends meet on student loans, a few credit cards that had not been activated before his bankruptcy, and the income from part-time teaching.

Grayson wrote intermittently while he was involved in these other pursuits. "I hadn't been writing for a few years prior to law school. I thought, 'Well there's no market.' Only when I really wanted to write something did I, about one story a year. I'd get most of them published. Essentially, I'd write when I felt like it. I was a columnist for a little newspaper in Hollywood, Florida. I wrote one story that people paid $3,000 for, which was the most I ever made, a humor story. Plus I got another Florida arts grant and a New York Council for the Arts writer-in-residence award."

Eventually the urge to write more steadily returned. "In law school, during the second year I just started to want to write again. I had new things to write about. I learned a lot, and I was living a different kind of life. I was living in a small college town, Gainesville, in basically what felt like the South. It was different. There was a big gay rights thing going on in town and I got involved in that too.

"I never intended to practice law. I didn't know what I was going to do

after law school, but I got a job at the law school. I graduated fifth in my class. After the first semester I got the book award in two out of five classes, which meant I had the highest grade. I thought, 'Boy I'm pretty good at this or else I'm just smart or something.' I got a job as a research faculty member and I was a staff attorney at a think tank at the law school.

"From a few months after I graduated until last March I was a staff attorney at the Center for Governmental Responsibility. At the same time I was teaching business law part time for another school. So I was teaching at two jobs, and I was writing a lot at this time. Because, to be honest, I had never had an office job before, a nine-to-five job. I wasn't used to it. My first day on the job, my secretary came in and said, 'Can you sign this approval for someone to get paid?' I felt like I was a total fraud. Suddenly I'm in charge, and people are coming to me to sign things, it was just very weird.

"At this job I had an office, and I had to appear at it every day and be there a certain number of hours, although no one watched my hours. I realized something about office jobs— if you have the right one, you can goof off a lot of the time. People were amazed at my productivity because I wrote all these memos, because I could write fast. So I had a lot of free time. And so I would sit and write at my desk. My last story collection was basically written on the job."

The grant money for this job ran out, and although Grayson's employers wanted to keep him on to work on different projects, he let it be known that he wanted to leave Gainesville, and so he was officially laid off from his position. Since then he's been in residence at writers' colonies, including Ragdale, in Illinois, and Villa Montalvo, in California, and teaching composition and law classes part time. He has some savings as well, because in Gainesville he lived in an apartment that cost only $295 a month.

After he left his office job, Grayson began writing enough fiction to compile a book manuscript. He said, "Sometimes when I'm not writing fiction, I'll think about it and I'll put my ideas in a notebook. I don't seem to write like a lot of people do. I do write every day in a journal, and I've done that since I was eighteen years old, but I don't sit and write. ·

"I'm pretty lazy. It's a wonder that I published at all. Anything I do, it's sort of grist for the mill. If I'm reading the newspaper I figure what I find there is helpful, it can't hurt. Also, I've started to do more and more journalism, and I'm starting to like that.

"If I ever want to stop writing fiction, I will. But I see now, having given up a number of times, that I keep going back to it, so it obviously has a hold on me. I keep trying to stop, because there's absolutely no remuneration in it. My oldest friend, Linda, has been a very successful

commercial writer, not of fiction, but of diet books and all kinds of self-help books. A few years ago, she decided she hated writing and decided she was going to become a literary agent. Last summer she said, 'Let me try some of your work out.' And I kept putting her off and saying it's of no use, that I get published only by small presses.

"My last book got one review in one newspaper. The good news was that it was the *New York Times Book Review,* and it was a good review. But my book isn't in the book stores, it's not going to sell, except to libraries.

"My friend gets excited when she gets bites, and I have to tell her, 'Don't get too excited.' She thinks she's going to get me a contract for even $35,000, and get her 15 percent. She's wrong; I know it. We heard from someone this week, and she said they were considering it very seriously, but they had a meeting and they said they couldn't market it. It had nothing to do with the book. They can't market it; I know they can't market it. It's kind of unclassifiable.

"I'd have a better chance if I'd never been published before. They'd think, well maybe he's going to write a novel. But I'm not going to write a novel. If I didn't write a novel after publishing my first book of short stories in 1979, then I'm probably not going to. They're not going to make money afterwards.

"Besides, you have, for instance, a situation in which they gave Whoopi Goldberg $6 million for her book, and that really screwed up business at that particular publisher when her book didn't sell that much. I'm a realist, and I know that that's the way it is.

"I used to rage about this. And I still have artist friends, writer friends, who rage about this, but hey, that's the way it is, that's the way the world is. That's the world we live in. It's not 1950, and it's not 1910, and it's 2000, this is it. That's fine.

"I recently taught at an arts program at a high school in New Orleans where the writing program is run by an old friend of mine; I've been there several times. He's still very upset about all this at fifty-one years old. He's still being published by small presses. He has twelve unpublished novels. I say, 'Yes, it's terrible.' But talking about it does no good, and it's sort of like, okay, let's just accept the world as it is. So what I tell his students is that even though I've been a recognized writer for years, even though if you go to the library and you look under literary criticism I'm there and reviews of my work are there, and I get into artists' colonies, and I get grants, and my books are in some libraries, I'm not going to make money from it.

"To me, in a sense that makes it a hobby. Like my grandfathers, who were businessmen, would say, 'If you're not making money from it, then it's a hobby.' On the other hand, a hobby can be at the core of your life. For many people it is more important than what they're doing for a living. If

you can make a career out of your hobby, then that's great. I do it a little bit here and there, but you can't make a living writing short stories anymore than you can writing poetry.

"At one time I thought I could get a job as a full-time creative writing teacher, but even that's impossible. And I've gone off the track, having worked in computer education, having worked as a lawyer. I can get adjunct work very easily teaching creative writing because of my credentials. But the truth is, I don't even want to be a creative writing professor, having taught creative writing courses— who wants to read other people's bad stories? It's not going to make me want to write any more. I'd rather be a lawyer and get material from what I'm doing, which is outside of writing.

"There's something strange in American life, in that so many writers are writing professors teaching other people to be creative writers. And the pyramid scheme gets weirder and weirder as fewer of the young people find jobs as writing professors, let alone get published.

"I was disappointed years ago when people said, 'Oh now that you have a book published you can get a professorship in creative writing, and I wasn't able to, probably because of the job market and possibly because of me. But I'm glad now that it didn't work out that way. I'm glad I had all these weird experiences and I probably will continue to. I don't know what careers I'll have in the future, but I mean it's wonderful. It's much more interesting I think than the kind of life my professors in the MFA program had of being students, going to graduate school, teaching in graduate school, and retiring at seventy. I like to have adventures."

Grayson also likes the idea of having several layers of identities that cloak each other. He said, "I remember going to the MacDowell Colony and talking to the writer Meg Wolitzer. I told her that when I was teaching computers, and I'd go to the schools, they'd say, 'Oh, the computer expert is here!' They had no idea I was a writer. Just like when I worked in law. I would appear on local TV because of the kind of place where I worked, talking about issues, and no one would know that writing was my other life. It's funny, sometimes people would say, 'Oh there's a writer by the same name, is he related to you, or is he your son or something?' I think that's sort of neat.

"A friend of mine with whom I was in the MFA program at Brooklyn is a lawyer, and he's also known because he owns a bar in New York that's very fashionable. I admire people who do other things. Meg Wolitzer said she couldn't stand it if people didn't know she was a writer all the time. She was upset about the possibility that they wouldn't because it's her whole life— she's a writer. It's not my whole life. It's not my identity. Yes, to some extent it is, but I have other identities. I get a lot of satisfaction out of those other identities. Because it tells me, if I'm not making a living as a writer, I can make a living doing other things, and I have mastery over things.

"Believe it or not, my success in law school gave me a lot of confidence. I went when I was over forty, and I was concerned because there were all these bright young kids. It was very hard to get into because it's so cheap; it's one of only two state law schools, so they only take about 10 percent of the applicants. And I heard all my life from my lawyer friends about how hard law school was. Well, it wasn't that hard for me. And it gave me a lot of confidence for the first time of how smart I was. It started to annoy my lawyer friends.

"At a Hanukkah party about ten years ago I told someone that if there's an economic downturn, I'm prepared because I live so poorly anyhow. He asked, 'How are you prepared? Nobody needs what you do. I'm a lawyer, they'll always need me.' When he moved to Philly, he couldn't find a job in Philly. He was commuting to New York for three years before he found a job in Philly, because there was such a glut of lawyers in Philly. In a way it was a vindication for me, because there are people who are such careerists.

"I also feel that I have much more flexibility. And I think in today's workforce, it's actually good to be an artist. Because artists always have this mentality that they're working for themselves. I think that everyone is essentially out for herself or himself these days, because no corporation is going to take care of you for thirty or forty years. This is a work environment where people who are artists can flourish.

"This is what frustrates me about a lot of my friends. One called yesterday, a friend I met at Ragdale. She teaches comp and has a lectureship at the University of San Francisco, and she's not too happy with it. She doesn't think she can do anything else. A lot of writers think that they can't do anything else, and they don't realize how transferable their skills are."

However, Grayson admits that just because there may be lucrative worlds open to him, he does not necessarily choose to enter them. "I don't want to work for a law firm for a couple of reasons. One is I don't want to have to wear a suit everyday. And I hate to do that kind of stuff, because it would be boring to me. To be frank, when recruiters came around, I didn't want to see them because I didn't want that kind of job. But I could have made myself into that kind of person who makes a lot of money. It's not so much purity, it's you get lost in your job, you get sucked into something and you forget other things, as friends of mine have done when they got that kind of job.

"On the other hand, you wonder, maybe they weren't cut out to be artists or writers in the first place. So that when someone gets a job as a prosecutor in Baltimore, like a friend of mine did, and he stops writing, I don't know that it's his job that made him stop writing. It is an excuse. There are enough lawyers who publish novels these days very successfully; you read about these guys all the time. And women who have full-time jobs, whatever job they're in, and kids to raise, and they manage to produce

things; so it can't be that it's only because of a demanding job.

"Of course it's much easier being a single person like me with no children. I'm gay for one thing, though today that doesn't preclude having kids. But long ago I decided not to have kids. Art is not a necessity in society the way putting food on the table is. I'd hate to think of people letting their kids eat poorly because they want to paint paintings. Part of my life, when I had the credit card thing, I pretended I was independently wealthy. I just lived on a low-level independent wealth. And I didn't work for long periods, and in a sense I'm doing that now. Obviously, if you have obligations, that's different— if I had obligations, say, to a parent. But my parents didn't ask, and I don't feel obligated to support my parents at this point. So I can pack up like I just did, I can move around to artists' colonies."

Grayson enjoys staying at artists' colonies because of the camaraderie of other artists and the chance to work for long uninterrupted stretches in a peaceful and supportive environment. At Villa Montalvo, located in a state park in the foothills of the Santa Cruz mountains in California, for example, residents are given an apartment on the grounds. They have dinner together once a week and meet socially, but for the most part they enjoy privacy and seclusion there. Grayson said that while he was there he felt like he was living in an apartment in one of the biggest villas in Silicon Valley. He thinks it's helpful for artists to live in a bit of a fantasy world for a little while.

He has met many talented artists at these colonies who have diversified backgrounds and histories. "The woman across the hall from me was basically an impoverished visual artist. But she gave it all up and she'll tell you that. She was an attorney. She was married. She gave up her lucrative law practice, she gave up her marriage and became an artist after she was in her mid-thirties. And while she may complain about it, I don't know that it's stopping her from doing the art, because she is compelled to do it."

Grayson acknowledges that many people cannot comprehend why artists continue to write, or paint, or dance when they know that there will not be any monetary compensation for their efforts. But he countered this line of thinking with these comments: "Yes, but it's incomprehensible to me why people do other things. Why would you want to be good at golf if you're not going to make money at it? I don't know why you'd want to. To me it serves no purpose, unless you were going to be a golfer. But actually I do understand, they love it. People do all sorts of things that are not for money.

"It's true that people don't understand why artists do it, because we live in a society that is such a winner-take-all society. What's interesting about

this is that with this winner-take-all, you have two or three famous writers or artists or composers, and the rest are totally unheard of. You're now seeing this in the business world and academia, where you have stars— people who are making incredible amounts of money; the CEOs are making $9 million and everyone else is making minimum wage. But those are the values of our society. When you're a writer, people say to you, 'Oh you're a writer? How come I never heard of you?' You and I could list 300 writers who are writing today— their books are in libraries and bookstores— whom nobody's ever heard of.

"But, hey, that's fine. No one ever promised me that. I never had any illusions. In the back of my mind, maybe I dreamt of that. But my career has pretty much gone as I thought it would. What's surprising to me is the twists and turns my life has taken. If anything though, I'm thrilled that the *New York Times* reviewed my book, even though it was only the second book out from a small press in North Carolina, which tells me that someone there knows my work. They reviewed two of my books, both from small presses. I can live off that for awhile. It meant a lot to me. I had a book published in 1996. That seems fairly recent to me. I think if I don't have a book published by 2002 I'm going to start getting real antsy about not getting a book published. Even though I have a book ready, I know how hard it is.

"Most of the things in my career seemed to have just happened— there's no connection. That's what I think bothers people about artistic careers, performing careers, there doesn't seem to be a connection between the amount of work you do, how hard you work, or even in some cases how good you are and what's a commercial or artistic success. So, once you accept the fact that it's sort of like a fluke and you've got to appreciate the good parts, it's a lot healthier.

"I don't feel bitter, I feel joyful to be able to do the things I do, and sometimes to get even. I was being interviewed once and the guy asked me how I felt about success or failure. My answer surprised him, and I could tell because it was reflected in the article, where he wrote, almost with incredulity, 'This guy thinks he's successful!' In a nice way he said I have a strong ego. I do consider myself successful, because most people who write books don't get them published at all."

Just the writing itself, although it gives Grayson much satisfaction, is not enough to sustain him in his art. He said, "I do get satisfaction out of the writing itself. But I have to say that I do need some kind of validation. Even if it's just being published in a Webzine or something like that. Somebody else seeing it helps. I'm not that secure. If everything I wrote got put away in a drawer and I just thought it was good, that's not enough. I get satisfaction from things I've written that are good that haven't been published

yet, but I still need that validation, which is probably a failing on my part. I mean it's not my diary. My diary I write for myself. I get satisfaction when I write something really wonderful in my journal, but it's not for anyone else, and if I want to transform it, that's something else."

Grayson has thought about his future and how his writing life will fit into any other work he will find himself involved in. He said, "In terms of jobs, I'm not that dedicated to my writing that I won't work at something else too. I need to be among people and I like the social contact of work, and I like work for that reason. Even when I had enough money so I didn't have to work, I did adjunct work for $900 a course in Florida. Even if I didn't need the money, I wanted to get out of the house for an hour and a half to teach a class. Writing is very lonely, and I am very chatty and very into people and it's just too socially isolating. Even if I had all the money in the world, to be stuck in a room all day having to write all day would just be horrible. I'd just go out and do other things too. I need to be in the world."

12

A Non-Linear Path:
Sharon Nordlinger

Actor Sharon Nordlinger has worked in theater, film, television, and commercials. Among the shows in which she acted are the Comedy of Errors *and* Wild Echinacea, *both at the Actors Theatre of Louisville;* The President, *at the Wilma Theatre in Philadelphia;* Hello Stranger, *a one-woman show at* Theater 313 *in New York; and "Central Park West" and "Guiding Light" on CBS television.*

Sharon Nordlinger was bit by the proverbial theater bug as a child in Richmond, Virginia, where her stage mother took her for auditions to local theaters. Having remained passionate about acting into adulthood, she studied drama and earned a BFA in theater from the University of the Arts, in Philadelphia, and continues to take acting classes in New York, where she now lives.

Nordlinger was very fortunate to find a wonderful mentor in college who became a dear friend and source of inspiration. Nordlinger said, "Her name was Alexandra Toussaint. She died a few years ago, after struggling with diabetes all her life. Alexandra was an incredibly gifted teacher and actor. She had seen how hard it is to meld together the different aspects of theater—your love for it, and what its demands are, and what it can do to your soul. She had been in New York for a short time, but I don't think she wanted to stay very long in the commercial realm. She very much kept alive what I had always wanted theater to represent: the love of it, the exploration of the human condition, the things you can find out about yourself and in turn give to other people. It's kind of hard to keep that alive here in New York without her."

Trying to find acting work and constantly auditioning for parts are often grueling and demoralizing experiences. For young actors like Nordlinger

their enthusiasm and level of confidence can fluctuate between exuberance and despair. Nordlinger explained, "This has been a very cynical week for me. I just sort of lost my drive this week. I was just relieved that my agent didn't call about any auditions, because I was just not up for it. Because so much of it just has to do with politics and knowing the right people and 'getting in the loop,' as they call it. There's an overwhelming amount of actors and not enough work. The casting directors also look to see if you're in the loop. Sometimes they make their determination based on whether you have already been approved by others, rather than any qualities they can define in you themselves.

"There is a great deal of that. Once certain doors are open to you, you've already got a stamp of approval. Also, you often have an in if you went to elite schools like Yale or New York University. It's as if they say, 'Okay, we don't have to think here.' People are terrified of looking stupid I guess. They often don't have their own opinion. Of course, even though you know this, it's still coupled with lots of self-doubt. It's hard not to see yourself through those eyes that haven't selected you for a role. I've been doing some writing for this course I'm taking called The Artist's Way, which is based on the book by Julia Cameron, to relocate how I feel, because so many things can be skewed by perception, you can see yourself through others' eyes as well.

"I did a play a few months ago and was getting paid for that. Usually, I work at jobs other than acting about thirty-six hours a week. On the weekends I'm cocktail waitressing in a very upscale place, and I also do catering. You freelance yourself out, different people call you. If I wanted to, I could really make a good deal of money. But I want to find something I really love. Interestingly enough, my feelings about outside work change from day to day. I change my mind constantly, it strikes you differently on different days.

"For instance, I actually enjoyed working last night and last week, because I was proud of myself and could focus on something other than myself, which is very freeing sometimes. Also, I'm able to work with people who are like myself. I see all this talent, and great things, and humor. So many neat people. And also there are people who are battered and cynical, but you see a great number of people you have comradeship with, and it makes you feel less alone. Like last night, I met a lot of neat people, I also met people I wouldn't want to hang out with. It exposes me to people, which I'm interested in.

"It is physically depleting work though. Sometimes it's horrific. You feel physically exhausted. It's strenuous labor, you feel like a scullery maid looking in from the outside at all these people who are privileged. It makes you feel shabby and poor and hungry and tired. Particularly in New York I am privy to seeing the very, very, very well-off, and I wait on them. It's very

interesting, I don't know if anywhere else I would find the kind of things I find here. New York is New York. I often forget that the rest of the world isn't New York City. I see a lot of pretension and ostentation here. I feel somewhat envious, yet at the same time I'm glad I'm not them. It's always the mingling of conflicting emotions. I feel like that a lot.

"I guess being privy to these conversations will help in my acting. But I guess everything in life helps you. I forget who said, 'Whatever doesn't kill you makes you stronger.' Part of me relates to that, and part of me just says, 'Damn, it isn't fair.'

"I should work more. A lot of times I'm finding that I feel guilty that I could be doing more. But then I find I have to take care of myself, I have to get a certain amount of sleep, and take care of life things— wash my clothes and make sure I eat properly. A lot of times I feel very proud that I'm just taking care of myself here in the city, and a lot of time it means nothing to me."

Besides working and acting whenever she has the opportunity, Nordlinger also attends classes and auditions. She finds that it is difficult to sustain her energy level and to work out the logistics. "It's kind of perfect if you're not in a show to be working on the weekends, because most of your auditions are not on the weekends. So when I stay up late, I can sleep late and not have to come in shell-shocked to an audition. I was bartending for awhile on week nights, and I found that during the days I was so tired that I was out of it and looked terrible, and that was really hard. I'm always juggling. When I book catering work during the day, I pray that my agent doesn't call on that day. Days aren't good to work really, because you never know if the phone's going to ring. Of course, if it doesn't ring then I'm thinking, 'Well what am I doing with my days?' For the next few weeks, I'll have to be working during the day, and I hope that an audition doesn't fall during one of those times.

"When I am working during the day, sometimes I have to change in the bathroom and try to shake the smell of grease off myself and run to an audition for a role that might be glamorous, though I don't feel at all glamorous at the time."

Like most people, much of Nordlinger's sense of who she is is tied up with how she spends her time and earns her money. When she spends a period of time being paid as an actor, even if she's barely getting by on that income, it makes her *feel* more like an actor. Conversely, if there is a stretch of time when she's primarily working in the restaurant business, waiting on people, she often feels as if she's not worthy of being an actor, as if she's not worthy of identifying herself as an actor anymore, because that's not where she's been investing her time. She explained, "I even have a hard time when I'm not working as an artist to call myself an actor, I don't feel privileged to say that I am. But then what am I? It's excruciating."

One day it became clear to Nordlinger that there may never be an either-or situation regarding acting and work that is unrelated to her craft. She said, "It's amazing to me— when I first worked at a good regional theater that had a good reputation, I was working with these actors, some of whom were my age, and some who were a lot older. And there were some who had worked on Broadway and the New York Shakespeare Festival— who have huge résumés. And I realized that there's an in-between. People are always thinking that you make it or you don't make it. But then there's this in-between mostly, where it can go on a lifetime. It was new to me in the last few years to realize that.

"Right now that's been on my mind. A year ago I would have said, 'Oh yeah that's fine, whatever it is I'll do it, I love theater.' The difference right now, and I'm constantly changing, but right now I have a lot of doubts about being able to do it my whole life. Right now I'm taking it day by day until I can decide. I want to do something that matters to me. I was recently thinking, 'What do I love?' I love literature and I love theater. I could be an English teacher. Do I want to go back and get my MFA?

"There's always that question that I've been battling with, which is, 'Am I just an effete? Is that enough?' When I'm not creating it makes me feel terrible. Most of all, I'd like to find a way to weave into my life the creative nub. And sometimes I think, well, but I can't write like Thomas Wolfe. But that need to create is like a dagger, and I don't know how that will turn out for me. I don't know, if I chose something else besides acting, if that would be enough. Would teaching theater be enough? Would teaching English be enough? Would being a social worker be enough?

"Alexandra was a huge role model for me. She always said that what she wanted to be remembered for was living on her own terms, and she truly did. And she enjoyed life. She so much enjoyed teaching, and her life was full of creativity, and she found that. But would that be enough for me? And could I even do that? These are questions and thoughts that have just started cropping up in my head. I'm really surprised by them, I also don't buy them. I don't quite know what they mean right now. I guess I can just keep on doing what I'm doing until it becomes clear to me."

In addition to the self-imposed urge to succeed in the competitive acting world, Nordlinger also has to contend with making the inevitable comparisons with friends and colleagues who are achieving various levels of success in this field. "I have a lot of friends. I have friends who are going through very similar things as me. One of my best friends, who went to Yale, is getting quite successful. I have a hard time not being bitter. I have another friend who is this wildly successful Academy Award–winning screenwriter, who is less helpful to me than even the guy at the bar where I work

who said, 'Stick in there, stick in there.' That stranger was much more supportive than this successful person who makes me feel bad about myself because I feel whenever I'm with him that I'm not of his caliber.

"One night I was complaining that I don't have any connections. He said, 'It's not connections, Sharon, it's karma.' Now that I think about it, it really pisses me off. Yeah, karma. That's another thing, I try to live my life trying not to do anything to anyone I wouldn't want done to me. I have my own strong sense of keeping that intact, so why should my karma be any less than anyone else's?

"I don't want to be bitter, but I'm afraid that I will be or that I am. That scares me. I probably put that on myself. But also, he's just not incredibly giving. But then again, I've never asked him to open doors for me.

"On the other hand, I have found a lot of recognition from my peers and other artists. There's a woman writer who lives upstairs from me who I've gotten to be very good friends with, who knows I'm interested in writing and offered to put me in her class for free, and we talk about books constantly, and I think she gets excited about my love of that. That kind of excitement feeds me, that bouncing of ideas back and forth and realizing that those things are present in me.

"Some days, like today, I was listening to music and thinking of all the books there are to read and great movies to see and all that to live for and how there wasn't even enough time to do all that and how some days feel great that way. And then some days feel interminable, with those things not being as important, not holding the light that they held, and I feel empty again. It's constantly changing with me from day to day. And some days it feels like enough just to have a roof over my head and to listen to music and read the book I want to read and discuss the things I want to discuss. And some days New York is terrific, and some days it's hell."

Another aspect of the acting profession that Nordlinger has to consider is how she would react to an offer of a contract for a long-term commercial role. "My perceptions change whenever I've gotten close to soap opera roles. Sometimes I almost feel that I should trade on my youth and what looks I have, or at least my agent thinks I should. A lot of times I'll buy into this idea hook, line, and sinker, but a lot of times I'll look back on it and realize, that wasn't that important to me really. It makes me wonder if I'm a hypocrite. It's easy to say, 'No I don't want that soap opera, that's not important to me.' But since I haven't achieved it, am I just saying it as a defense? I question myself a lot. That's why I'd like to be accepted for something like a soap opera role, so I could really know for myself whether these are hypocritical defenses of mine. I don't really think I'd want to stay on a soap very long, but I don't know; how can I absolutely say that? It's defi-

nitely an entrée into other parts, and that I would welcome. But even the doing it, would that really give me what I want, or even what my agent seems to want for me?"

The life of an artist, Nordlinger is discovering, is not one that usually takes a linear path. It is an endless cycle of periods that burgeon with creativity and periods that are dormant. She described the experiences of some friends in this regard: "I was catering with some guy who was much older than me the other day, and I realized that he was just starting again to find some creativity. I realized that he was doing more now than he had possibly done in the past and finding new acceptance.

"Then I ran into a friend on the street, who was thrilled. Last week she had quit acting. She had *quit acting*. She said she didn't want any more of all that tedious work and feeling bad about herself. She said she feels so free. She's just studying now, and said she'll decide what she wants to do. I was amazed to see that. She was one of the first people I'd seen completely bailing out. I shouldn't say bailing out, but making that choice.

"A lot of my friends are very successful in the theater and in films. Most of them have gone through what I'm going through. I guess I'm at the place where I'm thinking they've still been luckier than me. I'll discuss this with the person I mentioned before who went to Yale and who is a very dear friend of mine. It's so hard when she complains, or I complain to her, it's all relative. She complains about not getting more recognition for the Broadway show she's in, compared to me complaining that I can't even get seen for that Broadway show. They are both realities, they make sense, but it's so hard for me to listen to that. She says she completely understands that and that's valid. It seems like no matter what you have, you're constantly looking up at the next person. Who was it who said each person's on a ladder looking at the next person's butt. That's horrible, but I do hear things like that."

Although Nordlinger does not have extensive experience with grants or funding for theater productions, she does know that raising money to produce a play is difficult. It's one of the reasons that soap opera stars who aren't even trained in the theater are able to get roles in Broadway shows— they will draw the audience in. However, actors and producers are resourceful in finding ways to underwrite shows. Nordlinger said, "There are these companies that you want to be involved with because of the cachet of being involved with them, because they're associated with stars like Marisa Tomei and other big names, so they end up being critically acclaimed. Other people also try to start up a company, and there are just so many of them, and even the ones that don't have the stars somehow keep going and do their

productions.

"I just worked with this company, the head of which is this vital young man who had gotten lots of funding, and he also has a whole lot of cash advances on his credit card, but he started this great company. I think if you really put your mind to it there are resources and things can be achieved. I think it's a lot of work. People are creating their own work.

"One of the best experiences I had in New York was that I actually put on my own show. It came out of a class I was in about a particular playwright. We all felt passionate about this playwright. But I was the leader, I got it off the ground. With my energy I kept on saying yes we can, yes we can. My partner backed out, but we went on, and the show got good reviews and was well received and was one of the most artistically satisfying things I've ever done.

"Imagining doing that right now seems completely alien to me. I feel cynical now I guess, and I'm not passionate now about anything in particular. I was very passionate about that play, that group of people. I'd like so much to find a group of people with whom I could really be simpatico artistically, people who really excite me and want to do the same kind of things artistically that I want to do, and really work hard at it. I would throw myself into that, but it really hasn't happened. There are so many people doing so many different things, and trying to keep a roof over their heads."

Nordlinger is often distressed by the lack of value that is placed on art in this country. "I get frustrated and angry with popular culture and what is out there," she said. "Also the idea that people, sports figures for example, are paid so much; it's all so ridiculous. There are people starving in this city, in this country. There ought to be a law against it, there really ought to be. We don't really need that much to live. Money can't buy happiness, I think that's really true. I was talking to a bartender where I work. He was saying that there's money in computers. He was saying, 'If it pays a lot, that's what matters to me.' And I was thinking that I'm fortunate that that's not important to me. I wonder if I have found things to love that he hasn't?

"My little nephews are growing up, and working in computers, and making tons more money than I, and don't know anything about the arts. But I know that I'm not interested in money purely for money and would rather do what I'm doing now than be doing something just for the money. I guess that's just the way that artists think. It's the way we look at the world; we're interested in *looking* at the world. I guess that's what artists do. They're interested in holding up a mirror for themselves and for others. Whether or not I'm creating at any given time, that's still my interest.

"I wasn't around when my parents were growing up, but I tend to think that things are changing rapidly and that things have changed since the

1940s. There is an unhealthy growth now of wanting money for the sake of money. Education is no longer important. And that it's only money that is valued. But I think there will always be people who want to live a slower life and who won't need the idea of money to be successful. I guess that's what I'm most trying to cultivate, the things that make me happy, art, books, theater, thinking, and talking."

13

Writing in the Hollywood Hills: April A. Dammann

April A. Dammann is a screenwriter and playwright whose work has been presented in film and on television and the radio. Among her credits are **Rose and Katz,** *a short dramatic film; "McGee and Me," on* **ABC-TV;** *"The Brady Brides," on* **NBC-TV;** *a half-hour drama series on the Arts and Entertainment (A&E) Network; features on the* **Post-Oscar Talent Showcase;** *and the "Adventures in Odyssey" and "Heartbeat Theatre" syndicated radio drama series.*

April A. Dammann is truly a child of Hollywood. She grew up in that famous town, met her husband at Hollywood High School, and attended the University of California, Los Angeles. It was also in the Hollywood Hills that, as a young mother and wife, she became a scriptwriter for radio, television, and film.

"To begin at the beginning," Dammann related, "I got married young and had children around age twenty-seven and thirty. It was around the time that my second child, my son, was born, that I realized I needed to have a career, that my kids weren't going to be young forever. My sister was an actress, working at that time in radio drama and doing voice-overs. And I began writing radio scripts for "Heartbeat Theater," a nationally syndicated radio program, thanks to my sister, who had let me know that they needed writers. I've found that, at least in this industry, so many of the jobs are won by personal references and by who you know. I think maybe with fiction writing, novels, and playwriting, it's not so much who you know, it's your raw talent and making your talent known, and exploiting all the opportunities. But in this town, it's so much who you know. So I was lucky that my sister opened that door for me.

"After writing radio dramas for a few years, I got a very good literary

agent, and I started having pitch sessions to promote my original ideas in television. I began with a partner to write half-hour sitcoms like 'Mork and Mindy,' 'The Brady Bunch,' 'The Brady Brides,' and 'WKRP in Cincinnati.' Then my partner went to the American Film Institute's directing program, and that's when I began writing again on my own.

"I've done some movie scripts, but I haven't had a feature film produced yet. I've done television movies for the networks, half-hour dramas, and comedies for A&E and the networks. And right now, besides a memoir that I'm working on, which is a Mae West project, I'm adapting a very interesting book for television. It's based on a memoir written by a writer whom I met at an artists' colony. I can't say the title of the work because I don't own the rights to it yet. That script is further along than the Mae West project."

Before taking a crack at the radio drama, Dammann hadn't done any writing. She was a French major at UCLA and also attended the Sorbonne in Paris. Later she earned a master's degree from the University of Rochester in foreign and comparative literature. She never taught French though, but worked for a few years at the UCLA Alumni Association in a public relations job before having her children.

Dammann had the advantage of enjoying a comfortable income from her husband's art gallery in the Hollywood Hills when she began her writing career. She said, "I was lucky, my lifestyle was always very comfortable. My husband was always very pleased to see me pursuing my creative endeavors, but he was never counting on my income.

"But I, for my own self-esteem, was very pleased to make my own money, and that's been very important to me. But as a freelance writer there have been lean times. Sometimes my income in a given year has been very good, sometimes kind of meager. So it's been rather sporadic. Now that I'm exploring this new area of nonfiction, if I was supporting myself, it would be a very iffy proposition, because it is not a time when I'm earning a lot in the area that I'm more experienced in."

Dammann was also very involved in her children's lives when they were growing up. "It is another job, but everybody does it, most women do it, it was just my life," she explained. "I loved being involved in their lives. My two kids were very successful child actors in TV and film, which is another story. So I was kind of managing their careers. In fact, a few writing jobs came from shows that they were on, where I got to know the producers. It's amazing— I was a lowly stage mother. There's no one lower than a stage mother on a set; it's worse than being a fifty-year-old writer. But because of my background and my credits, I was able to finagle some jobs on shows like 'The Wonder Years' and 'Mickey and Me,' and others.

"Sometimes I felt that I exploited my kids. As long as they were doing it, I tried to find as much positive in their careers as I could, because there

were negatives, there were sacrifices— they would miss a lot of school, and there were big family decisions to be made here and there, but at least I got some writing jobs out of it.

"Taking them to auditions and being on the sets took away from my time to write, but as I said, I did get some work from it, so there were trade-offs, and I really can't complain. I must say that I'm probably unusual among many other writers in that my husband has been so supportive. We both work at home, so he was always there to babysit, or sometimes he'd take the kids on auditions. Most auditions were here in Hollywood, where we live. Everything was really working in our favor. It was more at our convenience than our inconvenience, which is quite unusual. I've heard about families that drive up here from San Diego. I don't think we would have pursued it if that had been the case with us."

Dammann described the process by which a script moves from an idea she may glean from, say, reading a human interest story in the *Los Angeles Times* to production as a television movie or program. "I'll work out a two-paragraph treatment in my head about who the main character would be, what the story would be. I can see it all, the trick is to make it concise, make it compelling for someone else in a couple of paragraphs. Then I'll call my literary agent, whom I've been with for many years. Maybe my idea will be a baseball story, based on a player I read about who had Tourette's syndrome. Everyone just thought he had anxiety out there in left field, and no one knew he had this disease or neurologic condition, and his baseball career just went to hell. So I want to write a story based on a baseball player who has a problem that turns out to be physical, and then cover the whole arc of his career.

"My agent will say, I happen to know that Disney is looking for sports right now; or ABC is only gearing up for women, it doesn't sound like a story for women, so let's call Showtime or HBO. She'll psych out who the best buyer for such a story will be. Then she or I will arrange a pitch session. Then I'll go in and pitch my story to the producer.

"In the pitch session I explain it, but in more detail. The producer will ask, 'What's the act one break, what's the act two break? What's the climax? Is there a love interest?' They're very good at asking questions, because they know their audience better than we the writers do. I hate to say it, but some of this is very formulaic for television. We all know the formula, we all know that women are the main audience. This is almost exclusively so for the Lifetime channel. There are all these TV movies, disease of the week stories, and the women in jeopardy that are so big in network prime time drama. I write those and I know that my audience is women.

"So if I pitch a baseball story, in a way that limits where I can pitch it. But then, hopefully, I'll leave a treatment and I'll get a call in a day or two

saying they're interested. And if you're in the Writers Guild of America like I am, then what you have is called a stepped deal. It's very proscribed by the union. You get paid for a treatment, which is a pretty detailed twenty-to-thirty-page outline. If they like that, then you get paid for the first draft teleplay, which is about 120 pages, then if they like that, you get paid again for the second draft, and then if all goes well, you are the credited writer when it gets produced.

"What happens often is that it never does get produced. I've had so much material optioned by the biggest producers in town, Dick Clark Productions, Larry Thompson, and Paramount. There's a lot of enthusiasm when you start the process, and there are so many reasons why it may not get produced, and it happens with every writer. But it's wonderful when it does go all the way.

"The other crazy thing, according to the union rules, is that you could get cut out at any step in the deal. It could go to a different writer after the first or second draft, or they can decide at rewrite to go with another writer. In essence they're buying your idea right at the beginning, and you can get chopped out at any point."

Compromising on her material is something that Dammann has had to struggle with to greater or lesser degrees during her entire career. Her level of anguish and frustration varies depending on the nature of the project. She explained, "I think it has to do with how passionate you are about the particular project. Some people just aren't willing to make changes, and other people are just so hungry to get the deal that they'll do almost anything. And sometimes that comes back to haunt you of course. It's like an actress who poses nude and then ten years later has to deal with it.

"It's a project-by-project decision. There are some where I go in, and I'm just so happy to have the meeting, and I'm not wedded necessarily to every plot point. Another thing that comes into play is that sometimes the producer is very bright, and gets your story immediately, and comes up with wonderful ideas that you didn't have. In that case it might appear that you're giving in, but in fact what's really happening is that a collaboration can start in that room in just a forty- or forty-five minute meeting that can result in something better than what you came in with. That's happened to me.

"There are horrors too. And we've all been tempted to sell out, and it all depends on where you are at that given moment, and you have to go and live with yourself. Like the memoir that I'm working on now. I love this story and I'm working hard on it. But it's not my story, it's the author's memoir. I have the idea of a voice-over narrator speaking during quite a large portion of the story. The author was in Czechoslovakia for fourteen years and spoke Czech. Well, how does that translate on HBO? I just don't

want subtitles the whole time. This was something I talked to a producer
about; I just thought we could hear the voice-over in English talking about
her experiences, and you'd see her on the screen and she would be speaking
Czech, and the narrator would explain what was going on. And this guy just
had a totally different take on it. 'No, they're speaking English the whole
time, we know she's in Czechoslovakia, this is not *Dancing with Wolves*, we
don't need to hear the Sioux language.' At that point, I went, well fine.
Maybe he knows what will work better. My job is just to translate the
author's story and get something compelling out there, and how we do the
narration is not the deal breaker for me."

In general, Dammann has taken a philosophical approach to having her
story idea taken over by another writer or changed radically from her origi-
nal concept. "I consider myself a religious person, and my idea is that God
is really watching over us and there will be justice, if not in this life then in
some other. I say this somewhat facetiously, but I really do believe it. The
other, less karmic point of view is that you have to give it away for a num-
ber of years before you start being paid for it. I feel that we all either get
ripped off or give it away, or have to share credit, just in the way that you
pay dues, because the rewards are so big here. It's just a price that you pay."

Perhaps because the rewards in terms of fame and fortune *are* so great in
Hollywood, so many writers and actors flock there and are willing to work
at unexciting day jobs that allow them to fit in auditions and meetings.
Dammann described the experiences of many such people she has en-
countered and even mentored through the years. "I know a writer who's
about thirty. He's writing a lot of plays and getting them produced, and he
has readings of screenplays with very good actors and gets people to come
and see these, and he's hustling and writing, and arranging meetings. He's
actually just landed a very good agent. But he's working long hours as a
copywriter every day, and he's always tired, and he has no romance. He
wants to have a girlfriend, but he has no time for dating. He's just working
these long hours as long as he can until maybe the money starts rolling in
for his passion, which is writing.

"If you go to a restaurant here in Hollywood, the waiters and waitresses
are these beautiful kids, and you know that they're actors waiting tables at
night so they can be available during the day for auditions. Everybody
makes sacrifices. I see it all the time, men and women who have a rough
time making it as a writer. And they take day jobs, and some people give up.
Here in Los Angeles it's a crazy thing that happens— in most every other
industry, you make a couple of stabs at something and if it doesn't pan out
right away, you don't really have a trail, a reputation behind you. It's like
you're starting fresh every time, but in Hollywood, if you had one script

proposal that was turned down two places and bad coverage— coverage is what someone writes, coverage is a critique of your script— that coverage sort of lives on in infamy and comes back to haunt you. Even before computers, somehow every studio would know who had submitted what and how your script was reviewed. And in this town, if in two years you had one or two scripts turned down, I won't say you're blackballed, that would be overstating it, but really they're thinking, 'Well, this person didn't make it, let's look for the next person.' It's very tough. You hear it's tough, and you hear all the stories, but the reality is almost worse than even what you hear.

"Again, if you make it here the payoff is much greater than say for a first novel. That's why everyone takes the bus here, all the young people with stars in their eyes. I don't know about the actors, that's just a whole different ball game. But the payoff is potentially so huge— fame and fortune— that people are willing to work very hard for even more than a few years. Even when all the doors are closed and they're getting older.

"I have heard the statistic that it can take ten years to succeed as an actor or a writer or almost any other position. You have to be willing to give it ten years, at least until age thirty, if you do start young. Of course some people make it very fast, and there are people who have plugged along longer than that and still haven't done much. I think there should come a time when you look at what the universe is telling you. After so many years of fighting the good fight, and having people read your stuff, and getting reactions, if it's not happening after a long time, you should face the fact that it's not going to pan out.

"Especially these days, you hear about people changing careers and not doing one thing for twenty-five years and earning the gold watch. I think society is making it much more okay for people like me, or even people who haven't accomplished anything in the arts or whatever their field is, it's much more okay to try something else and not consider yourself a failure, but just that you're moving on in another direction."

Dammann knows middle-aged people who dream of chucking it all to achieve success in Hollywood. "I have friends, lawyers for instance, they're in their early forties, and they've read John Grisham and seen these stories about lawyers and doctors, and they want to write for 'ER' or to make major motion pictures based on their law experience. The truth is, to start at forty, I would never say it's impossible, but you just can't encourage people to do it. You walk in the room and you're twenty years older than the person on the other side of the desk, with no credits and no experience in the medium, and no one is going to take a chance on you. That's just the way it is."

The whole issue of ageism in Hollywood has been spotlighted recently in the media, particularly as it pertains to discrimination against older actors,

and even more particularly against female actors. Dammann described her own experiences with the youth culture that pervades her hometown. "I'm about age fifty, so I consider myself a little beyond mid-professional career right now. As a writer in Hollywood ageism is very real, very troubling. Of course, if you're an actress, anything over thirty begins to be a problem. As a writer or producer you'd think that since you're behind the scenes age would not be an issue, but in fact it is. So I'd have to say that I was probably at my prime as a writer in screen, television, and radio ten years ago. Even though I've worked more in the last ten years, I think I was perceived more as at the top of my game ten years ago.

"It's not the female thing as much. Women are really making wonderful inroads in Hollywood. I belong to Women in Film, a very large group; I think we have over 1,000 members. It started twenty-five years ago. Twenty-five years ago we needed an organization called Women in Film, because there *weren't* any women in film. But I've just been made aware recently at our big annual awards lunch that women have invaded every area of Hollywood, including all the technical areas. It doesn't change the fact though that no matter where you are in the scheme, after a certain age, things start to slow down.

"Many of my friends are my age, and we are all starting to look at the fact that when we walk into a pitch meeting now, most of the people listening to us, the Disney people or the other executives, are in their twenties.

"A gimmick that some people are using in Hollywood now is to take a bright, attractive young person with them into a pitch meeting and present themselves as partners. All the eye contact is with the kid, they expect him to do all the talking, but if they get a deal, it's their deal. In fact, in reality, it's the older writer's deal. These are the lengths that people are going to; it's kind of desperation time for some people.

"It is risky behavior to do this; you could really close a door. So you'd have to take someone who is somehow attached to the industry, who has some idea, a bright young person, who truly does have aspirations for writing. It'd have to be a savvy enough person so that if a producer points to him and asks, 'What would plot point B be?' he could answer and respond and really engage in the pitch session. So I think it'd be foolish just to bring any handsome young person. I don't want to whine, but it's a sad situation.

"In Hollywood, longevity doesn't work. I know writers a little older than I am who are knocking fifteen years of credits off their résumés, impressive credits, like 'Hallmark Hall of Fame,' very important credits that are just too old for anyone to respect. The *Journal* is the magazine of the Writer's Guild of America, a very good magazine— it used to be called that, now it's called *Written By*. There was something in there recently written by the Ageism Committee of the Writer's Guild. I have not yet joined. Some of us are reluctant to join it, because that alone is admitting that it's a concern. There

was something about a very established writer, not Larry Gelbart, but someone like him with unbelievable credits who walked into a pitch meeting, and the young producer said something like 'I could smell the decay.' I don't want to dwell on that though, because I feel I've been very lucky to have the career I've had, and I'm still going strong, and I feel the secret is to explore new avenues all the time."

To those outside the insular world of Hollywood, it is astonishing that young people have so much power while the legends in filmmaking are shunted aside. Dammann explained who has entrée into the entertainment business and what in the marketplace supports this phenomenon. "What's happening in Hollywood right now is that the Ivy League is just the cat's meow. Anyone who comes out here at age twenty-one with a Harvard, Penn, Brown, or other Ivy League degree, they can get an interview anywhere, Disney, Paramount, Twentieth Century Fox, Universal. All the TV stations, they're all just drooling over these kids with their Eastern degrees. That happens to be the hot ticket right now. They're getting writing and producing deals right out of college. In the past you had a lot of nepotism, sons and daughters of producers and directors, production people, and studio executives getting jobs. Their kids got a good crack at it, and they gave them good jobs.

"Quentin Tarantino was the hero of the moment. He's almost a has-been. Now it's Matt Damon and Ben Affleck. It's the flavor of the month and fifteen minutes of fame. Of course this is such an impatient society, in which things move so fast— the TV, remote control, and all that. It's hard to think back five years, let alone to all the people that came before who we should revere. It's sad, but that's how it is. I'll tell you what it is, it's the bottom line economically. The audience out there is eighteen- to around twenty-five-year-old males. So if I walk into a pitch session, I just don't look like a person who is going to write the next movie that's going to bring those guys into the theater."

It is very important to Dammann to be a mentor to the next generation of scriptwriters. When she joined the then fledgling organization Women in Film, she was able to arrange interviews and have doors opened just by saying that she was a member. She did find though that women aren't quite as willing as are men to help other women. Dammann believes that this is because women still perceive that the opportunities are somewhat limited, and that there's a little more competition among women.

She is listed in the alumni files of the University of Rochester as someone who is willing to help aspiring graduates coming to Southern California. Dammann said, "I get several calls a year. I'm mentoring someone right now, a very sharp young woman, I think she'll do very well, she's

very smart, very driven, and doing all the right things. On the other hand, someone else came out here, and after two weeks was feeling disheartened and called her mother on the phone. Her mother said, 'Come home,' and she did. What on earth did she have in mind? It's just laughable.

"But I do try to do everything I can to introduce young people around and help them find agents, and meet with them. I really feel now that at my age part of my job is to mentor others, and many people out here feel as I do. There's a lot of positive stuff happening out here."

To renew herself and find inspiration, Dammann visits artists' colonies, where she said, "You really do meet people from the whole cross-section of ages and disciplines and experiences. I find it very uplifting. It helps put things in perspective too, because there's always someone there having a tougher time than I am."

She had the opportunity to visit Hedgebrook twice and Ragdale once. Hedgebrook is a colony for women writers located near Seattle that is run by a wealthy philanthropist. It accommodates only six writers at a time, and each has her own cottage. During her stay at Ragdale, in Lake Forest, Illinois, Dammann roomed down the hall from Jacquelyn Mitchard, who had recently had her novel *The Deep End of the Ocean* selected as the first novel in Oprah Winfrey's Book Club. Later it went on to be produced as a major motion picture starring Michelle Pfeiffer and Kevin Kline. Dammann said, "Earlier, while she was a Ragdale Fellow she got that deal and wrote about two-thirds of that book during two or three stays at Ragdale. She's a delightful, funny woman. And while I was there, it was like Jackie was the queen, she had the big suite. Although the Ragdale administrators are so wonderful, they treat us all equally. But among the artists there was this reverence for her.

"What's interesting for me is that I have always been the only screenwriter each time I've gone. There haven't been other people writing for television or film. There's always the possibility that any good novel could become a movie. When I met the author of the memoir I'm working on now at Hedgebrook, we didn't talk about it then, but six years later we got in touch with each other about collaborating on her book. That can always happen. The people I talk to at the colonies, there is the thought that something can happen down the line. I'm always looking for the next great idea."

During the last few years, a few intriguing projects have come Dammann's way. She gave an overview of them, as well as where she finds herself at this point in her career. "As I mentioned, I'm doing a memoir about Mae West now, which is the most fun and exciting thing I've worked

on in years. It's a man's story, and I've been hired to write it for him. Every time we meet, I can't wait to hear the stories. I just love his enthusiasm for the project. I must say that at this moment I'm enjoying adapting or writing someone else's memoirs as much as I've enjoyed anything. I think it's because Mae West was such a hoot, such an original.

"If this nonfiction works out, I could hire myself out as an author who helps people write memoirs. I know another author who is making a fabulous career as a co-author. In fact, I took her course a few years ago at UCLA, and she inspired me to say yes when this man came to me proposing I co-author this. So I think I could be a hired hand more in the next ten years.

"I don't know that I'll ever have a feature film produced; I think it might be getting a little late for that. But maybe my kid will. He's asked me to look over some scripts and give him some pointers, I'm kind of helping the next generation. I think there will be more of that in the next ten years too.

"I have relied a great deal on God's guidance through all of this. Whenever I feel that the holy spirit within me is going in the wrong direction or perhaps that I'm not seeing the results of my hard work and efforts, I realize it's maybe because that's not where I need to be going. I would suggest to anyone who is an artist of any kind that you are a person who needs to be in tune with your holy spirit, which is to me where the creativity comes from, whether it's what I may call God-given or what others may say is just that which comes from the holiest part of what's inside them."

14

Hanging in There:
Kimmika L. H. Williams-Witherspoon

*Kimmika L. H. Williams-Witherspoon is a poet, playwright, and perform-
ance artist who has written six books of poetry and fourteen plays. Her latest
play,* **Dog Days: The Legend of O.V. Catto,** *was presented in Philadelphia.
In 1996, Williams-Witherspoon was the Lila Wallace Creative Arts Fellow at
the American Antiquarian Society in Worcester, Massachusetts. The Pew
Memorial Trust awarded her a Pew Fellowship in the Arts in 2000.*

When Kimmika L. H. Williams-Witherspoon was a child, she would come
bounding down the stairs in the morning and find her mother in the
kitchen cooking, or cleaning greens, or canning fruit and reciting poetry to
herself from memory, the poetry of the greats— Paul Laurence Dunbar,
Claude McKay, Gwendolyn Brooks.

Today Williams-Witherspoon is an adjunct professor in the theater de-
partment and a faculty fellow in the anthropology department at Temple
University, in Philadelphia. She is also a performance poet, playwright, and
journalist. But much of Williams-Witherspoon's love of language, narrative,
and movement she attributes to those early childhood years.

As she related, "I've been writing all my life. I was raised in a Pentecostal
family and we weren't allowed to go outside to play, so books became my
friends. I read a lot, and I've always written poetry. I fell in love with it be-
cause of my mother, who was a product of the segregated South. She was
born and educated in Ft. Lauderdale, Florida. She could recite poetry be-
cause when she was growing up recitation from memory was a very impor-
tant part of learning.

"My mother was very religious, and in the church she was the per-
son who was always asked to do special presentations for special events,

Women's Day and those kinds of things. She would write what were in essence performance pieces, based on the Bible or a theme that she wanted to highlight. And she'd take them on a biblical walk through various verses in a structured way, and people would sit back in awe of her.

"I liked the way she could use the word and make people come alive. I started writing. My writing wasn't necessarily religious in nature. When I first started at eight years old, the stuff was really immature. The older I got the more sophisticated the ideas I was trying to communicate became. But they still stayed flowery, about love, romance, education.

"When I went away to undergraduate school at Howard University, in Washington, D.C., it was kind of a culture shock because I went to Girl's High in Philly, which was then a very good school, and it was predominantly white. Then to go away to an all black university, it was very strange and very wonderful at the same time. My poetry began to change; I started writing about black popular culture, and what was happening in my community, and racism."

Two weeks after she graduated from college in 1980, Williams-Witherspoon eloped with a man she hardly knew and wound up living in eastern Texas. There she experienced an even greater culture shock, as the society she found herself in was particularly racist. She said, "I graduated at the top of my class with a bachelor's degree in journalism. Then when I went to look for a job people would say, 'Howard, well isn't that a Negro school?'

"My poetry then started to become more revolutionary and radical. I couldn't find a gig, and I looked all over Texas. I got offered jobs in retail, but I figured that my parents hadn't paid all that money, and I hadn't done all that work, to work behind a counter. One day I saw an ad for the director of a play at a black theater company, and I applied, and I got the job.

"The play had seventeen cast members. It was called *Where Were You in '65?* I made my directing debut, I ended up acting in it, and at the last minute one of the actors got sick, and I wound up singing one of the lead songs. It was a tremendous success, it sold out for the entire run.

"I was bit by the theater bug then and I started writing plays. I was also having a hell of a time being married, so I ran back to Philly on a one-way Trailways bus ticket with a six-month-old baby. In Philly I started going to places where there was poetry, particularly at London, a bar that had a thriving poetry scene. The Painted Bride, a community art center, had a big series, and the club Bacchanal had poetry readings on Monday nights. I got to hang out with writers, poets, novelists, and painters, and I read poetry there. Someone would be putting together a reading in the neighborhood and would call and ask if I wanted to come down. People started paying me for that."

In addition, Williams-Witherspoon became a columnist at the *Philadel-*

phia Tribune, an African American daily newspaper, and a creative writer in the rehabilitative program run by the Pennsylvania Prison Society at the Women's Detention Center. For five years she ran workshops in poetry, prose, and playwriting there.

"The hard part about being an artist in Philly is that there are so many artists that the competition is steep for money and funding. Especially since Jesse Helms, much of the funding has dried up. I was always very fortunate though, because of my degree in journalism, I was always freelancing. Because I wrote for the *Tribune,* one thing would lead to another. I've also written for the *Philadelphia Daily News* as a freelancer. I was the arts reporter for the radio station WXPN for two years. I worked for the U.S. Park Service. Just about any place that required any modicum of performance skills has sought me out."

All of her jobs have made an impact on Williams-Witherspoon and her art. She described her experience with one of the students in the women's correctional facility. "One of the students that I used to teach at the detention center was a repeat offender. She'd been in and out three or four times. Then she took my class. When she came in she was very hard and abrasive and carried herself like a man. At a certain point she softened for me. She said she really liked writing but she didn't know why. I said it's therapy. I tell lots of stories of things that happened to me in my poetry. They'd say, 'Did that really happen?' I made it okay for her to put her life in poetic form. The last time she got out she said she was not coming back anymore. She said she was going down South to stay with her great-grandmother. About three years later I received a letter from her and enclosed in it was one of her poems. It was fierce, it was so good; I was dumbstruck. In her letter she said she was working and trying to get herself together."

Another incident in the prison had a more hair-raising and dramatic effect on Williams-Witherspoon. In the last year she was doing work in the prisons, she and one of her classes wrote a play together called *A Day in the Life.* John Allen, founder of the Freedom Theatre, a theater in North Philadelphia dedicated to producing and performing the work of African American playwrights, agreed to direct the play. They hired Monette Sudler, a well-known jazz musician, to participate in its production.

Williams-Witherspoon described what transpired. "We did it at our facility, the Women's Detention Center, and then we took it around to Holmesburg [a maximum-security men's prison in Philadelphia that has since been closed] and then to a temporary facility, which also housed some inmates who had terms of six to ten years.

"Some of these men hadn't seen women in a long time. I had thirty women in the cast and crew. They sent us down to the combination auditorium and gym. They sent 200 inmates down with four guards. One of my

students got up to go to the ladies' room. It was just her jiggling as she walked from one side of the room to the other that excited this very strange energy. Before I knew it, there was a riot. Everyone was taken aback. It started out as cat calls, then woof-woof, then people got up and chairs were being overturned. And the women were very intimidated. All I can remember doing was grabbing the microphone from Monette Sudler and directing traffic, yelling, 'Put that woman down! What are you doing?' It was so strange. It was only a few minutes, but it seemed like a long time living through it. More guards came down, this time with sticks, and the men were herded over to one side and the women were huddled in a corner. That was the end of the program, and that was the end of my job. They canceled that portion of the rehabilitation program.

"I couldn't get over what a simple motion could do. I liked the idea that a gesture, a movement, could do so much. I started to work more with movement in my own performance work, so that the poetry went beyond just recitation and became a combination of theater and poetry."

Some of the other jobs that Williams-Witherspoon has held also taught her valuable lessons that she was able to employ in her performances. When she was a park ranger for the U.S. Park Service at Independence National Park in Philadelphia, she tried to interpret history at the Liberty Bell, the Bishop William White House, the Dolly Madison House, and the Second Bank in such a way as to make it dramatic and accessible at the same time.

"I would make history come to life," she said. "I did sort of miniature performance pieces every day. It honed those skills. Tourists came from all over the world— every seven minutes there was a new group at the Liberty Bell. I realized there was something to this when I had 150 kindergarten kids at the Liberty Bell who were literally enthralled, so that no one wanted to leave when the talk was over. It takes a lot of energy. It was draining, but fun.

"I do a lot of work in the schools even now, despite my responsibilities at Temple. They're always throwing me into different classes. I have a grand time. I've done an artist-in-residence at the Painted Bride, I've done neighborhood arts residencies. I've been an instructor with the Playwrights Festival for eight years. I regularly go in to do performances with the Delaware County Literature Board; I go in through the library system.

"The reactions from the audience feed my creativity. One of the things you learn is that there are universals. A lot of people, especially with multiculturalism, would like to believe that art is and should be culture specific. But because I've performed in front of such diverse audiences, I've

learned that there are some universals. Comedy is a universal. No matter what the language barrier. And there have been times I had a group of German tourists in front of me who had no idea what I was saying at the Liberty Bell, but because I was flailing my arms and using my facial expressions, they were weeping with the other tourists who were weeping because they understood the story about freedom and liberty. But they were weeping because they saw me acting it out.

"Those kinds of things I learn and incorporate in my work, so that when I'm writing a play now, I know what's going to get the audience to empathize with a particular character. Or I know if a line is going to work because it's funny or because of the gesture that goes with it to make it funny. In that regard it has helped me as a performer and a writer."

For Williams-Witherspoon the affirmation of herself as an artist and the impetus that propels her writing and performing is the connection she has with the audience. The idea that her art can touch others— move, entertain, enlighten, cheer them— is her inspiration. She said, "When I first started in Texas, I would just say that someday I hoped to be a poet, a writer. I wouldn't claim it as something that I was. Until I went to a reading for Nikki Giovanni, and she was running late from the airport. It was standing room only, and the audience was getting a little antsy. The people who ran the bookstore had taken my first chapbook. I was sitting up front, and they asked me if I could do something, read something to keep people from leaving until Nikki Giovanni got there. It was my blessing that I had memorized a lot of my poetry. I got up and did several pieces. Then I saw that Giovanni had come in, and I said that our guest had arrived and that I was going to close out. The audience said, no, do one more. It was at that moment that I realized that I was a writer, a poet. It's the affirmation from the audience that keeps me going, keeps me trying.

"Every art brings people together. Even the anti-graffiti network mural art here in the city. I watch people go by and look at it, and even if just for a moment, their guard is down. They can open their hearts to a new experience.

"I did a performance years ago at a women's conference. There were 5,000 women milling around at the Bourse [a large, cavernous building in Philadelphia whose interior space is bordered by shops and eateries]. I ended my part with a poem called "Don't Call Me a Bitch." The Bourse echoes horribly. So I had to use my performance skills to keep it from getting lost in that huge space. When I came down off the podium, a little old Jewish lady was standing near the steps. She touched my hand. She said, 'Forty-five years ago Stanley called me that once. And I told him if he ever called me that again I was going to hit him with a frying pan. And he

never called me that again.' I was afraid at first, being that I was one of the few African Americans there, that I might offend some people. But she let me know that it was okay.

"I've had little kids follow me around. I might have done something in their school when they were little, and seven years later they see me again, and they can tell me all of my poetry. It's been a very good sixteen years since I first decided this is what I was going to do."

Still, it has not been easy economically for Williams-Witherspoon to do her art. She explained, "I never had health insurance except when I worked at WXPN. Even at the *Philadelphia Tribune*. When I worked there, even though I was a columnist, because of their union, they could only have so many people full-time. They paid me six cents a word. I was considered part time. I had to be very crafty to make that article long enough to pay the electric bill. At the time my children were young, so I was staying home with them during the day and writing at night. I'd have to get them up and on public transportation to get my articles in by the 9 AM deadline.

"That was why I wanted to go back to school. I had done all that I had done and people still weren't taking me seriously enough. I say that because with the kind of money I was getting, I realized that I needed more credentials. After I got the MFA in theater, I was very angry because I had done the same amount of work for the MFA as my friends were doing for a Ph.D. So I realized I had to go again. In anthropology they wouldn't accept my MFA in order to go for my master's in anthropology, so I had to literally redo the whole program. So when it's all over with, I'll have like nine degrees.

"Being a faculty fellow I don't have to pay them; they pay me. Usually they don't allow faculty fellows to work outside the department, but I was adamant that I was not going to stop being an artist to become an anthropologist. I would be an anthropologist who is also an artist. So they let me do both. People are beginning to take me seriously now."

For any artist there are many obstacles to achieving success, both financially and creatively. Williams-Witherspoon believes she had additional ones with which to contend. "Some people make it the first time out the door. They write the first novel at eighteen, and they're set for life because they don't have to work as hard to knock the doors down for the rest of their lives. For minorities in general it's a lot harder, particularly in the African American community. You can probably name three African American male poets or playwrights, but I dare you to name three females. The reason this is a reality is that as African Americans we're tokens in the publishing industry. But as a female, you're a token to the second power.

It's a hard fight. I've made the fight even harder because I've insisted on being many things at the same time, so that I'm knocking on all the doors as a playwright, a poet, a short story writer, a scholar, and an anthropologist.

"I was always a very emotional child; I'm probably the only person who cried at the *Wizard of Oz* when she was sixteen. The rejection letters early on were very traumatic, extremely, but I had to callous my heart to keep going and send my work out to someone else. I think with me it's arrogance. I'm so pissed off that I was rejected that I have to send it off to someone else.

"In this country we African Americans have been allowed to be entertainers, but we have not been allowed to contribute to the canon. Other people can write about our culture, but we're not supposed to. I don't think it's simply the subject matter, because Walt Whitman wrote about controversial things in his day, but because he had the right shade of skin and was the right gender, he could. Mark Twain talks about racism and those kinds of issues but from a different perspective. So it's not that we can't talk about those issues, but it's who is doing the talking. In this country the gatekeepers would like to make us believe that African Americans don't read. That is not true. Just as one small example, the romance novels' market has skyrocketed since African American novelists started being published, and the publishers realized that we've been buying the books all along. So you're fighting misconceptions, you're fighting racism, and then someone asked me once whether I could write less controversially. I told him that there are two kinds of writing, writing to pay the bills and writing from the heart.

"I wrote information for a video production company once. I tell people the worst experience in the world is when I wrote a commercial for the smokeless cigarette. I feel really bad that they sold that thing for $69.99 and that it sold because I wrote it. But in reality, $1,700 is $1,700— it pays the bills. That's something entirely different than *Dog Days: The Legend of O. V. Catto*, which was my thesis piece that was performed on the stage. That was something from the heart. That was about this man who no one else seemed to know about, who no one else seemed to remember or want to remember. It doesn't mean that I can't do both. I'm smart enough to know that I have to do both.

"I'm also dumb enough or arrogant enough to know that I'm going to write the stuff that touches my soul regardless of how difficult it's going to be. On some level I guess I wish I could write some of the froufrou stuff and sell it as a screenplay. But knowing the kind of person I am, it probably still would not be what they wanted.

"Even when I write a love story now, it's so revolutionary; I just can't

get away from it. That goes toward something that I tell my students at Temple. The reason that this is is because I am always black first and then female. A lot of artists don't have that challenge. They can walk into a room and say, 'Hi, I'm a musician, or I'm a visual artist, or a graphic artist,' and they will be allowed to rise or fall depending upon their constitution. But when I walk into a room, right away you see two things— that I'm black and that I'm female. My art comes far down on the totem pole.

"I have crystals in my hair, so I stand out even more. I'm a Capricorn, I've always collected stones. The good thing about combining art and scholarship is that no matter how flamboyant you may become, if you have the credentials, people will respect you and your art."

Generally, Williams-Witherspoon believes that the arts are in a sorry state. "In poetry ten years ago there were far more opportunities. Here in Philly, the American Poetry Center was here ten years ago, and there were clubs like the Bacchanal, London, the North Star Bar, which paid artists to come in. Now people are squeamish about speaking out for gay rights, or pro choice, or international politics. There were all those kinds of issues, and at a lot of those gatherings, they perceived it as important to have some element of the spoken word. These days, because so much of the political maneuvering of many organizations is done via the Web, the need to come together in rallies and groups has lessened. That then cuts down on the number of places where people can go to either hear readers or to read themselves.

"Then with the funding, we all know how devastating it has been on the grass-roots level because the National Endowment for the Arts couldn't keep itself together under the barrage of Jesse Helms. That's been a blow. Poetry magazines have failed, poetry journals have closed, poetry competitions have had to go by the wayside. The publishing industry is slackening on poetry because, again, they figure in froufrou writing.

"In theater there are opportunities, in Philly at least. There are some theaters that have come up in the last ten years that are trying to get multicultural dollars, so they're reaching out to a larger community, a larger audience of artists, for the work. Ten years ago that didn't exist, you just had the large established theaters. Now you have the Arden, Hedgerow, Bushfire, Freedom Theatre. So it's gotten somewhat better, but it's also gotten somewhat more limited. Nationally, more and more African American theater companies have had to fold because they don't get the money anymore, because larger theater companies can get the money under the auspices of multiculturalism.

"It's the same thing as with affirmative action. Whenever the powers that be think that they're doing something to right the wrong, someone will

find a way to circumvent them. So now they don't have to pay one of the smaller theaters because they were at least reaching the African American community, because now people can go to another larger theater to see a multicultural piece. It may just be one piece per season, but it's there. *Bring in the Noise, Bring in the Funk* is a tremendous piece of theater. It costs a great deal to produce it, but because people will pay $50 a seat at the Merriam Theater, they're not going to a neighborhood theater for $5, because now they can go to 'real' theater.

"For me, as a performer, because of the school system, there will always be work. Because they cut out all the arts funding for the public schools and don't have the arts as part of the regular program, they can only afford to bring people in periodically throughout the year. Therefore, they're employing many local artists. It must be very difficult for people who are just starting out, because they tend to call the ones who have a reputation."

The importance of "hanging in there" is stressed by Williams-Witherspoon. The ability to continue creating, to get back up after a fall, is what she believes is as important to an artist as the craft itself. "Artists are resilient," she said. "We find ways of doing the art. I tell my students how I ate black-eyed peas far more than I would ever want to now, because I was too poor to eat anything else, but I was doing what I loved.

"You feel bad for your students because you know the statistics. Even though you might have made it, or somewhat made it, there are another ten people who didn't or who won't. The other side of it is that you're still hoping that you're an example of hope and inspiration for those students because you made it. So they may make it too.

"I think the tenacity is the most important thing. The talent is going to come. If you keep working at something long enough, you're going to eventually learn it. That's why for playwrights it's spelled 'wright,' because you become skilled at that craft if you keep working at it. The thing that gets you over is if you live long enough, if you're healthy. Then longevity is going to help you, because eventually people are going to say, that person's been around a long time and she's been writing, my God let's give her a grant, let's give her a MacArthur Fellowship, let's give her a Guggenheim. And that's how it works. It's the artists who believe that they have to take part in a lot of risky behavior, to take drugs or alcohol or engage in promiscuous living in order to do their art who are not going to make it, or make it posthumously, because they won't live long enough. If you have to smoke to do your art, you're probably going to die before anybody knows you're around. If you have a healthy lifestyle, if you hang in there long enough, you'll probably succeed. Look at Sonia Sanchez, Maya Angelou, Alice Walker. These women have been in the forefront for thirty to forty years.

Sure they're getting the prizes and grants; they've earned it. And that's how it works in this country. The older you get the wiser they assume you are. And they'll give you the money."

"For those of us in our thirties or forties, or for younger writers, I just say you have to live right. You have to work at your craft, whatever it may be. You have to be smart at it. I've lived off of my art for ten years, but it's been hard. It meant that I had to stay up until four in the morning to do those three articles so I'd have them in by 9 AM, so that I could get paid by Friday to pay the bills. So for the younger artists who are coming up, if they're smart at it, they should make short-term goals and long-term goals to work toward, and after they achieve each goal, they should say, 'Yes I did it,' and keep going toward the next goal and the next and the next, until they eventually make it. It's just hanging in there.

"When *Dog Days* went up, that was the fourteenth play of mine to be performed. Right after that I had a stage reading of another play. My seventh book of poetry should be out by the end of the year. You just keep trying, and eventually they'll find you.

"I enjoy teaching the college students. What worries me is that so many students are coming through the school system, and they haven't done anything, and they think they've made it, and that they've got it. When they have me as an instructor and I'm talking about everything from the way they eat to the way they dress and how they wear their hair and how it all has an impact on their art, their minds are boggled, and they say, 'I never thought of that.' And I'm thinking to myself, 'There's so *much* you haven't thought of yet.' "

15

The Zen of Painting: Merle Spandorfer

*Merle Spandorfer is a painter and printmaker whose work is in the perma-
nent collections of such museums as the Museum of Modern Art, Metro-
politan Museum of Art, Whitney Museum of Art, and Philadelphia Art
Museum. Her art has been exhibited in more than 200 solo and group
exhibitions throughout the United States, Europe, and Asia.*

Merle Spandorfer became a professional artist at a time when it was par-
ticularly difficult for a woman in the arts. She had to balance her creative
work with raising her children and teaching. And there was also the blatant
sexism of the art world to contend with; the conflicts with family and
friends, who believed she belonged in the kitchen at the very least or the
traditional elementary school classroom at the very most; and the scorn of
some women artists who scoffed at her contention that it was possible to
raise children and also create serious art.

Making art was always an integral part of Spandorfer's life. Even as a
young child she remembers being mesmerized by painting, and she loved
tinkering and playing with crayons, paper, and paste. She cannot remember
not being literally up to her elbows creating art. Even so, in college she took
a dual major— education and art. As she explained, "I didn't want a total art
major, because I never liked people judging art and being judgmental about
it and saying that's an 'A,' that's a 'B.' I just didn't want to become an art
major where I would just do that and have people critiquing it. I was kind
of a rebel, I wanted to do it my way and follow a path of academic training
also."

After graduating from the University of Maryland in 1956, Spandorfer
taught kindergarten in Philadelphia. In those days, before children were
taught to read and write in kindergarten, the curriculum revolved around

art expression, so she loved working with her students on various projects. As was usually the case at that time, when she became pregnant, she quit her job and stayed home for several years to raise her two children.

She regrets not having gone on to get her master's degree. "In the days when I went to school, women just didn't do it," she explained. "You stayed home and had your children and your priority was with your kids. I really would have liked to have gotten my master's, because then I could have gone on and gotten a full-time teaching job in a college."

When her daughter was two years old, Spandorfer began taking classes at the Cheltenham Center for the Arts, a neighborhood art center in a Philadelphia suburb that has a fine reputation for its professional staff and juried shows. There wasn't enough room to paint in her small apartment, so she began taking an all-day painting class once a week. She said, "I was in that class for ten years. All during the years that my kids were growing up, and I was busy with them, I had one day a week, Tuesday was my day. If the kids were sick I hired a sitter, I never missed a Tuesday. That day was very precious to me, it was my time. I was in the class for ten years. When the kids got older and started going to school, I started breaking out into printmaking, and at that time I became active on the board at the art center, and I also started exhibiting."

At the age of thirty, Spandorfer made the decision to become a professional artist. "My kids were in school, and I decided I didn't want to go back to teaching on a full-time basis. I wanted to teach on a part time basis and to become a professional artist. I got a job at the art center teaching teenagers and adults part time and was painting as a full-time artist."

Because she needed to earn more money, Spandorfer took on other teaching duties in addition to her work at Cheltenham, including part time stints at Philadelphia College of Textile and Science (now Philadelphia University); Tyler, the art school at Temple University in Philadelphia; and Pratt Institute, in Brooklyn, New York. She also did workshops at a variety of institutions.

From her more limited vantage point as a part time faculty member, Spandorfer has concluded that teaching on the college level is an ideal profession for creating art and earning money. "Full-time college teaching usually entails being in the classroom or studio for fifteen hours a week plus the added committee and administrative work that is involved. But it allows for large blocks of time in which to paint, and the students' work and ideas are an exciting source of inspiration. Also, a teacher cannot keep a job in the university unless he or she is producing work, so it encourages one to continue being creative. And there is the advantage of having sabbaticals and summers off."

Spandorfer, who had her first show at the Philadelphia Art Alliance in 1963, said she has never regretted her decision to become an artist. "Some of the teachers in the school district where I was teaching are now making as much as $75,000 a year. So it was a major financial sacrifice. But it was one of the best decisions I ever made. Because I'm a professional artist now, and I don't have to wonder who I am or why I spent the best years of my life teaching full-time. I feel that I really needed that time, looking back at the evolution of my career, and I could never have done it if I was teaching on a nine-to-three or -four basis. I am amazed at my students at the art center who come at night after they've been teaching all day. I have such respect for them. I don't know where they get the energy. Also, they enrich my work because with teaching on a higher level, teaching adults, I have to go to Europe, I have to know what's going on, it keeps me from getting stale. But they don't have the time to get into shows. It's amazing that they are even able to make the art."

Spandorfer stresses that actually creating the work is only one aspect of being a professional artist. It is necessary to spend a great deal of time going to galleries to show the work, framing it, helping to design the invitation for a gallery show, preparing an artist's statement, and publicizing an exhibition. "All that goes into making a whole package. It's not just making a painting. It takes a tremendous amount of energy. You have to have a body of work completed. When I have a show, I have to spend at least five months getting all the administrative work together. Even though my gallery does a good portion of that, still there's a commitment for me to get the framing and other things done. If I had been teaching elementary school full-time, there's no way I could have done this. It would just be impossible. You have to just make choices."

Because of her own experiences, Spandorfer is adamant in her insistence that art schools should educate their students about the nuts-and-bolts reality of a career in art. "You look at the art schools, and you see that only 1 percent of those graduating become full-time artists. I feel guilty many times when I'm working with students, and I feel totally obligated to make them look at the real world. At Tyler they have a course called The Business of Art. It's very controversial. I had a big discussion with the curator of prints at the Museum of Modern Art in New York about it. She felt that it was horrendous to have a course on business at an art school. But I strongly disagree. Anyone who goes to art school must know how to write their résumé, how to get slides together, how to apply for grants. I think that it is irresponsible for an art school to graduate kids, and put them out in the world, and not give them the tools to make it as a professional artist.

"That is why many of them get out there and can't deal with it. They can't make a living; they have a starry-eyed vision that they're the greatest,

and they go to New York or they go to galleries elsewhere, and they get knocked down immediately. I also tell them they have to think of alternative ways of making a living. A jar of cadmium red paint costs about $27.00. I can use that up in two days. Now where is that money coming from? This curator I was talking to objected to the course because she felt that the students should be creating and not spending that limited time talking about business. That is dreamland. That's why a lot of kids graduate and can't hack it. They wind up becoming housepainters from nine-to-five every day, or teach in the public schools, and they have no time or energy to do their art.

"I have a friend, Hitoshi Nakazato, who was one of my teachers, and he told me that when he was teaching in Japan, if he saw that some of his students were not brilliant, he would encourage them to drop out, because it's so tough to go into the arts. You have to be really amazing, you have to have something really special. Not only to be really good at what you're doing, but you also have to have this tenacity that you're going to find a way to realistically paint and support yourself.

"If he thought some kids were mediocre and in la-la land, saying 'God will provide,' he would flunk them out of school just to get them on another track. You do feel guilty as a teacher. I feel very guilty encouraging kids to go into the field of art unless I paint the picture very realistically."

Spandorfer's choice of a life in art did not occur in isolation. When she announced her decision to teach teenagers and adults part time and not return to a much better paying job in the public school system, her husband was mystified and not very pleased. "My husband was very upset about that decision. He didn't understand it and didn't know where I would go with a career in painting, and of course, you don't think you can make a living at it. But at the same time, you don't even think about it, it's just something you have to do."

Making a decision to pursue a career in art at a time when the Women's Movement was just gaining strength meant that Spandorfer had to contend with many negative opinions and criticisms that would not be encountered by a young woman wishing to be a painter today. The admonishing words came both from women whose lives were centered around art and women who viewed the art of homemaking and child rearing as the only viable one.

"It was tough," she said. "It was very hairy for awhile because in my lifetime I've been through the sexual revolution and women's liberation, and it was a very stormy and rough time. When I got married, most of my friends stayed home. After they had children they didn't go to work. I got a lot of flak from some of my friends years ago about wanting to be a professional artist. I remember having an argument with one of my friends who

disapproved of the time I was taking away from my husband to prepare for a show. She asked me what was more important, my marriage or my career? I said if I had to choose between the two I'd have to choose my painting, because that's my life force and that's what keeps me alive. If my husband couldn't understand this I wouldn't be able to have a marriage. Most of my friends were not artists and I started gravitating to a whole different group of friends. It was hard for my friends who were not artists to understand what I was doing."

Today, some thirty years later, Spandorfer is married to the same man. He is her biggest supporter, beaming with pride and respect when she has an opening in a gallery. Many of those artist friends she discovered at the beginning of her career are still her closest friends and colleagues. But in the beginning she also encountered virulent criticism and discouragement from established women artists.

Spandorfer reminisced, "The acclaimed artist Grace Hartigan, who was one of my teachers, thought it really was impossible to have a family and to be a first-rate artist. She heavily challenged me on this. She came to critique a group of us who were advanced students at the art center. She told us that we were wasting our time, that we should all just be better in bed with our husbands and better cooks, because we couldn't have a family and be happily married and also be artists.

"I think that was the thing that triggered me. I was so angry and so challenged that I took that challenge. For anyone to tell another person that you shouldn't do something— I think in a twisted way she was a big force in my life. I was also heavily challenged by a high-power New York agent who told me if I really wanted to make it big time, I'd have to move to New York. He said that the artists who've made it big time and become famous are in New York— networking there, meeting people— because the capital of the art world is in New York. I think that's basically true.

"I think there was a point in my career that if I had not had a family and had lived in New York, I would have made tremendously big strides as far as an international reputation. As it was, I made a sacrifice. But, when I decided to become a professional artist at the age of thirty, I had two kids and a marriage. I was twenty-four when I had my first child. So when I was at an age when my kids were filling my life, I decided to become a professional artist. But, the truth is, if I had been in New York and wasn't married and didn't have children, I think I would have been miserable.

"I am happy that I achieved what I've achieved. The happiness I've gotten from my kids and grandchildren cannot compare with becoming a multimillionaire superstar in the art world. There's nothing about that that thrills me. And as it turns out I've gotten into forty museum collections, I've exhibited all over the world, the Baltimore Museum just acquired five pieces this year. I'm where I'd like to be. I'm not famous in the sense that

Elizabeth Murray or Kiki Smith is famous, but I feel that in my lifetime I'm
happy with what I've achieved.

"I think that having children and a family actually enhanced my work as
an artist. I've been looking back at the thirty-five years that I've been at this.
I can't believe some of the things I did. I can't believe that when my kids
were little and in the house that I had a show in New York and did hun-
dreds and hundreds of silk screens. I just found time to do it, and I don't
think my kids held me back at all. I really don't. I think what holds you back
is if you lack the focus that you want to do it. I think you can have it all, but
it depends how much energy you want to put into your career.

"Today most women who have children do have a career. And they're
working nine-to-five every day and coming home and fixing dinner. For
many years, I was a full-time mom home with my kids. I was painting
downstairs while they were napping. I was able to do that in the house. I
didn't get my own studio outside of the house until my kids were in college.
I had the best of both worlds."

The art world was a very sexist environment when Spandorfer was
starting out and making the rounds of the New York galleries to show her
work. "It was somewhat insane, going to New York and having to deal with
the insanity of being a woman and being treated like a sex object by some
of the gallery dealers. If some of the things that were said to me then were
said now, I would have lawyers working on a lot of cases. I would be suing
all over the place. This one gallery owner who is now deceased, I had on
this dress, and there was a designer's signature across the breast, and he
took his finger and ran it across the signature and said, 'Oh, I wouldn't
think that someone who looked like you would be doing work like this.' I
wanted to smack him across the face, but women were talked to like this,
women were treated like this. I thought to myself, I guess to get into the
New York scene I'm going to have to put up with a lot of ridiculous abuse.
Basically I had four different shows in New York over the years, and it
never got any better. Some of the attitudes were just horrendous; it was so
prevalent and women just were nowhere.

"Another example— I had a show in a very respected gallery. After the
opening the gallery owner said to me, 'Look, from now on I'd like you to
wear skirts whenever you come into the gallery when you come to see me.'
I was always wearing jeans or pants; I thought he was developing some
strange new dress code. When I asked him why, he said that it would make
it easier for us to make out in the back. That's when I pulled my work out
of his gallery. I pulled my work out fast. And it had been so hard to get
that gallery. "It was very difficult for me because I was very young, and

attractive looking, and the male gallery dealers were just coming onto me like I was not serious. I had to be very firm. You didn't make a big deal out of it, but you had to be firm about what you believed. Women artists have had a hard, hard struggle. And even now— just the other day there was a survey of museum directors all over the world who were asked which painting was their most valuable, and not one chose a painting by a woman.

"I don't know what drove me. I must have been insane. Trying to find a gallery in New York is like trying to find a needle in a haystack. New York being the capital of the art world, every artist from all over the world is trying to get galleries and trying to get shows. Especially when I had young children, and I had to schlep to New York and take my slides, and get accepted and rejected. I was just determined that I was going to do it. I was so focused on getting New York recognition.

"This is why to become a professional painter and to make it, there are so many obstacles, there's so much frustration. You really have to believe in yourself and believe in what you're doing, because you'll be knocked down by so many people. And then, when you finally get the show, and finally get the gallery, and go through all the time and expense of framing, then a critic comes along and writes the big critique, and you have to be able to take that. It's rough, it's really rough.

"I have read reviews on the work of friends of mine that are so unbelievably destructive, and yet they come bouncing back. And that's what it takes, you have to have the belief in yourself that says no gallery, no critic, no sales, is what matters. You just have to believe in what you're doing. And that takes a lot of strength. It really would have been much easier to teach kindergarten, come home, relax, and be a hero to my husband. I would have made $75,000 a year. I could be retired and getting a big pension now. I guess most artists really have to be a little nuts."

There was another major experience in Spandorfer's life that had far-reaching ramifications. In 1986, she was diagnosed with breast cancer. After undergoing a lumpectomy, she began radiation treatments. At this time, she had a show of thirty-five paintings at the Science Center at Drexel University in Philadelphia. When the show was over, she collapsed from exhaustion and was hospitalized for a month with pneumonia. "When I got over the pneumonia, I had five years to look forward to seeing if I was going to die from the metastasis of the breast cancer." While continuing to paint and make prints, Spandorfer decided to write a book that she had conceived of because of her illness. She became convinced that there was a good chance that many of the art materials she had been using for decades contained poisons and carcinogens that had caused her cancer. With toxicologist Jack Snyder and writer Deborah Curtiss, she authored the text *Making Art Safely:*

Alternative Methods and Materials in Drawing, Painting, Printmaking, Graphic Design, and Photography, published by Van Nostrand Reinhold. The book includes the experiences, work habits, and nontoxic substances used by artists all over the world. She explained why she undertook such a project. "The book caused me more stress than the breast cancer. But I got centered on writing a book and giving something back to artists by helping them to use materials safely. That centered me getting through five years of breast cancer. I think that the whole art process is a centering thing."

Most artists lead a double life of the mind. One life is involved with the practical concerns of daily living and the other centers on the colors, textures, shapes, and ideas that comprise the universe. Spandorfer described how it feels to shift from one to the other. "When you're doing the art work you have to somehow magically create a lobotomy for yourself to block all the other stuff out. A few years back, when I was preparing for a show at Mangel Gallery in downtown Philadelphia, I started working on it, thinking, 'How will the work look in the gallery? Is it going to sell?' But I just had to turn that off. Because when you're thinking about that you come up with the worst crap, everything becomes commercial, and you have to turn it off like a switch. It's very tough to do that.

"I've read so many biographies of artists, just wondering how they lived through it. Each one, the best work is on the way up. As soon as they become famous and in the gallery, somehow they lose the freshness, and the intensity of the work comes down. You want the gallery, the critics, the sales. But all of that works against you too. As soon as something becomes too saleable, you worry about that. It's amazing when you have a show, the first thing that people ask is, 'Well, how did you sell?' And that should be the least barometer. It shouldn't have anything to do with sales.

"Once you start painting for the outside world, you are really into prostitution, you are really not creating from your soul, you are creating for an audience. When you start doing that you really have one foot in the grave. You really can't do that. You have to find a way to create a place for yourself that is away from anything commercial. I turn on music. I'll do a lot of paintings. I'll work on about ten things at one time. And I'll try and work up to a pitch where I lose it and lose it and lose it, until I lose myself. Because in the act of doing a lot of work, by the time I'm to the fifth one I'm working on, I'll get enraptured in the paint and in what I'm trying to think of, until I get into a state where it's pure— the state that I call the 'Zen of painting,' where you're mindless, you're not thinking, you're not involved in anything but the paint and what you're trying to express. It's almost like meditation. You have to get rid of all the chatter, get rid of all the commercial stuff, get rid of 'will they like this color or that color, this frame or that frame?' You've got to unload it before you do your best work. I mean

that's how it works for me. Maybe other artists can work in a different way, but I can't. I can't do anything for any commercial reason or for any specific person.

"With one of my shows, my dealer didn't see anything that I was doing until I completed the whole body of work. I won't allow anyone to come to my studio. I don't allow people in my studio, because I don't want to hear their opinions. I have a two-story carriage house studio that's really beautiful. I know people who would love to come or students who would like to visit. But once someone walks in and gives an opinion, says 'oh that's nice,' it jades me. So I just want to be left alone."

In much of Spandorfer's work she uses wide energetic and elegant brushstrokes that move in organic, circular motions, conjuring nature, cycles, the wholeness and integration that she has found in her life. And she sees creativity, art, personal relationships, ambition, and teaching not as aspects of her life that conflict with each other, but rather as ones that enhance one another.

She said, "I had a wonderful opportunity to be a student recently. I was in a workshop taught by Bill Daley. I decided to try something I'd never tried before and went to this ceramic workshop. Here is a man who has international fame. He is an incredible artist, and he showed slides of his career, and he started off with slides of his parents, and of his wife, and his children, and his grandchildren. He said he could never have done his art without his family and their love and support. That to me is a person I have tremendous respect for. He's an incredible artist who's done incredible work, and yet he's a good person. It was so inspiring working with him.

"When you read these biographies of Picasso and Louise Nevelson, you discover that they were rotten people. Terrible to their kids. I never quite understood why that has to be. I don't believe that if you're a creative genius you have to be a jerk. I just don't believe in that. I think that you have to be a good person to be centered, and that you have to be centered to do good artwork.

"I think that I probably had no choice but to become an artist, and I thank God I did what I did. If I hadn't, I would be a long-time resident of a mental institution, and then I'd probably be doing great outsider art. I would have more time to work. Maybe I would have been even better if I had been manic-depressive.

"Now I think I'm at my happiest period. Even being in a gallery and all that isn't so important. It's going into the studio and doing my work and reaching a certain level, and once you reach it, you know what you have to do. I mean I'm still hustling. I guess my major thrust is to get my work into museum collections. That has been a big push. Even this year, I went to the Baltimore Museum and made a presentation, and they took five pieces. So I

still feel driven. I drove in the rain to get there, and was schlepping and wrapping and unwrapping. I was thinking to myself, 'Why do I do it?' I just do it. And that's something you have to find out from a student, can she get herself focused? You're not going to be a millionaire like Julian Schnabel when you're thirty; it's a long-range plan. But then, one thing I really love about being an artist is that there *is* no retirement age. It's great for anyone who can take it seriously, who can take the good and leave out the other stuff that's immaterial."

16

The Truest Part of Oneself: Akua Lezli Hope

Akua Lezli Hope is a poet as well as a sculptor of paper and glass. Her collection of poetry Embouchure *won the Writer's Digest 1995 poetry book award. Hope's poetry is included in several literary magazines and anthologies, including* Sisterfire, Erotique Noire, *and* Confirmation. *She was the recipient of a creative writing fellowship from the National Endowment for the Arts, an Artists Fellowship from the New York Foundation for the Arts, and a Ragdale U.S.-Africa Fellowship.*

Akua Lezli Hope does not find the split life she leads as a writer and artist in the studio and an employee in the corporate office to be unique or unusual. She expressed her thoughts on this dichotomy. "I know so many creators, but there are only a rare few, maybe three, who make their living at their art. That's why whenever I meet anyone in my art context, and they ask if that's what I do for a living, I'm taken aback. Because while I like that I occupy that moment so fully that that's the only self they see, the other part of me wants to ask, 'Do you actually know someone who only writes poetry for a living; have you ever heard of that? Am I missing something?' "

What she does for a living is guide and enlighten visitors through 3,500 years of history and 30,000 glass objects at the Corning Glass Museum, in Corning, New York, where she is the senior public relations manager. As such, she is responsible for creating brochures, newsletters, sales letters, and other communications for the museum, including information about its $62 million renovation and new glass innovation center and sculpture gallery. It is a job that takes up about sixty hours of her time each week.

Not everyone whom Hope encounters can so easily accept that she can thrive in both worlds. She related one of her experiences. "Several years ago when I won an NEA grant, I got a phone call from someone in research

and development where I worked. I never knew this guy, never met him. He was totally accusatory, because he'd read that I won an NEA. He said, 'Well don't you have a job?' I said most artists have a job. I knew he called with an agenda but I disarmed him because his presumptions were so wacky. He started out with something to say, he had his back up, but I guess having a conversation with a real human being disabused him of whatever wacko, depressing messages he had received.

"The year I got it was 1990, the year that they required that you sign something [a 'decency and respect' clause], and for me that was a big, big debate. But I felt so impoverished as an artist, I didn't feel that I had the option that some people did to refuse it and to say I'm not going to sign it and I'm not going to accept it. For me it made a profound difference. So when this guy talked about the money, I said 'Well, let me tell you about some of the things I'm going to do with it. I'm going for the first time to be able to subscribe to a number of journals, and then I'm going to buy some books.' The first thing I purchased, using a credit card because I knew then that I could pay it back, was a filing cabinet. It's a wonderful filing cabinet for which I'm so grateful, because it made things so much more organized. And I was able to join a few organizations, without having to decide, the Poetry Society of America versus the Academy of American Poets versus Poet's House versus the Poetry Project at St. Mark's. I was able to join for that year and for the years since because I did try to save some money just for that, to be a member of these organizations and subscribe to these journals that I previously could have only taken out of the library.

"For this huge windfall I did all these fabulous things, fabulous for me things, but I can imagine some of his imaginings, reading some of the things in the newspapers at the time. Then he changed tactics and said that maybe since I'm employed I shouldn't get this money. I said, 'But I'm a taxpayer too and so are my parents, and they're very glad their taxes are going toward me for once.'"

Hope emphasized that she worked very hard to earn that NEA grant. She said, "For more than a decade before I won anything, there are certain grants I applied for every year because the application itself required that I edit things, organize things, formalize things. You can write and write and write and write but where were those deadlines, those signposts, those check-ins? And that's how those things functioned for me. For awhile I used to do a kind of ad hoc newsletter to about fifteen or twenty friends. I called it C Jam, which stood for creative junk mail, and I would try to bring others along. I used to tell them about deadlines and other opportunities as I would hear about things. I worked in an office, I would copy things, and mail was cheaper; I would stuff things in an envelope and send it out to people.

"I so wanted to win. There were some grants I applied for that were really hard to get and they never happened, and now I'm too old for them. The Yale Series of Younger Poets, if I had gotten that I would have been ecstatic. When I got the NEA, which came at such a wonderful affirming time; it wasn't just the money, it was also the affirmation, a milepost along the way. Two close friends, and they're well known, asked how I had done that, and I wanted to say, 'But I've been telling you to apply with me for years. If you don't apply, you don't get it.' None of the people who were on the panel were at all familiar with me, even though I had met some of them. None of them had any kind of personal acquaintance with me. That's why it was so remarkable for it to happen. But also part of it was that it had been part of my discipline from the outset, from say when I got out of college. All through grad school—I wasn't in grad school for poetry, but I thought it was still okay to try for grants. When I got it in 1990, that was after a good fifteen years of trying for the NEA grant and other things. The NEA I did annually, every so often the Guggenheim was on the list, Walt Whitman was on the list, Yale Younger was on the list, and the National Poetry Series. And the collections of poems I sent out, the names have changed, the contents have changed over the years. And I've yet to have a major publisher publish my poetry, which is sad, but I've been really well published.

"I try to do everything I can to make things happen along the way. If you don't send your stuff out, then are you a writer? There's another level that one can go to that's PR—going to the right parties, hanging out in the right places, schmoozing the right folks. That's not what I'm talking about. But packaging and presenting your work in such a way that it is received, disseminated, and shown. In the visual arts that means being included in exhibitions, and on the writing side it's being included in anthologies and magazines; that's part of being an artist."

Hope acknowledges that it is difficult to go to work and still have energy to make art, both for herself and for other artists who find themselves in the same situation. However, she thinks it counterproductive to whine about it. "Sometimes I feel frustrated, but sometimes I just say, 'Suck it up.' Sometimes I'm very empathetic and sometimes I'm not—both to myself and others. I'm not married. I have been, but I'm not now, that leaves lots of time. I'm pretty organized. Not to say I'm not messy, but I wouldn't spend any more time organizing myself than I do already. I feel that I have lots of systems for lots of things. I think that my attitude comes from my particular psychosocial and ethnic background. I'm the first born in my family in an African American–Caribbean household. My parents were second generation and I'm third generation. And part of the 'just suck it up and do it' attitude is theirs. I'm thinking, I don't have four jobs like my

grandparents or two or three jobs like my parents, I just have one job, but I also create, so that's my other job.

"There was a skit on the TV show 'In Living Color,' in which there's this West Indian who says he's got fifteen jobs; and then there's this Korean guy who's bragging, saying well that's nothing, I have twenty-five jobs— I'm the cook, the cleaner. . . . Maybe it's a burden that the next generation will relinquish, but I saw people doing all that; I can't complain."

Creating art and working in an office environment can at times create a double focus that is disconcerting and draining. At such times, Hope feels an urge to rebel. "So my art is where I rebel," she said, "where I'm going to assert a more healthy, holistic way of thinking. My art's my rebellion, my art's my reward, my art's my retribution, my art is my truer self, my better self, the self I would like to be all day long.

"At other times though it's not a split mind set. My job also has a creative component to it. My work often causes me to use some of the pieces that I use for my art. I have to figure things out, and I have to write, and I have to devise solutions. What's really wonderful is when the workplace allows me to bring some of my other self to it. So the only strain is that I'm not working on my stuff, but it's wonderful when I have those experiences so that the way that I work on my work stuff is not an alien way of being. I've come to discover that it's less about the task and much more about to whom I'm reporting. Because the task can be engaged in in a creative way; in a wonderful way; in a way that doesn't cauterize the feeling, thinking, joyful part of myself. But we all encounter the joy killers, people who can't be light about it, who have to do it in a way, or make you do it in a way, that is strained. That for me is when it gets disconcerting and strained. Because I spent time and money acquiring skills for the job that I'm doing. I have an MBA and a master's in journalism from one of the country's top schools. So I hate when my abilities are doubted.

"Sometimes I wonder if I feel frustrated because when I come to my own work I'm already spent, I've already given a lot away. Or is it like love, the more you give the more you get? Sometimes it seems like it's a limited supply and sometimes not. For me it's never been all one way or the other. I must say that I'm much better now in my forties than I was in my twenties, because now the moment I walk out the door, work falls away. When I go home I don't think about it, I usually say, 'Am I going to go home and shred some paper, blender some paper, string or design some beads, or write, or play?' Usually when I come home I drop my stuff, turn on some music, and 'moosh' the cats. When I was younger I would go home and worry about work, and make lists for it, and do some of it.

"The other thing about juggling my art and work is that I seldom get a vacation. For the past twenty years, my vacation time has almost always been used for some art I was working on, to do the art or market the art. If

I was doing a reading, I'd take a half day off to do that reading; that's my vacation time. The year I did the poetry book I'd take a long weekend to work on it, but that, again, was my vacation time. What I find is there's a lack of do-nothing time, a lack of real rest, a lack of relaxation, a lack of time to just kick back, because vacation time is when I can work on something.

"I consistently envy Europeans because if I even got four weeks. . . . I remember one year I got five weeks, and that was unbelievable. I was here long enough that one year I got two weeks bonus vacation. It was unbelievable because I generally use up three weeks of a day here and a day there to do things. If I have a reading in another part of the state, well I'm not going to be back home by the next day. I have this dream that I'll find a patron or win the lottery. But it won't be about retirement or lethargy at all. I'd have my glass studio, my paper studio; I'd get to buy a new computer."

At age forty-five, Hope has also discovered that she can make more art by simply saying no when others come knocking with demands for her time and talents. Throughout her twenties and thirties she was an active member of the Black Writers' Union, the New Renaissance Writers' Guild, the National Association of Third World Writers, as well as other organizations. She concluded, "I was involved in all these organizational formations and I will not change the person that I was, but sometimes I wish I had thought more about myself. I was so into trying to build institutions, so into 'come on guys let's get it all together, come on let's do this all together,' versus going for self.

"What I will never do again is sit in another meeting discussing bylaws. I'm not writing anymore constitutions. I served that time. No more meetings; meetings are for work and that's it. I didn't reach that point until late in life. I started thinking like that in 1992, but by 1995, it was over.

"I'm still a member of the New Renaissance Writers' Guild; and they're working on a Web page that I'm working on with them. When I moved up here from New York City I looked and looked for those kinds of organizational connections and didn't find them. There are writers around here, and I've produced events and readings for writers, but the kind of interaction I had in New York City I didn't get until 1988, now it's over a decade. I went on CompuServe and became a member of the writers' forum, which became the literary forum, which at some point split up and became the poetry forum. I've been on the Internet for over a decade, and that's where most of my sustenance as a writer came from, and I could workshop poems and even my science fiction, there's a science fiction writers' forum, and find out what people are doing, and exchange ideas, and have camaraderie. I was very much aided by some wonderful writers. People have grown up

over the years. My international e-mail is really important to my sustenance."

Hope is a bit leery of all the hoopla and "oh wow" reaction to writers' Web pages that some of her writing colleagues are displaying. "It's the Web pages that people are responding to. While I think that's a great thing, it also makes me suspicious, because it's like hey guys, writers could write long before there were Web pages. I have a Web page, so it's not that I'm averse to it. But it just seems like now there's more of the Hollywood glamour aspect to it, when people have had the ability to communicate state to state and internationally cheaply for a long time.

"Writers could have been corresponding and sharing files of their work for ten years, even though it's not the same as having pretty colors on a page. But if you're talking about people reading, the opportunity to read and to be read has been out there for a long time. In terms of human history, ten years is a drop in the bucket, but for everyone who's saying new, new, new, ten years is not a new thing."

Being involved with online organizations, Hope discovered that the e-world was taking on the same shape as the real world. She found herself attending virtual meetings, getting drawn into arguments, monitoring sites, and not creating. "We were doing bylaws and constitutions again, rules and regulations again. Monitoring so and so who used a dirty word in his poem, and I have to move it, take it out of public view. Then have this person talk about how I'm a censor, not me alone, but we, the founders and the organizers and regulators." So she removed herself as much as possible from that kind of involvement to focus on her own creative work.

Another place in which Hope found artistic sustenance and community was in the artists' colony Ragdale, outside of Chicago. "Ragdale's a residency program. The woman who created it founded this colony that artists can go to. There are two houses, and then there are studio houses on a mini-campus. We'd gather to eat dinner. But the other meals were on our own.

"Another tradition is that sometime during the day people share their work. While I was there, because of the special U.S.-African program, we had performances at the Chicago Art Institute. Some of my old college colleagues got to come and hear my latest work and tease me. I'll always treasure one of my old friends saying, 'Oh, you're still talking about that nasty stuff, huh?' People who came to see me do readings in college came to see me do readings as a grown-up in another context, with a few hundred people there versus a small coterie of friends. Instead of the old days reading in the basement when I would have been barefoot and sitting on a stool, there I was in Chicago.

"The experience at Ragdale so changed my life. It was only for three

weeks. The residency was for six weeks, but I couldn't get six weeks away from my job. However, my boss was enlightened enough that he responded to the occasion by giving me three weeks off as education leave. I had three weeks vacation coming to me at the time; I could have used it, but I wouldn't have had another day for the rest of the year. So by deeming it educational leave I could go. I was involved in a very major project at the time, but I worked up until I was going to make sure the project was in good shape, and then I left, and I did take my computer with me, so I could get e-mail and respond if necessary. But basically, I was away from the telephone and people couldn't catch me on a day-to-day basis.

"I'd never just stopped before, so that was like a little bit of heaven. And the people who were there with me were just unbelievable. There were some people who were there whom I hope I will know for the rest of my life. I couldn't believe I could learn so much and write so much and be so productive. I started a novel I had thought about, which I have yet to finish. While I was there I wrote forty pages of the novel and twenty-something poems. I'm used to getting up and going to work every day, so I got up and went to work every day, but my work was my art. I long to create that for myself again sometime, because I know how much I can get done."

Paper, poetry, and glass. Hope talked about how these three areas of creativity are evolving for her. "I've been making paper; not paper for people to write on. And I've been making glass. My first craft show I made what to me was an unbelievable amount of money, which was $500. Last year I made considerably less. I guess once people saw my glass stuff it left my paper stuff in the dust. The glass stuff was much less expensive, more accessible, and wearable. I have to think of a new strategy for next year.

"Working in glass and paper is very time consuming; it's hard to do. Writing is portable. I evolved as a writer writing on the train, etcetera. A few years ago I bought a great book on papier-mâché. I guess I had been reading and talking about paper because I use so very much; I write on it. The whole thing with papier-mâché was that there were these huge bins of shredded paper that you could just play with. All this waste product that I could use. That was very intriguing to me.

"Then the glass work— I took my first glass bead–making class in November 1996. Having seen glass, talked about, and written about glass for about eleven years, I still had never experienced it. Taking the class, I just had this great epiphany of joy in learning how to create something. Having molten gob, twirling it, it was just so delightful.

"The same weekend that I was taking the glass class my mother was taking a quilting class. We talked that Saturday and exchanged news, and she died that Sunday. I had sent her Polaroids of my papier-mâché works, some of them were sculptural, some were bowls. I look at them now and

some of them are hideous to me, I have so many different ideas about what to do, and I think much more evolved and graceful ideas about what to do, but it was just this enthusiasm. So it began in November and then my Mom died, so it became my grief work, because I couldn't write in the way I wanted to about any of it. But I now had these things I could make to express my sorrow, my longing, my joy, my memory of her. So my first show, my first paper show, was mainly about grief and recovery. But not in any formal way, because it was all called 'sky-sea' and most of the stuff was blue. I wasn't even sure I was going to continue to make them, but both the paper and glass forms have continued to evolve.

"One of the things my sister said— and she is a wonderful, skilled artisan, she does fiber and clothing, much like our mother did— is that my mother blessed me in her passing. I just say those words and I think that these art forms are my mother's blessing, her gift, that they didn't recede as the grief receded, that they've taken root, and I've blossomed with them.

"With my writing, I did publish *Embouchure*. I was waiting and waiting and waiting to have a book published. I wanted to win the Yale Younger Series, but to do that you have to never have had a book published. I knew any number of people who have had books that are self-published. There were some people who were self-published, and I'd look at the work and just want to puke. There were others where I'd look at the work and just be amazed. But for me, I just thought there was no way I was going to be so indulgent as to self-publish. That was until I was forty and could no longer apply for the Yale Younger Series. So, when I was forty I thought, 'Well you haven't convinced anybody to publish a book, maybe you should at least do a chapbook because you've got all of this work out there, but nothing collected, no marketing tool, no package of your work alone. You should have a compendium of your work.'

"Publishing the book, I decided to reuse some of the wonderful skills I acquired at work in terms of marketing, PR, and creating and packaging a book. So now I know how to do it really cheaply and fairly well. Plus, I know people to bug and nudge to check over my design, not once but twice and three times, people who for a meal or something I can get to help me out. But I understand a little bit about type and proportion. The book is not fabulous but I think it's pretty damn good. I'm not a designer but I at least know how to make things fairly presentable. I was delighted that it won the *Writer's Digest* Award, which was an affirmation that I wasn't a total idiot in doing it or just egocentric in putting it out there, as a lot of chapbooks are; they're ego enterprises that have next to nothing to do with verse or anything else. At least someone else was convinced that that wasn't the case.

"Now, I'm kind of off-track, because the money I would have spent on doing another chapbook that I want to do on women and family, I've spent

on making glass and taking glass classes, which are rather expensive. The chapbook didn't cost more than $1,500, but whatever spare cash I had I've spent on taking classes or renting time in the studio to make glass objects. I need to do more of one thing or the other so that I can make some money so that I can spend more on my art.

"I'm thinking about how I can make more money because I've got to do the book next year, the book is on the list. I had enough poems for a chapbook, but then I thought that I could say some of this better, and I have some other things to say. Now that I've done this paperwork grief work I can write about my grief for my mother. Part of me is saying to myself, 'You haven't written the best one yet, but you know it's in you.' "

17

The Need to Make Things:
Gregory Maguire

Author Gregory Maguire has written several works of fiction for both adults and children. Some of these titles include Confessions of an Ugly Stepsister; Wicked: The Life and Times of the Wicked Witch of the West, *which has been optioned by a Hollywood film production company;* The Good Liar; Five Alien Elves; Six Haunted Hairdos; Oasis; Seven Spiders Spinning; *and* Lucas Fishbone *and* The Peace and Quiet Diner, *which are both picture books. Maguire is also the co-editor of the nonfiction books* Innocence and Experience: Essays and Conversations on Children's Literature *and* Origins of Story: On Writing for Children.

When he was seventeen years old, Gregory Maguire worked part time at St. Peter's Hospital in Albany, New York. His job was to collect soiled linen from each floor and bring it down to the basement laundry. He would wait for the service elevator with his enormous cart piled high with dirty sheets, surrounded by the horrific sounds and smells of the very sick, and imagine how the shelf of his published books would someday appear. Now, at age forty-four, he can stand in his Concord, Massachusetts, study and admire just such a shelf.

Maguire's professional writing career began when he was only twenty-four, with the publication of his first novel for children by Farrar Straus. "In some ways I had some professional respectability at a young age. It wasn't a particularly respectable novel, but to be published by Farrar Straus was respectable. It was a fantasy for middle-aged kids—for ages ten to fourteen, a period I consider basically the real prime period of human receptivity. They're wonderful at that age. The El Niño of hormones hasn't fully hit, and they have all their childhood curiosity and not all the peer pressure and stuff that makes life so dreadful, basically until the age of seventy," Maguire explained.

He grew up in a lower-middle-class home that placed great emphasis on the value of literature and culture. His father was a columnist for a newspaper in Albany, New York, and his stepmother, who raised him, was a poet whose published work was well received.

In addition to Maguire, there were six other children, four of whom also became professional writers. "I'm the only creative writer among them. The others are science writers or journalists or public relations people. So you can see that my upbringing was such that I was encouraged to think of writing or being an artist as a sensible and desirable thing to do. I didn't have the struggle of dealing with troubling family prejudices against a creative life that some people do when they decide to be artists. In actual fact, though, my parents really hoped that we would grow up to be doctors and lawyers so that we wouldn't struggle like they had.

"I had a good education. I also wrote voluminously as a child because my parents were very strict and did not allow much in the way of home entertainment except library cards, scrap paper, and crayons. We were like little Brontës running around in Albany, New York, putting on plays; putting out newspapers; putting on pantomimes; and writing long sagas, and fantasies, and family trees, and chronologies. If it had been in the days of the camcorder, I'm sure we would have been making movies.

"So by the time I was graduating from college at twenty-one or twenty-two, I was sure that I wanted to be in the arts somehow— a poet, an actor, a singer, a musician, a novelist, a picture book person. I didn't know how I was going to proceed, but I realized later, in my early thirties looking back on my twenties, that at any juncture where I was trying to decide what to do next, I had always asked myself the question subconsciously, 'Is this going to be better or worse for me as an artist?' Sometimes that meant, 'Is it going to be better or worse for me as an artist to sleep with this person tonight?' 'Is it going to be better or worse to take this job, or to make this commitment, or avoid it?' It took me a while to realize that that was how I was thinking, but when I did, I realized I had been enormously consistent from about the age of five in that regard."

Maguire was not unaware, however, of the financial difficulties associated with being an artist in America. Therefore, he decided to earn a master's in children's literature at Simmons College, figuring that if he did not become successful as a writer, at least he would be able to teach something he loved and write on the side. "I wasn't an idiot about it. But I did decide to go into teaching art rather than working for Mobil Corporation, that kind of thing. I always knew where my heart was," he said.

During the last ten years Maguire has made his living through three types of work. Writing has composed the major portion of his income, particularly since he closed a Hollywood deal optioning one of his novels several years ago. Schools often hire him to speak to children about creative

writing. He is also the co-founder of a nonprofit organization, based out of his living room, called Children's Literature New England. This group organizes an annual conference on children's books that is based on a substantial theme in children's literature, such as "Swords into Ploughshares," on issues of war and peace, or "Let the Wild Rumpus Start— Play in Children's Books," which examined how authors explore the theme of play in children's books and how children learn about what play is by reading. This nonprofit organization provides him with a modest part time salary and some benefits, including health and dental insurance, and a small pension.

Although he has tried to structure his life in a way that allows him to pursue his art, Maguire readily admits that sometimes he has taken on work that was not ultimately the best use of his time or talent. He related one such example. "I met a man socially who called me up and asked if I ever do work on commission. 'I have an artist who does great drawings of animals in restaurants,' he said, 'I wonder if you could think of a story that goes with the art?' I said, 'Of course not, that's not how a true artist works, I have tons of ideas sitting here waiting for my attention.' Then I asked, 'By the way, how much would you pay?' He said, '$4,000.' And I said, 'Oh, well let me think about it.'

"I was going on vacation to Martha's Vineyard. The first day I went to the beach with a can of beer, a blanket, umbrella, pad of paper, and a pencil. In ninety minutes I wrote a rhyming story about animals in restaurants. I mailed it to him and he bought it. I thought, 'This is the way to go. Now I have discovered my ticket. I'll do a few of these a year and I'll be set.' Of course, I could never do it again. Ideas don't just come like that. It took me eight years to do something like that again. I just sold a fourteen-page text for $8,000, but I can't do it all the time, I can't count on it."

Maguire has always lived frugally. For ten years while developing his writing he supported himself by teaching literature in college. He was accepted into a doctoral program, knowing that he would need a doctorate to get tenure and that he would need tenure to remain a college professor. Maguire realized that he might have to be a college professor for forty years in order to support his writing habit. But in the end, he left the teaching job and earned the degree anyway.

Besides teaching, Maguire used to do more speaking than he does at present. In the early 1990s, the fees he earned for speaking to children amounted to about $20,000 a year and comprised half his annual income. The rest was made up of one or two advances a year plus a small salary from the nonprofit organization.

With the publication of his adult novel, even before the Hollywood deal, his income became more stable. Writers receive bigger advances for adult novels than they do for children's novels, especially if the former has the potential to be commercially successful.

The average advance for a children's novel for a new author is between $3,000 and $5,000. Only recently have Maguire's books sold enough that he could request more money and have a chance of getting it. "My books have had the advantage in the last few years of reselling into paperback, and that's one way publishers make more money and then are willing to front you more money," he said.

The adult novel that helped improve Maguire's financial situation was published in 1994, and was entitled *Wicked: The Life and Times of the Wicked Witch of the West*. It is a retelling of the story of the *Wizard of Oz* from the perspective of the witch. It begins with her birth and ends with her death and describes what Oz was like before Dorothy arrived and how the situation evolved after she landed there. Every publication that reviewed it gave it a positive review, except for the *New York Times*. John Updike admired it in the *New Yorker*, and it had a front-page review in the *Los Angeles Times* book section. The day after the *Los Angeles Times* review, fifty copies were bought in Hollywood, and Maguire was offered a movie deal the following week. Universal Studios, in conjunction with a production company owned and run by the actor Demi Moore, optioned the rights. They had a screenplay done and recently extended the option. Maguire does not know whether it will ever see the light of day, but he's not complaining, as Hollywood has largely supported his fiction writing for several years now.

In 1999, Maguire's novel *Confessions of an Ugly Stepsister* was published by HarperCollins. It is about commerce in Western culture— how we choose to sell the beauty of young women, the beauty of tulips, the beauty of art, and morality. It is a retelling of the Cinderella story from the perspective of one of the stepsisters. Currently, he is working on a new novel.

Although the Hollywood deal has made his financial situation a little easier, Maguire is still far from rich. He mused, "At this point I've been a professional writer for twenty years and have had more success than I expected. I'm still always worried about where the money's going to come from in three or four months time; and that keeps me productive, among other things. I told my agent the other day that I have several story ideas, but I just can't get the first couple of words. He said, 'I know what the first couple of words are: I'm broke.'"

But it is more than just the need for a paycheck that drives Maguire. "When I go into schools, I show kids slides of the extensive writing I did as a child. I kept it all. It's all profusely illustrated, very ordinary, very derivative. But the habit of productivity was begun in childhood and I have about 150 stories that I wrote between the ages of ten and twenty. They're obviously the work of a child. I was not a *Wunderkind*, except that I was busy. I show them all my mistakes and let them see how terribly silly much of my work was, and they laugh, and they say that I was as stupid as they are. I show these to kids and urge them to have writing as a hobby. I tell them,

don't wait until your teacher gives you an assignment. Think to yourself, if you were bored and wanted to go to the library or rent a movie, what kind of a story would you be looking for, what interests you? And then write that stuff."

As an author of children's books, Maguire has no illusions about the lack of prestige attached to such writing. "Much of the culture looks down on children in general. Many of the people who write for children are women, and many are women who are now older and who were supported by their husbands. They were able to bring in a little butter-and-egg money. Belonging to their generation and being raised as they were, they had the kind of time to pursue their writing that many people who are younger and in a tighter economic world do not now have. So a lot of my friends are women writers who perhaps now, toward the end of their lives, are making some money, but if their husbands had died and left them pensionless, and they had had children to raise, you can be sure they wouldn't have been writing children's books, unless they were enormously talented or lucky. There just isn't enough money in it to raise a family.

"There is a terrible stigma attached to writing for children. People think that something's wrong with you, that you're not as capable a writer, that you don't have the goods to write for adults, or that you're hopelessly fey. But the truth is I love the energy of children and the way they are in the world. There's a kind of light in their faces that to me is as nourishing as air and water and vitamin C and music. There's a certain something that they give you, a certain way that they approach the world, that is the only answer to existentialist despair. Even art doesn't do it as consistently, as reliably.

"The best of writers for children are among the best of writers period. Children are just as demanding readers as adults are. Children may sometimes be satisfied with the literary equivalent of junk food, but for something to work as art for children it has to be just as well done, because children won't stand for nonsense. They won't say, 'Well, I'll give this book a hundred pages to see if this postmodernist exercise will be pulled off,' and then draw their eyeglasses down their nose and say owlishly, 'Well, I don't quite think he did it.' No, if it's not working by page 2, forget it, it's not working. Children are a very hard audience.

"Issac Bashevis Singer said he wrote for children because they care about plot and character. They're not quite sure about what happens in the world yet, not so sure about cause and effect. And they read partly to learn. If I'm not yet sure about cause and effect at forty-four years old, how much more confusing it is for children."

All his life, Maguire has had a strong need to work. "I often tell the kids I go in to speak to that you have to imagine what you want, to get a clear

idea what it is. The way of courage is placing yourself in an imaginary situation and accepting yourself there.

"For example, I tell them, I'm going to picture myself on a stage in front of people, singing. I'm going to picture myself there every time. That way next Saturday night, when I'm wondering should I stay home and watch TV or go to a concert, I should go to the concert because that way I can see how people are on the stage and learn something. I didn't talk myself into writing as a kid, it was a natural function of boredom, but boredom can be very productive. I pictured myself having published a shelf full of books, even if few people ever read them. I didn't picture winning the Nobel Prize, but I did picture being productive. I had a Yankee, Calvinist, faintly Roman Catholic impulse always to work, never to be resting."

In addition to having a strong urge to be productive, Maguire has also always had an instinctive need to create. He expressed his thoughts about this drive and how it affected his life. "I sympathized with a glazed expression in my eyes with those of my friends who in their twenties and thirties and even forties felt that they hadn't done what they wanted to do in life and had had to settle for the fact that they had made wrong choices, or set their sights too high, or that fate had just intervened and not allowed them what they had hoped for.

"This always dismayed me a little bit. I don't claim to have any greater virtue of persistence than they have. I think that I *have* just been lucky, or there's been some little bit of personal biochemistry that made my need to create things just a little stronger than, say, my need to travel widely or to impress my friends by earning a high income or living a flashy life.

"I see people struggle, sometimes even have a moral struggle, about how to spend their time and their life's energy, and I feel a little guilty because I haven't had that struggle. Because I've known from the very beginning what I wanted to do, and in that way it's been easy for me. I think that's why I've been able to make a career out of it. I've never had to lie awake wondering should I do this or that, because I've known this is what I have to do.

"But I also feel very lucky, lucky to have been born into a family that did not disparage the arts. Lucky to have been born into a family that was articulate and born to parents who, though not wealthy, had set goals for themselves and met them."

On the other hand, Maguire, having had the rare opportunity to focus mainly on his art for the last thirty years, now finds himself in the reverse situation of many of his contemporaries, wondering about aspects of life that once would have seemed to be mere distractions to him. "I have been pretty happy with what I've done, and I have had just enough literary notice; I don't feel that I've been working in the field for twenty years without having been able to get recognition, which some people do. Now what I'm

asking myself is, at forty-four should I be thinking of having a family? Many people do the opposite, have their family and think about what they put aside for it. I'm asking myself, after thirty years of having art be my central focus, and not being bad at it, is it enough? Maybe I'm just working backward from everyone else. Is it time for me to adopt a child or get involved in the world in a different way? That's what I'm facing.

"My mother died giving birth to me, which was why I was raised by a stepmother. One of the reasons I've felt that I have to be productive is that I have a lot to answer for. I have to answer not only to the question, 'Did you live your life?' but also 'Did you live so fully that you also lived hers as well, because she granted her life to you?'

"That's one of the things that's kept me going, but it's also one of the questions, now that I'm in midlife, to think about even more. I think I've lived pretty well; one could always have lived more fully, one can always have regrets. But now I also think, 'Well, I also had a stepmother who put other ambitions aside to raise me. Do I have something to answer for in that regard? Should I be putting my ambitions aside for someone else?' Perhaps that is the supreme aesthetic act. I don't know the answer yet."

Note: A year after this interview, Maguire and his partner adopted a child from Cambodia.

18

Dancing from the Heart: Cheryl Pento

Dancer and choreographer Cheryl Pento has performed numerous dances with her company Bina Kachine Dance. These include **People All Kinds, She Likes to Play, Wonderland,** *and* **The Concept, Let's Dance!** *These were presented at many art centers, universities, and theaters. In 1998 she received a ChoreoLab grant to study with the director of the American Dance Festival.*

When Cheryl Pento was a child, her parents enrolled her in the neighborhood dance school. In the third year of her studies, she had become so accomplished that she was given a solo in ballet, jazz, and tap during the school's annual recital. On the ride home from the studio her father, a staunch Italian Catholic, pronounced that she was not to study dance ever again. "She's too good," he proclaimed, "and I don't think she should have the life of a dancer." She did not resume her study of dance until two decades later.

Having received a full scholarship to Temple University, in Philadelphia, Pento was discouraged by her academic advisor from studying dance and instead majored in foreign languages. She also was granted a scholarship to the University of Madrid for graduate work, but quit after a year, deciding that life as a Ph.D., rifling through index cards during lectures, was not for her.

While all this was transpiring, Pento married. At twenty-five years old she had her first child, and three years later her second daughter was born. Right after each child's birth, she took a belly dancing class, using the desire to get back into shape as an excuse. But not that long after her second daughter's birth, she announced to her family, "Okay, I've done everything you've always wanted and asked of me, now I'm going to do what I want." And she began again the study of dance that she had abandoned twenty years before.

Being drawn back to the dance would affect every aspect of Pento's life—her marriage, her development as a dancer and choreographer, and the unexpected positions she would find herself in as an artistic director and even a real estate agent.

Pento briefly related the story of her adult immersion in the dance world. "My ex-husband happened to have been a very, very wealthy man, so it made it quite easy to go to New York and take dance classes. My mom would watch the kids. My husband tolerated it in the beginning because he thought it was just a hobby. A girlfriend of mine and I would stay in a rather inexpensive motel, usually for a week every two months, and take dance classes from 8:00 in the morning until 5:00 at night, get something in a restaurant, go home and crash, and the next day do the same thing.

"Then I heard about Gary Flannery coming back from dancing with Shirley MacLaine on Broadway and opening up a studio in Langhorne, which is not too far from my house. I went and took some classes from him. During this whole time I got divorced, because as it became evident to my husband that this wasn't a hobby, that this was something I was going to do, he couldn't accept it.

"In fact, we lived in Buckingham on ten acres on the side of a mountain, which is a very elaborate place to live, and I had a dance studio in my house, and some of my friends would come over and we would dance, and he couldn't even stand that sometimes. Then when I started performing with the Gary Flannery Dance Ensemble, he asked me once why I had to perform. He said he would build me a stage in the woods. And I answered, 'What, perform for the squirrels?' I tried to explain it to him. He'd ask me over and over why I wanted to perform, and I'd say, 'You know, if I can make people forget their problems for one second, for one second, I think I'm doing a lot. And applause is also quite nice. When they say "bravo" it's the icing on the cake.'

"But aside from that influence, which was pulling me back, I had so many influences on the outside that were pushing me forward. I had a master teacher from California. He saw me dance and said I should be studying in New York. This was when I was just starting, before I was going to New York. He said he was going to take me on the train one day, show me where to go, make sure I knew.

"I had all those influences. Gary Flannery was a good source of positive feedback. As I went through my divorce I began to teach for him more and more. I first started as part of his company, and then became a principal dancer and soloist, and then became his partner until he moved to Chicago.

"It became evident to me real fast when I got divorced that I had to teach as many dance classes as I possibly could. For many years of my life I taught at four studios, cared for two children, and taught advanced modeling and voice-over work for John Robert Powers Modeling Agency.

"I just taught, taught, taught, and did recitals, and began doing choreography for the Miss North America Scholastic pageant, the Miss Hemisphere Pageant, traveling, usually to their national pageant. I had to work with all the contestants, and do those numbers, and pull my hair out. But that was very good for me because it helped me work the stage, it helped me work patterns, and I learned a lot. I learned how to use that space, and move around masses of people who really couldn't dance, and rely on the ten or so who could to do something for everyone else to key in on.

"But it was nice. I would go for about three days before so I could relax a little, plus I had my own private room, everything was paid for. It was the first time I really saw some money in my hand. I was working all different aspects of choreography. Not really legitimate choreography, but the stuff to pay the bills. I think it was toward the last two years that I was choreographing on this national level that I choreographed for the magazine *GQ*, which was doing a fashion extravaganza. I also did work for the American Modeling Association of America, and I won first place for my runway choreography.

"The last two years that I did it, I told the woman who ran the Miss North America Scholastic Pageant that I needed a core of five professional dancers. In order for the show to look good, I needed the five dancers to front the whole thing, just as in the Miss America Pageant, where the fifty contestants are then in the back. She said fine. The five women I selected would later become the core of my dance company."

During these years when Pento was making a career for herself as a choreographer, teacher, and dancer, she was also raising her two daughters. She said, "It was very good that my mom lives close to my house. One of the studios where I taught the most was five minutes from my home. My kids were very independent, because they had to be. Many times they were with me at Gary Flannery's studio, and his wife would come and feed them, and they would do their homework or take dance classes. So I had help. My children could take dance classes there; his wife would watch my children while I took my own dance classes; I didn't have to pay for anything.

"On the other hand, until four years ago, I never had health insurance. I paid from my own pocket. And you'd be amazed the difference in price. It's much cheaper. I've gone to hospitals sometimes and they'd give me a bill for $175.00 and say just send it to your health insurance company. When I said I didn't have health insurance, they'd come back with another bill for $55.00. Another big thing was taking care of my teeth. Thank God I had a good friend who is a dentist; she'd take my dance classes, and we bartered."

In 1995, Pento decided she wanted to showcase her dance and choreographic work more. She joined the Philadelphia Dance Alliance. Through this organization she became a member of the Independent Choreogra-

phers Exchange (ICE). ICE is funded by the Philadelphia Dance Alliance, so all the performances by member choreographers are paid for except for the video made of the production. Also, if any money is realized on the performance, all the participating choreographers split it.

Pento became a member of ICE's steering committee, and was instrumental in helping to increase both the number of performances and size of the audiences attending them. As she became more involved in her choreography, she began to assess how she wanted to spend her time and energy. "All this time, I'm realizing in the back of my mind that I really like this choreography and I want more time to do this choreography; I don't want to be teaching forty hours of dance class, and I'm getting older. I guess getting out there and performing more and more and getting out into the Philadelphia scene more and more, it became quite evident to me that I needed to do something that would allow me to pick and choose what I wanted to do."

For some time, Pento had been contemplating getting a real estate license. Being a real estate agent offered her the possibility of earning more income while still keeping a flexible schedule that would accommodate her dancing and choreography. She said, "One of the things that led to that decision was the fact that my children were growing up. My one daughter is now twenty-four years old. She went to New York University on a performing arts scholarship; voice was her major. My other daughter is twenty-one; she is an outstanding athlete. She goes to Slippery Rock University on a big scholarship, and she's going to graduate with a Ph.D. in physical therapy, just when her mother needs her. So I had that freedom, they were out of the house. Also, people said to me, 'You've found something you really like to do with dancing; you get paid for it; you have no stress over it; how many people walk this earth who get paid for something that they really love to do?' But the truth of the matter was that up until this year, I wasn't getting paid enough."

Pento enjoys her work in real estate. She works part time for a very small agency, which consists of four other agents and a broker. She said, "Some agencies like it when their real estate agents make a sufficient amount of money at another job, particularly when they have flexible hours. They like that, because it doesn't make you so aggressive. On the other hand, in some big offices I couldn't do what I do; they wouldn't allow it; they wouldn't even hire me."

Pento easily integrates her work in real estate with her dancing. "I tell most of my clients that I'm a professional dancer and that I teach here, here, and here. And you'd be amazed how they work around my schedule if they want me to represent them; in fact, they love it. They come to see me dance. On my card is my home phone number. Some will call at 8 AM or 10

PM, because they want to catch me before or after I teach. I think there's a creative part in everyone, and they often wish they'd explored it, and with me they find someone who has explored it but who is also in this straight job.

"Then you have the other side. I have many adult students at Abington Art Center. They have seen me as their dance teacher for four years. The other day in class, one of the master teachers I'd hired was mentioning that he's looking for a house in this area. I told him that I'm a real estate agent, and he said, 'That's great.' I understand about dance teachers' salaries and how we don't have a lot of money. In fact my mortgage broker plays in a jazz band, so when I come up with these clients who are in the arts, he's very creative and helps guide them through. He'll tell them you have to do this, show this much money, put this much in the bank for six months, etcetera"

Everything was going quite well with her choreography, dancing, and new incarnation as a real estate agent, when another bit of good fortune came Pento's way. Abington Art Center, the community arts center in the Philadelphia suburb where she had been teaching, invited her to become the director of its dance department. Pento explained the impact this had on her artistic life. "By doing that, by getting the additional money for being director of the dance department, I could then start, only start, to pick what I wanted to do as far as dancing and choreographing."

As an administrator, Pento sometimes finds herself immersed in details about the physical plant or internal politics that seem far removed from the art of the dance. Her initial appointment caused a schism among many long-time members who had backed a different candidate for her position. There was also wrangling with the board of directors over the awarding of a contract to replace the dance studio floor, which had originally been laid in the 1920s. And one morning she breezed into the studio prepared to dance, only to discover a large puddle of water— courtesy of a new air conditioner that had been installed.

However, she is still finding the job very rewarding. "This summer at Abington I'll be teaching dance class and a dance camp for seven year olds and up. We're going to do *Grease*. One of the women who dances for me is going to work with me, and we're going to use the lunchtimes to choreograph another idea that we have.

"We did a summer workshop where we invited all master teachers, so I could kick back and only teach two classes and take some classes myself. We are trying very much at Abington to offer new things, like dance for people with disabilities. We're offering workshops in swing, tango, and Polynesian dance."

Early on, after she first formed her dance company, more experienced colleagues suggested Pento apply for grants, advising that she wouldn't even begin to receive any funding until the company was performing for at least three years. They told her that she would have to be persistent about applying.

Reflecting on grants in general, Pento said, "There's not enough funding. And the funding seems to never go, or rarely go, to U.S.-born residents. I don't know why that is; there are many different reasons. Ten of us were invited to a group meeting with a long-established choreographer from California, who has gotten so much money, and has gotten it for the last twenty years, that he has his own little theater. He says that the whole situation has changed now. It used to be that the people who were choosing who got the grants were dancers and choreographers, or at least people in the arts. Now the people who are giving the money want to make the decisions also. They don't know what they're looking at.

"Then we also have this lean, or tilt, toward the idea that the choreography has to be totally bizarre or totally avant-garde, that that's what's new and different. Sometimes you get sick and tired of it because you have to think of your audience. And there's just as much an audience out there for every style of dance, and to flood the stage, to push all these venues to all these same kind of choreographers—I don't see where the balance is there. And that's what happens to the dance money too. Sometimes I know they write a very good grant proposal and say they're going to do one thing, but when they get the money, they do something else.

"Also, you really have to learn how to play the game. You really have to learn how to write those grants. You have to put it in their language. I've read some feedback where some of the people who sit on the panels say the writing of the grant proposal is not as strong in their decision making as the work sample, as the video. I think that's baloney, because when I began to write in their language, I began to get calls from people on the panels saying I argued my grant very well, even before they saw my tape. You have to learn to talk in their language, you must.

"You better be sure that your grant says 'community' 40 million times. You better be sure that you actually got into the community 40 million times, or they won't come near you. Not that I have a problem with that. I think that's a very good perspective to go from. At least you're not just dancing in the studio. You're taking your dance out to the community and letting other people be exposed to it."

Pento is brimming with ideas for developing and growing in her art. Recently, instead of dancing with her whole company, she did a piece entitled *Verve* with a male friend, Michael Yousko, which was well received by the critics. She wants to perform solo, and has some new plans for her com-

pany. "I'm thinking of changing the company around a little bit. When I first started my company, I had three older women and three college students who had studied with me before they went to college for dance. I thought it would be a good idea to let them see as they were going to college if this was what they really wanted to do, but their immaturity really got to me. One teaches for me at Abington. She is also on a full scholarship for dance at Temple and was chosen to go to Temple in Rome and integrate dance with the visual arts for six months.

"But my company will be a more mature company. Because I know so many women close to my age who are terrific dancers, and if Baryshnikov can have his White Oak Dance Project and have some dancers who are over fifty, then why not? There is so much to be said for a more mature dancer. I don't see where you lose technique. I understand how Baryshnikov says he doesn't want to dance a full ballet; they're grueling. I don't want to dance them either, but I have. But there's so much inner stuff, older dancers give purpose to the movement. They know where it comes from. If I say imagine grief, they know what that is, and not for a couple of years, and not in a light way."

Some wonderful mentors have helped Pento focus on the solo that she is developing and on her approach to dance. Through the Philadelphia Dance Alliance, she was accepted into a mentoring program in which Joan Myers Brown, the artistic director of Philadanco, a highly acclaimed African American dance troupe, agreed to be her mentor.

Pento said, "Joan Myers Brown has been an excellent help. Pat Thomas, who is the rehearsal director of Philadanco and head of the modern dance department at the University of the Arts, also stepped onto the bandwagon. They have both been so helpful to me. Joan Myers Brown told me to write for every grant I could possibly write for. I have an idea about doing a long piece about the integration of Louisiana, about how so many ethnic groups started out in the 1700s in Louisiana, and because of so many hardships have learned to live together. She thought it was an excellent idea. Plus I got a lot of feedback from people in Louisiana. The state folklorist is willing to help me."

The other mentoring experience that deeply influenced Pento occurred when she received a ChoreoLab grant. She said, "Finally, I had my first grant. I was chosen out of a group of about fifty to seventy-five. There were seven of us chosen to study for a week with Martha Myers, who is the director of the American Dance Festival. She's a seventy-five-year-old beautiful woman. She helped me immensely during my week.

"I'm really beginning to think about myself and my solo. And I thought, 'Who better than Martha Myers to help me do a solo, to be my other pair of

eyes?' I've done solos before, but they've been choreographed on me, for me. Also, I'm a very technical dancer, I'm a very trained dancer, and the avant-garde is more popular now. I think that's why Joan Myers Brown wanted me, because I'm very technical, my choreography is dancing, I'm not standing on the stage moaning and moving an arm."

What Pento learned that week is really the essence of her relationship with dance. "We were asked the first day of the ChoreoLab what we liked about our dance and what we didn't like. I said I liked my dance because it moved, and flowed, and entertained. And six other faces looked at me like, 'Oh, this little egotistical bitch.' I said what I wanted to improve about my dance is that I'm so technical; sometimes I will think in my mind, 'What is the hardest thing you can think of to do right here,' and sometimes I don't think that's the way it should be. I want to get away from that a little bit. We were also asked from where our movements originate, and my answer was quite different from everyone else's. I said, 'My heart.' And they all looked at me. Other people said, my hand, my eye, my shoulder. Martha asked, 'After the heart where does it go?' I told her, 'My mind, and then into my body.' One of the messages that Martha gave me during that grant was that if I could take that message from my heart to my body, and forget the mind part, my body really knows how to do it, and my heart is really telling me what to do."

19

Finding Art's Place in One's Life: Angela Alston

Angela Alston is a maker of videos and films. Her video **Serious Underwear** *is based on a poem; the film* **Lament** *is a dance film dealing with grief; and* **The Weeping Woman: Tales of La Llorona** *is an experimental documentary. Alston won an Award of Merit at the Sinking Creek Film and Video Festival, and a Juror's Choice Award at the Film Front International Student Film and Video Festival. The film* **Lament** *has been screened in British Columbia, Hungary, and the Czech Republic.*

More than a decade ago, when Angela Alston's friend invited her to a film shoot of a public access television show in Seattle, Washington, she knew she had found her medium. All her education in the arts, all her studies in writing, dance, music, acting, and photography, came together behind the camera and in the editing room. As Alston said, "It had movement, it had words, of course there was the visual aspect; it was a complete marriage of everything I had been doing up until then."

Alston has been immersed in the arts all her life. Her mother believed she should know how to do everything, so as a child she studied flute and piano and took acting lessons. In college she seriously considered a career in acting, but one of her professors gave her a dose of reality. "He asked how much I wanted it and explained that not only was it an extremely difficult life, but being that I'm a black woman, it would make it really hard. I was very grateful to him, because I think it's really important to tell people what the risks are. I wound up taking photography classes for a couple of years instead, and I had practically twenty-four-hour access to the darkroom. I lived only about ten blocks away, so I was there all the time. I ended up loving photography and taking lots of pictures."

After her initial introduction to it, Alston did several public access televi-

sion programs. "The first piece that I produced and directed myself, involved a friend, Jan Wallace, who's a poet. Her poetry is very visual and very funny. She had written something called *Serious Underwear*. We applied for a grant to produce it, which we wound up not getting. But by then we were so into it, we had written a script, and we decided we were going to do it anyway. It turned out she had done a one-woman show on underwear also. I finished that piece in 1988. Since then I've done several dance films. I had started taking dance classes in college and got very interested in it. It made me think about interacting with the camera quite differently. I also directed a narrative film for a friend of mine.

"Eventually, I got my MFA in Filmmaking at the University of Texas at Austin, because I decided I was making too many mistakes. Every time I made a video of my own I'd make a different error. So I wanted to get the technical stuff under my belt very quickly. I have to say that film school was a really productive time for me. The reality was that I could have access twenty-four hours a day, seven days a week to an editing room. You start to take it for granted. I was really committed to my work, but I never stopped to think about what I was going to do to get this kind of access again. When I graduated it was a bit of a rude awakening."

Alston always keeps in the back of her mind the possibility that she will have to endure the grind of taking a long-term temp job to earn some solid money. But fortunately, so far she has been able to land a number of jobs that are at least tangentially connected to her filmmaking. Currently, she is the director of education for Sessions.edu, a start-up Internet company providing online training in design. "When I was in graduate school I took some multimedia classes, and so I was able to find work as a co-manager of an audio lab. That was pretty cool, because a lot of what I was interested in was at my job. It was kind of seductive because it was sort of close to what I wanted to be doing, but it still wasn't my own work, but it pays all right.

"I worked for three years doing public relations, which was really great to do because I was doing it for an art college, which is something I could really get behind. It was a great experience for me because I had to think of all these ways to get people to pay attention to what we were up to." Alston found that the knowledge she gained was invaluable in presenting and marketing her own work. "One of the things that's really important is to be able to publicize yourself and your work, as you're doing it, in the process of doing it, and after you do it, and to think about it as a critical part, the marketing. It certainly helped me even to get freelance jobs. I have a meeting in a couple weeks just because I went online and found this company and sent them e-mail, and they said that yes, we'd love to meet with you and in fact we're really glad that you found us this way. It showed them that I was thinking in the way that they wanted me to think."

At one point, Alston was able to arrange a seven-month contract job with a corporation to produce a series of short videos. Her nontraditional mother had an atypical maternal reaction when she heard about this arrangement. "Oh no, you've joined the middle classes," she lamented. Alston described what it was like to be stationed with a crew of creative filmmakers in the belly of a corporation. "That job took so much out of me because it was a corporate environment, so I had to constantly educate them about what it takes to produce videos. I'd have to tell them that if we're here until ten at night, maybe my people are not going to be here early in the morning. Meanwhile other people who work for the same company get fired if they're late twice. It was different cultures. When you entered our space it was literally like night and day, because we were working with the overhead lights turned off so they wouldn't produce glare on the screen, while the other offices had fluorescent lights. Even something as mundane as that makes a huge difference. There was a lot of stuff that I preferred not to talk about unless I was asked. Like one of my producers shaved her head at one point; she is a Buddhist so she did it partly as an offering. The president of the company asked about that. It turned out he was a fundamentalist Christian. You really don't want to get into certain discussions with some people. I don't think a fundamentalist Christian would be too comfortable with some of the things that Buddhists do."

Before recently moving to New York and beginning her work at Sessions.edu, Alston was working hard to establish herself in Chicago as a freelance video producer. "It's very seductive," she said, "because it pays really well when you're working, unlike a lot of other things that artists wind up doing, especially if your client is corporate. To me anyway, it is a huge chunk of money that you're getting. And you're using all your skills. And producing is really quite creative work. You're figuring out who are the right people to go to, and how can you accomplish this, and sitting in with the editor, and maybe you're directing it too. You're working to get the best lighting. But it's still not your own work. So it's incredibly draining too, because one of the reasons you get that kind of money is because you're working such long hours. It's a conundrum."

Alston has many artist friends who also have had to come to terms with balancing earning a living with pursuing their art. She described some of their situations. "I know one man who is about sixty years old. He has a day job in a university that has nothing to do with art; it's in something like human resources; it's that far removed. Then he makes very simple films at home.

"One woman I know had completely given up the idea of doing her own work. She was running the Austin Film Society, and now she's moved

to a position in New York, and what she's doing is closely related, but she's still not producing her own stuff. And I don't see how she could, because she's a real hard worker, and she just wouldn't have time.

"Another friend of mine makes enough money that he can take some time off to write. Most people I know still want to do their art and are being really creative about it. There are all these different ways that people are trying to get to the same place, which is to make your own stuff full-time. One guy left school with a job as a professor. He went down to teach at the University of Florida. He and his wife are trying to do everything together. Their goal is to write a feature-length screenplay and direct it in the next year and a half.

"One of the women who was teaching us in Austin left because her husband got a job in San Francisco. She had already been commuting to Minneapolis where her husband lived; he had a job as a fund-raiser there. And they had a small child. In San Francisco she has a job with a national media-related organization, so I don't know if she's able to do her own work. She was very successful, she got grants and made some highly regarded experimental films, and she made a feature film. I don't know how she would have time now to do her own work either.

"Another friend of mine was a violinist and teaching in Austin in the public schools for two years. She had five elementary schools that she visited every day, so she was constantly rushing, constantly speeding all over. Then the second year she had three schools, and one was a high school, and it turned out to be even harder. She ended up quitting. She was my housemate and just taught privately out of our house. It was less money, but it was a lot less wearing too.

"Then there's the whole health insurance thing, which we all struggle with in this country. If you're underemployed because you want to have some time for your own stuff, well then chances are you don't even have health insurance. If you do work a full-time job, and then you come home and your child needs you, then what time is left? When it comes to health care, I think one of the things that makes us so complacent in this country is that because we're so big, it's easy for most people not to know how most people in the developed world live. My sister lives in Spain. Everything is completely covered. So if she comes to visit this country and needs to see a doctor, or her child needs to see a doctor, well no problem, that's covered too. I think people are just clueless."

In addition to having the time and energy to do creative work, there is also the problem of funding that work. For filmmakers, who need expensive camera equipment, film or videotape, editing facilities, locations, and actors to make their art, grants and underwriting are of particular importance. Thinking about this, Alston mused, "Sometimes I envy writers be-

cause they don't have to get ten people around them before they can do what they need to do to make their art." She has found it difficult to secure grant money.

"I used to live in Austin, Texas, where there is a really good fund for supporting independent work. It's a grant made by the Austin Film Society, which is kind of the baby of Rick Linklater. He decided to raise money to offer this grant because his first film, *Slacker,* was funded by money from the National Endowment for the Arts. Well that money is no longer available. So he felt that since he was only able to make that film because of that money, he wanted to help other emerging filmmakers to move up. He does that specifically for people in Texas. It's kind of amazing, and he's been very successful in being able to add to it, so that every year he's able to give it to a few more filmmakers. But that situation is pretty unusual.

"If you make documentaries, sometimes you'll find yourself in a stronger position, because someone is interested in the subject matter. Although some places will specifically say they don't fund films. If they don't say that, still, your project has to fit within their guidelines. For example, I was working on a documentary about housing. When I moved to Chicago, I did a lot of research in one of the foundation libraries and found foundations that were interested in housing issues and community development. When I pitched the film, one funder said it sounded like a very interesting project, but it was too sociological. Then we had a meeting with another funder, with the MacArthur Foundation. This is a project that's in Chicago, they love media, and they're really interested in housing. So I thought, 'If they don't fund it, then I really don't know who is going to.' They ended up not funding it because they said they didn't think that the housing model was replicable on a national level. It had absolutely nothing to do with the quality of the film we might make. It was kind of like double jeopardy, because we went into the meeting having the housing people there and the media people there, which I thought was going to work to our benefit, but in the end it didn't.

"They said, 'When you've shot the film you can come back to us.' But then someone's got to fund the shooting. Not so much the shooting, because if you own a camera, it's just the videotape. But someone's got to pay for the edit so that you have something to show them.

"So you have to get really creative. You have to pick your projects very carefully. Several people said this to me when I was coming along, that you really have to be in love with your project, because you're going to be living with it for like seven years. Unless you think it's going to be really easy to fund immediately, then you might not have to love it quite so much. Now I have to ask myself questions about this housing thing, Do I love it that much? There are other projects too— it's like I have all these children and they're clamoring for my attention."

Besides projects that are funded by grants and the independent film festivals, there are a few venues on television for some film work. HBO, for example, has a documentary series, as does Cinemax. Alston said, "Then there are various kinds of screening that aren't festivals around the country. Sometimes you can dig out these things and sometimes they come to you. I've had one or two people find my Web site and approach me that way."

These various possibilities have made her begin to consider on what scale she would like to work and what sacrifices she would be willing to make. "When I was in graduate school, one of the reasons I was so productive and I made work that I could be proud of was that that was pretty much all I was doing for three years. But that takes its toll. Because your work is really about people and the way they are, and if you wind up sort of not living. . . . It's not like I didn't have any contact with people, but it wasn't like I had a huge circle of friends, just the people I did videos with, and if I ever went anywhere it was because I was scouting a location or I was on location. I realized at one point how miserable one part of me had been when I was finally winding down and finished shooting my thesis film.

"It's important to have a balance and to realize what in life feeds you as an artist and a person, and I think it's really important to not give that up. It's really not the level that I'm aspiring to, but this first assistant director from Hollywood came to talk to us when I was in school, and she said they have a really strong pension fund because so many people are dropping dead in their fifties. I think it's a struggle to find the right balance. Other people probably struggle with it too, but maybe artists do so more because so often our work for money is not related to our personal work. But if you also throw in that you might have an intense personal relationship, and maybe you have a child, and the rest of your family, then it's an incredible juggling act. It's something that everyone is taking a second look at. Just look at physicians, for example, some of them are rebelling and saying, okay I'm going to be a family practitioner and work four days a week so I can see my kids."

Despite the difficulties inherent in being a time-starved, under-funded filmmaker in today's competitive independent film world, Alston finds much to be optimistic about from a somewhat unexpected source— technology. She said, "The flip side to all the difficulties is that the medium is changing, so now there's digital video. Now it's a heck of a lot cheaper to shoot a feature-length film. If you're willing to give up some quality, it will still look okay. The film *Celebration* was shot in digital video. There's a documentary called *The Cruise* that was shot on digital video and transferred to film.

"Also, unless they think of a way for the Internet to cost more than it does now, it absolutely is another very powerful way to distribute stuff. I

haven't tried to sell anything that way, but if you work at it, and you work at getting the right links, and you work at other kinds of publicity, it's very valuable. The Internet is also very good for getting information about funders. Many funders are now online. That's really helpful, instead of having to go to the library and find the right directory, and then write all the information down by hand.

"I don't know if other artists have experienced this, but it seems that now, because of technology, for the first time people have a chance to earn decent money and to do something that's related to their work. So artists can do digital art. Or it may not even be related to their art, but they may have computer skills. I met a bunch of people who are programmers, but they're also musicians. And they seem to go together well. In fact, they enjoy programming. Even though it's not their own work, at least when they're doing it they can make good money at it. So in some ways, I think we're a little bit lucky to be living right now.

"One of the things that I fall back on if I don't have any freelance work is temp work. And it's all computer related. So some of the stuff I've learned doing temp work makes my own work easier. Because I can format a script in Word really easily. Or, because I'm comfortable with computers, when I do video editing I can figure things out. If it crashes, I'm not at a loss."

The Weeping Woman: Tales of La Llorona is a film that Alston co-produced and directed as a final project for her first film class in graduate school. She explained how the concept for the film evolved. "I got the idea from one of the first conversations I had when I moved to Austin. I went to a party for incoming graduate students and met this Tejano guy, which is someone who is a Mexican American who grew up in Texas. I don't know how it came up in the conversation, but he told me this story that I just loved. She's kind of like a boogie man, the weeping woman. The story is somewhat different depending on whom you're talking to. She was doomed because she abandoned her children for her lover, or in some versions maybe she killed them, and now she's doomed to wander forever looking for them. And in the process, she keeps people on the straight and narrow. If you're a guy who's a womanizer, then she may appear to you as a woman with a horse's head to scare you, so you'll stop doing that. Or sometimes kids would be messing up and they'd be told to stop it or La Llorona, that's her Spanish name, would come and get them.

"So what we did was we decided to shoot it as an experimental documentary. We used a dancer and shot all the scenes with her wandering and looking and scaring people. And then the sound track was interviews with four Mexican American women telling versions of the story that they had

heard. One of the women we interviewed ended up also acting in part of it; she's also a stage actress."

Alston finds that on the level that she is working now, the attitude of her fellow filmmakers is one of cooperation and encouragement. She said, "We all know it's hard, so it's how can I help you, how can you help me? It's very collaborative and supportive, with just the occasional odd person out there who feels competitive and threatened by somebody else.

"Hollywood is just a whole other thing, people just think so differently. I worked on one feature, and I was just a production assistant. Most of the people came from California to shoot it. And they said to me, 'Houses up here are so cheap. They *only* want $213,000 for it!' Those people live in a completely other world."

Looking toward the future, Alston speculated, "I think in the best of all possible worlds, what I would like is what I had when I was in Austin, which was a part time job that paid okay and that gave me some structure. Because one of the things that I have trouble with is just giving myself structure. If I don't have set things to do every day then there is just so much to do, and it's hard to pick the one project that I just can't wait to do. In a way I just get paralyzed and finally say forget it, I'll look at somebody else's film.

"I really want to do my own stuff. I have a feature-length screenplay, and there are several documentaries I want to make. But the reality is that after a certain point I don't want to make myself miserable. I think for myself I have to figure out how much time I'm going to give it, but I want to give it just a fixed period of time. If I can't get funded, then I want to re-think it and say, 'All right, can I do it for somebody else?' There are filmmakers whose work I could completely get behind and not be frustrated. I think I need to be realistic and maybe just do something small."

The film *Hilary and Jackie* about the musician Jacqueline du Pre, directed by Anand Tucker, and starring Emily Watson and Rachel Griffiths, has stimulated many of these thoughts in Alston about her life and the place of art in it. She shared some of her impressions and the impact they had on her. "It's a fabulous film. I personally think that the ending is a cop-out, but the film is absolutely marvelous. *Hilary and Jackie* does help raise those questions about where you want to be with your art. The kind of audience and size of audience that you want to reach. That's something that I've been struggling with too. When you do a feature-length project, that's something different than when you do a dance film. I've never set out to do this, but it just so happens that all the ideas I've had up until now have been completely noncommercial. It's not that I have a problem with being commercial; it's just that those are the ideas that I've had. Well, now I have an

idea for a feature which actually is potentially commercial. It's something that I think is important to talk about and has to do with women and power and marriage and an important historical figure and sex; there's a lot of sex in it. Maybe I could actually make money on it. It's all a part of asking myself 'Where is the place that I want to be?' "

20

The Practical and the Spiritual: Toshi Makihara

Percussionist Toshi Makihara has been working as a freelance musician for more than fifteen years. He is a member of a jazz trio, an avant-garde ensemble, and a group that plays rock and electronic music. Major dance companies also seek him out to perform live with them. Makihara is the founder of Improvisation in Media and Performance, through which he produces a series twice a month that showcases new music at the Highwire Art Gallery in Philadelphia.

Sometimes when percussionist Toshi Makihara is in the men's room at work, and nobody else is around, he sneaks in a three-second improvisation by tapping on the sink, or he thinks about tapping his feet or going out into the offices and scraping along the walls or opening and closing file cabinets in a certain rhythm. Or he contemplates what would happen if he were to do some experimental music in the office or bring in the music of, say, John Cage. "If I actually did it, I imagine they would probably just call security to take me out of there," he speculated.

The office in which he works from 8 AM to 5 PM each weekday is at the Cigna Insurance Company, where his job is to speak to hospital personnel and process insurance claims. "I have a small income from music, but that's totally not enough," he said. "I always had to work at something else. I worked in restaurants for a long time; many artists do. I was a waiter for about five years. I also taught when I was in graduate school." Artistically, besides improvisational jazz, he is working with dancers on a performance piece, and collaborating with a New York filmmaker on a work about Cleopatra.

Makihara has mixed feelings about his job. "What I like is that it gives me a stable financial situation and the benefits are nice. Ten years ago when

I was younger I felt a lot of resistance to this type of job. But now I'm getting a little older, I'm approaching 40, and you just need to have a certain stable living condition. I need the benefits and a health plan and dental plan, it's just a matter of fact.

"I like working, but I wish I could work a little less and make the same amount of money, which is really not possible. I'm working between forty-five and fifty hours a week. I wish I could do like thirty, although that's not possible."

With working full-time, Makihara finds it difficult to practice. He tries to work on music in his basement studio for at least a half hour each evening, but there have been nights when he was so tired that he actually fell asleep on his drums. He also has to worry about disturbing the neighbors in his quiet, middle-class suburban neighborhood. "Percussion is very loud. I shouldn't really play after nine at night. In my neighborhood, people are nice, but not hard core artist types. I'm kind of both. I'm kind of a hard-working suburban-looking kind of person, but then when I go into the basement, I do all kinds of crazy stuff."

"It's just so strange; I've been at this job for two years now. I go to the job, and sometimes I think, 'What am I doing here?' I go to the bathroom and I address myself in the mirror and I say, 'What am I doing here, why am I here? Why don't I get laid off?' That would be nice. I go back to my desk and it's the same old piles, endless piles of things, and I just have to do it.

"On the other hand, it's kind of interesting to see the so-called everyday world. It's kind of interesting to see how people behave, to listen even to very boring conversations about sports. That's what people do basically; many people just go home and watch the ball game, and they're very happy."

Makihara made an analogy between artists and other groups who have an alternate lifestyle outside the workplace. "Many gay people kind of hide themselves at work and act very normal, and then after work they go to the gay community, and it's totally different from where they work. Artists too are kind of like that. There's nothing wrong with artists, and nothing wrong with gay people, but they have, it's not a secret, but it's just not necessary to tell everyone what you do. It doesn't really help anything, so why say anything?"

Even with this self-imposed separation of his two lives, something of his creative life sometimes seeps into his work-a-day world, as he commits a gentle form of "office terrorism," by e-mailing messages, artistic ideas, or compositions to fellow musicians; making arrangements for tours; or occasionally copying flyers to announce a performance.

Some of Makihara's musician friends reject the idea of having a full-time job and the lifestyle into which such a commitment would force them. They don't have many material possessions, but prefer to be poor and have the time to play and compose music. Others, like him, hold down day jobs in a whole host of professions that provide decent incomes, and keep the two areas of their lives separate.

Makihara has come to terms with his own decision. "I heard a great statement in the movie *Shall We Dance?* There's a scene where after work some of the characters go out for a drink, and a young lady asks this guy, 'Do you like your job?' And he answers something like, 'It's not a question of like or dislike, it's just a job.' That's how I like to think, I don't dislike my job, but I don't like my job either. I'm doing it mostly for financial reasons. And if I start thinking, 'Do I like it or dislike it?' I don't think I could continue."

Makihara is not inexperienced at living a double life. Even when he was a high school student in Tokyo he had a secret artistic life. He played in his school's marching band, went to basketball games, listened to Led Zeppelin records with his friends, and pretended to be like everyone else. But once a week he snuck off to a private percussion teacher, one of the avant-garde musicians in the 1970s Tokyo scene. He was interested in contemporary experimental music and new jazz, which were not part of the popular teenage culture. He was also very drawn to African American culture, drumming, and jazz. "I don't know why, but I saw some kind of freedom, or at least a searching for freedom, and I was very attracted to that."

Makihara hid his interests because he didn't want to seem weird or strange. Also, he explained that in Japan traditional Japanese music, dance, and theater are deeply respected and strongly supported, but it is very difficult to be an experimental artist there. His teacher, who had lived in Chicago and traveled around the world, recommended that after his graduation from high school at age eighteen, he go abroad to study in the United States. "As soon as I got here I felt a little more freedom regarding studying this type of music, especially in music school. I met some students who were interested in this type of music; some of them are still good friends," Makihara said.

"My family didn't know about this kind of music. They thought I was going to study classical music. That's the impression they had. They were maybe expecting me to become a tympani player in the Boston Philharmonic, which was possible, but I just didn't go that way."

He was originally planning to study at the Berklee College of Music, but instead he enrolled in Glassboro State College, now known as Rowan University, in New Jersey, because the tuition was much less.

"They had a good music program and their faculty is excellent. They had about fifty practice rooms open twenty-four hours a day. I almost had my own room with my instruments, and I could go in anytime and practice.

"It was a hard life though, I didn't have a car, and living in South Jersey without a car and trying to play music— it was strange and difficult. Also, I had some difficulties with English. I had five years of English in Japan, but that's like a high school kid here studying French."

After graduating from college, Makihara became very involved in the interdisciplinary performance art that burgeoned in the 1980s. Through this work he met many dancers and even began taking dance classes himself, which he continued for five years. He said, "It was good that I studied dance, I even took ballet class, because now when I work with dancers, I can relate to them very well, not just as an accompanist, but when they're talking about something I can figure out what they're talking about. I can talk in their language. Many dancers like what I do because I'm in synch with their way of dancing. Most of the time when I work with dancers I perform live with them, because my percussion has a very strong physical presence, and I think they like that. Sometimes I'm on stage with them or on the side. I seldom do any recordings for dance pieces; dancers prefer to have me live onstage. I think taped music is very hard to deal with because it's not flexible, but live musicians can watch the dancers move and adjust things if needed.

"Another thing about dance, because I'm a drummer and I play drums and percussion, it's kind of like dance. When I play drums it almost has a dance feel to it, it's not leaping or anything like that, but it's body movement that produces sound, not just sounds but movement. I learn from dancers. When I practice I try to work on some of these things. I think about movement a lot and things like breathing and eye focus, which dancers are very good at.

"Many musicians are not good at that. Because musicians are kind of specialists, they tend to be an expert, but sometimes it's not great to be an expert, because you're inflexible. You can become an expert classical pianist, but if that's all you do, than you're an expert in this very limited area. If you need to work with dancers in a very improvisational situation, then many people can become confused because they don't know what to do. I'm glad I studied dance."

Makihara's immersion in music also caused him to begin exploring ideas he could not have anticipated as a young music student. "What happened was that I found when I play drums I have a mystical experience, not always, but sometimes. Sometimes I feel like I have this trancelike mental state, and when I play music I experience some kind of higher reality. When

that happens I get very happy afterwards. It's like therapy, it's like a good meditation. So I was interested in intellectual research into that area. What happens to the mind at such a time?

"Then I became philosophical and started asking questions like, What is art? Why am I doing music? What is music? Of course there are no answers to these questions. But in many traditions music is very strongly connected to religion and spirituality, like African drums and rituals, Indian music, Bach and Christianity. Another big interest of mine was spirituality, spirituality in different cultures.

"So I applied for graduate school at Temple University in the religion department. I was in the religion department for about four years and was really into those studies. That's another area that enriched my musicianship. I was in the Ph.D. program but I didn't quite finish my program before I left. I was teaching undergraduate religion courses, Buddhism and stuff like that, for awhile.

"But then I guess I had enough of that, and I left. Also financially, I was getting older. I got married, and I got a job and a house, and that happened very quickly, but I tried to still do music as much as possible. I still keep trying. Right now I have my job, which is my practical side, and my music, which is my spiritual and artistic side. These two aspects of my life are in very good harmony. Again, I wish I could work a little less, but other than that, it works very well. It is stressful sometimes, after working nine hours to come home, and there's nothing to eat. So I get another pizza. Sometimes I get very depressed about not having enough time.

"I think it is harder to get to that trance-like state because of having less time and being tired. It would be great if I could come home at around three o'clock in the afternoon and practice before it gets dark. It's not really great to practice at night. So usually I practice a lot on the weekends. And my practicing is not just practicing tunes but it includes some spiritual types of things and experiments, so practice itself becomes very creative."

Makihara thinks that this creative aspect is missing from the lives of many of the people he encounters in his daily life. "Some jobs are just not creative. My job isn't creative, I'm not really creating anything new. I'm just processing. This processing thing, processing a database, or processing on the computer—most people are processing something, and their life becomes like processing something too. It comes and goes and is not creative. You get things assigned and you process them and they're done, and you get more things and process them. And then at five o'clock you just go home. You go home, but some people are so used to being passive, they process processed food, and are just couch potatoes processing the football game, and then they're tired and take a bath and go to bed.

"Conversation is like that too. When I talk to most people, most of the conversation is not deep, I must admit, including my own conversation.

Usually it's some stupid jokes and some cheerful conversation about sports or whatever, but after a half hour I don't remember it; it comes and goes.

"The creative process is the opposite of that. The creative process to me is examining one's spirituality and artistic nature. It's not happening at work. I guess it's the opposite type of personality. You're supposed to work and do the job and the real creative process happens after work.

"But it seems that many people are not interested in the creative process, particularly in America. For instance, in the section of the newspaper called Arts and Entertainment, they don't really differentiate between the two. That's very American. I don't think that happens in Europe. I think in Europe they have a much deeper appreciation of the arts because they have a history with the arts. But here in this country, I'm sorry, if it's not entertainment— Disney, or 'Saturday Night Live,' or Hollywood— then it isn't so important, and it doesn't get supported.

"It's very difficult to be very creative and to entertain at the same time. There are some exceptions, people like Andy Warhol, who could be very successful commercially and very deep artistically. But that's a rare exception. Many entertainers are not so deep, and many artists are not so popular."

21

Writing from the Depths:
Olivia Emet

Olivia Emet is a writer whose stories have been featured in Story *magazine and on National Public Radio's "Selected Shorts" program. She has received numerous grants and awards, among which are a Ragdale Fellowhip, a Pew Memorial Trust Fellowship, a grant from the Pennsylvania Council on the Arts, and a grant from the Leeway Foundation. Emet asked that a pseudonym be used so that she could be as forthcoming as possible about her experience while protecting her privacy and that of her family.*

At sixty-six years old, Olivia Emet is adamant about telling the truth about her life as a writer and a woman. She believes that other writers, particularly women writers, have struggled and continue to struggle with many of the complexities and conflicts with which she grappled most of her adult life. These include balancing outside work and child rearing with writing, as well as trying to overcome depression and a lack of self-confidence.

She said, "I've been to workshops and writers' retreats and spoken to other women about things that kept them from doing what they wanted to do and was not surprised to learn that some other people had similar problems, tied up with lack of self-esteem and other issues that are written about often. I think that I and some of my writer friends have suffered from the 'imposter syndrome.' " By this she means the very real, if unfounded, feeling that she is really an untalented fraud and that at any moment the world will find her out.

"The upsetting thing in my own case," she continued, "is that there has been nothing, next to nothing in reality, to support that attitude in me, but the feeling persists nonetheless. So I think that even though I got a lot of help from my former husband and my therapist, it's just a very difficult problem. I think much more is known now about depression, and it's not easier to treat, but it's treated more knowledgeably."

But despite this fear of inadequacy, Emet always had the urge to write. "Writing was always in the back of my mind. I don't think there ever was a time when I didn't keep a little notebook, and I would jot things down. Actually I believe it goes back to my childhood. I remember telling stories, mainly scary stories, to my friends. I grew up in a tiny town and we would sit out on the front lawn at night when the sky was pitch black in the country. I would tell stories, but I also wrote little stories. I think I sent a story to a newspaper and it was published. I remember having poetry published in our little town paper. I seemed even then to have a good feeling for metaphor, even though the poetry was way out!

"My hometown when I was growing up was segregated. Everything was segregated except for the school. There was only one school. There were no black teachers. But despite that, I got a lot of support from the white teachers. They were very nice, in fact I got encouragement and good feedback."

Until her retirement a few years ago, Emet was an educator. She began her career as a teacher at various independent schools. In the 1960s in Philadelphia, where she worked, there were a great number of public schools in which experimental programs were being pioneered. "I think being in an academic environment, where the subject of education itself was exciting, helped to feed the creative part of me in a way that traditional academic institutions don't do, because people don't usually sit around talking about how to best reach their students. We were very involved in that sort of thing. While I was working, even though the administrative work was very grueling, I did a little bit of poetry, and I think I did a few narrative sketches that I showed to the woman who was editing the small in-house magazine, and she encouraged me to finish them, but I didn't."

After that Emet held a succession of administrative positions at a field study center run by Antioch College for students in Philadelphia. "I was very excited in the beginning about working for Antioch," she said, "and I virtually forgot about doing my writing. I was very interested in the experiment. It was a very idealistic time; we were all going to rescue society through education. So I really threw myself into the work at Antioch. But as the institution got bigger and more bureaucratized I got more and more into administration, and I realized after a point that I really shouldn't be doing that, but I kept on, out of fear I guess, though I'm not sure what I was afraid of."

Emet left the Antioch job to work for the Commission on Higher Education in another administrative capacity. It was while working there, at the age of fifty-three, that she wrote two stories that were eventually published in *Story* magazine.

Besides working full-time, Emet also had a child to raise. She said, "I

had my husband's support, both financially and emotionally, but I also only had one child. I don't know how people do it who have several children. I feel as though I was blessed with a much more helpful situation than a lot of women. Nevertheless, it was a big issue for me, raising a child, and I feel as though I did a lousy job. My son is thirty now, and I've actually talked to him about this, and he says I should stop beating myself up, that he wasn't as lonely as I thought, and he tries to make me feel better.

"But I recall how often he was sort of on his own. He was a very resilient, and also a very artistic kid, and he found a way to survive. He spent a lot of time at other people's houses. He was very smart that way, he was able to build a little family for himself by staying at his friends' houses a lot. He's still friends with a lot of those same people.

"I feel as though there were different things that were pulling on me— the job, and the desire to write, and also the desire just to be alone, to have solitude. It sounds very heavy, but that's the way I see it. I feel very bad about it, even though his present attitude is that I should stop feeling bad. I think he's a wonderful young man and I respect him a great deal, in addition to loving him. He's also very encouraging to me. Every time I write one sentence he says, 'Mom, Mom, you have to continue that, come on, Mom.' "

In 1989, Emet's husband encouraged her to take her writing more seriously by taking a writers' workshop at Temple University, in Philadelphia. She said, "The first story was simmering for years. In fact, when I looked at earlier versions of it I couldn't believe it, it looked like it was going to be sixty pages. I thought, what's wrong with me, that's not a short story. There was no center to it. So learning how to discipline myself and also to think that I could actually finish it took awhile. The actual writing it and honing it down, after I entered the workshop at Temple, probably took another year or so.

"One of the difficulties I found with the workshop was that because the individual writer was sitting right there, even though the instructor tried very hard to get people to be honest, most people were trying very hard not to hurt each other's feelings, which is not what I needed. My husband gave me a very good critique and I worked the story over a couple of times.

"I decided, with his urgings, just for the hell of it, that I was going to start at the top. So I sent it to *Story* magazine and the *New Yorker* and the *Atlantic.* Within two weeks I got a call from *Story* magazine, and they wanted to accept it. I couldn't believe it. My first story was published with really no suffering on my part. I didn't have to send it out six million times.

"You would think that would excite me, and make me feel good, and make me feel like I could conquer the world? No. I started to write another

story, but meanwhile my mother was extremely ill and my husband and I were on the verge of breaking up. The breakup had nothing to do with my writing and had to do with my depression. I kind of petered out, although I was still working a little on the story."

Lois Rosenthal, the editor of *Story* magazine nagged and cajoled Emet to submit another story. When she did, it was accepted for publication. "I did get a lot of editorial help from the *Story* magazine staff; they do a lot of close work with their writers. First an editor will call with the story in hand and ask about certain things and suggest certain things, and when that level of editing is over, then Lois calls and helps with the final editing.

"One of the things I knew was wrong with the story was that it was terribly long, and I didn't know how to cut it. But with Lois's and the other editors' help, I cut the story by 700 words. I think that Lois identified that I kept repeating things because I wasn't confident that I had communicated what I wanted to the reader, that I had said it right the first time and didn't have to keep saying it. When I looked back over the manuscript, I saw that she was exactly right, and I'm still struggling with that problem."

When the magazine was published, Emet discovered that her story had been selected as the lead story in the magazine. It also went on to win a national magazine award and was read on National Public Radio's program "Selected Shorts."

At the age of sixty-two, Emet made the decision to make a greater commitment to her writing. She applied for some fellowships, with the outside hope that if she received any she could cobble together enough of an income to retire early and write full-time. She applied for a Pew Fellowship, one of the $50,000 grants awarded by the Pew Memorial Trust to artists in the five-county Philadelphia area; for a Pennsylvania Council on the Arts grant; and to Ragdale, an artists' colony near Chicago.

To Emet's great shock and delight, she won all three fellowships. She said, "I remember the first day that the Pew Fellowship people invited all the recipients in for an introduction and to explain how we would get the money. They asked us to talk about ourselves and how we felt about winning the fellowship. And I said something at the time which is almost a cliché, but it was really true, and that was that it really felt as if it was happening to someone else."

Even after receiving this incredible critical and financial support, it was still difficult for Emet to take the radical step of quitting her job. "I was a child during the Depression. If my parents had been alive they would have had a fit. I knew that my pension would be less and that I might have trouble paying for my health insurance, but I think one of the things I mentioned in my Pew application is that I had read Tillie Olsen's book, *Silences*. Well, I started to cry when I was reading that book. I realized that life was

passing so fast, and here I was over sixty and I still was doing things I didn't want to do and was still afraid to venture out and write. So it became a very emotional issue for me. I wrote my boss a resignation letter, and he asked if I'd be willing to work part time. Like a fool I said yes. But when I saw what he wanted me to do part time, it was like getting a part time salary for a full-time job. So I said forget that. I finally just cut it out altogether.

"I do want to emphasize," she added, "that I don't think I could have quit my job when I did if I hadn't been as old as I was. Because I knew that even if I didn't get any fellowships, I could start getting Social Security at the age of sixty-two. I got a little less, and got a little less from my pension. However, I think I was in a position that younger people are not in."

Emet was also inspired to change her life by the first story she ever read by Harriet Doerr, entitled "Edie, A Life." "It was just a tremendous story, it's so beautiful. Then I looked at the notes in the back of the magazine and saw that Doerr didn't start writing until she was in her sixties. She was recently interviewed along with a bunch of other women writers on a PBS program. I guess she's in her eighties now. She seemed to have found a way to not let time stand in her way.

"Worrying about time passing and one's age is a very subjective thing. If people feel panicked, then they feel panicked, and it doesn't matter if they're twenty-four or eighty, you have to honor their feeling. I think when I was forty-five, I was so immersed in what I was involved in as an educator and an administrator that I didn't realize I should try to figure out what I should do to write. It took me a long time to get there."

The year after she resigned from her job, Emet received a grant from the Leeway Foundation, which supports the work of women artists in the Philadelphia area. She spoke about how her writing has been progressing since that award. "Since that time, although I still have the problem with depression and am taking medication, I am writing. I was writing, trying to complete the stories I had in my computer, which all belonged to the same cycle. I wasn't finishing the stories, some I had were fifteen or twenty pages.

"I had some excellent mentors though. Janet Peery published a short story collection a few years ago called *Alligator Dance*. Some of the stories I thought were just brilliant and so moving. She also published a novel that was a National Book Award finalist, called *The River Beyond the World*. Janet was one of the mentors at a workshop at Dickinson College that I took, and she said something that a couple of the other mentors I had said. That was that I was probably expanding these stories because I probably wanted to write a novel. And I thought, that isn't true, I can't write a novel. Come on, I'll be dead first. But I actually did decide to write a novel based on a historical event, and I'm working on it, and who knows when it will be done.

"But I think because I'm sixty-six, and I've been saying this since I'm

sixty, I have not appreciated fully enough the passage of time, and I think I *am* a little bit panicked, but all I can do is work each day. I no longer have any outside work that I'm doing. I'm writing more or less full-time, but I have a lot of other obligations, certain things connected with my health and my family, and it seems that I'm busier than ever. But I'm very, very lucky, because I have had so much help and support. All I have to do now is to convince myself that I can do it.

"That's what I've been talking about. I think there are some women who won't talk about it but who feel it too. When I told my first mentor, the writer Sharon Sheehe Stark, about my feelings, she said, 'Oh, listen, I know what you're talking about.' She said when she received a notice in the mail that she'd gotten a Guggenheim Fellowship, her reaction was, 'Who are they kidding?' I think she is such an incredible writer, and here she was telling me she had these same problems. I think this lack of confidence and self-doubt has been a serious problem for me, but I'm hoping that as I work on the novel I can somehow focus enough and also stop worrying that I'm going to die tomorrow.

"I don't know where this imposter syndrome came from. Certainly the depression played a role. But still, it became rather absurd after awhile, because again, all my life I've gotten good feedback in whatever I've undertaken, I just don't know. It's a horrible feeling. Part of it is fear of failing. Especially when I look at some of the scathing reviews of other people's work."

Emet recalled an earlier experience in her life that illustrates how persistently the worry about having her work exposed and judged inferior has dogged her. "When I was at Hunter College in New York, I did some writing. I took a playwriting course. The teacher thought my play was so good, she sent it to the director of the Hunter College theater. He wrote back that it was a very good play and that if I made a few changes, he would be interested in trying to stage it. Well, talk about panic. I completely fell apart, and I put that play away and never looked at it again, in fact, I think I threw it away."

When she was in her early thirties, Emet knew a friend of a friend who was writing short stories, a few of which were published. The short story writer eventually moved away, and Emet lost track of her. A few years ago this woman, Annie Proulx, resurfaced, having written the award-winning *The Shipping News.*

"I was interested in how she made that leap from the short story to the novel, which was very exhaustively researched; she's very thorough. In addition to being wildly envious of her, I thought, 'I can't do anything like this.' Here's this woman I knew in New York City, and she was clopping along with her short stories. I fell to pieces. Then I called our

mutual friend and yelled, 'Annie got the National Book Award.' The two of us were screaming and carrying on. I think my friend is going to get her act together and really start working. I think she's going to quit her full-time work too.

"The idea of comparing yourself to someone else, though, is just so irrational. I encourage young people to try not to do it. It's so destructive and it hurts you and creates more pain in your life. I'm still trying to let go of that. The thing is that everything you write doesn't have to be great. That's one of the pitfalls that I haven't learned how to avoid yet, but I really want to do it. I've spoken to Lois Rosenthal quite a bit about the things that come into *Story* magazine. She told me that they've turned down plenty of things by Joyce Carol Oates and people like that. And she said Joyce Carol Oates is very professional about things. If Lois suggests certain types of changes, Oates will make them. If she doesn't agree, she won't make them. She does the work and trusts her own rhythm. I think we need to do that, first find out what the rhythm is. But it's very hard.

"I think if I could only divest myself of all these crazy emotional problems I could rip through. At least I didn't turn into a drunk. It seems that artists tend to have a hard time of one kind or another. The life of writers has real stuff in it, and we have to acknowledge that."

Despite the obstacles that her work and personal life and her own psyche may have thrown in her way, Emet considers herself very fortunate. Right now, in her art and in her life she is focusing on the importance of telling the truth. She said, "As my public self, I'm little Miss Cheery. I once told one of my therapists that if I'd been a white girl in high school, I would have been a cheerleader." This is because, although her school was not segregated, there were certain things that were *not* open to the African American kids. "So although I still usually show the public face that everything's fine, I'm beginning to have the courage and confidence to talk and write about what is truly beneath the surface."

22

Sustaining the Magic:
Paul Nash

Paul Nash is a composer, jazz guitarist, and music director whose work has been performed by the Aspen Music Festival, the Chamber Symphony of San Francisco, the Manhattan New Music Project, and the Bay Area Jazz Composers Orchestra. In 1997, Nash's ensemble featured his jazz orchestral works at the JVC Jazz Festival at Carnegie Hall. His albums include **Paul Nash: A Jazz Composer's Ensemble, Second Impressions, Night Language, Mood Swing,** *and* **Soul of Grace.** *Nash is the recipient of many grants and fellowships from, among others, the Banff Center for the Arts, Yaddo, the National Endowment for the Arts, the New York State Council on the Arts, The MacDowell Colony, and the University of California at Berkeley.*

When jazz guitarist and composer Paul Nash earned his master's degree in music at age twenty-eight, he felt as if he were being "launched into chaos." However, today, more than twenty years later, he is a successful and respected musician and composer. Nash, who lives and works in Manhattan, where he shares a studio apartment with his wife, briefly summarized his other musical endeavors. "This year I'm finally getting my music published in print. The University of Northern Colorado will be publishing my jazz compositions. They have a jazz program and a music publishing arm. They seem to use the Internet extensively to promote their catalogue of works to the college market. I also compose chamber music. I recently completed a commissioned work for a New York–based group. In addition, I'm also involved in a theater project— kind of an opera where the words are spoken to a musical accompaniment. I just negotiated permission rights, and already presented it in one form. Now I'm looking for a theater in which to perform it."

The journey, as yet unfinished, that led him from his initial uncertainties to his present accomplishments, began when he was a teenager dabbling in

music. He said, "There was always music at home, and my sister was a jazz enthusiast when Elvis Presley was much more *au courant*. I took some flute lessons when I was a kid. I didn't think anything about being a musician until high school, when I started playing the guitar and listening to Bob Dylan and the Beatles. I started cutting classes, and staying home to learn Rolling Stones songs and stuff like that. Finally, I dropped out of college, playing for a couple of years in some hippie-dippy rock 'n roll bands.

"Before long I realized I had to make some decisions. The first one was, Where does music fit into all this? I'm not going to become a rock 'n roll star. People started encouraging me to study music, which is not something I had really done. So I went back to school and first started to study music when I was twenty. I became a student of music with the idea that I would become a musician, but I still had a very fuzzy idea of what that meant. I looked down on the commercial aspects of music as being worse than being a street sweeper.

"Basically, my life revolved around studying music for eight years. I was totally unprepared for what was going to follow. I had assumed that I'd have some kind of academic existence, because those were my values. I thought that the music I wrote would flourish in an academic setting. But I never was able to get a regular academic teaching job.

"I did find teaching work outside of that setting, even though it was sometimes precarious. I guess the important thing is that when I was twenty-nine someone encouraged me to form my own band and perform my own music. That was a defining point. I thought I would be someone who just would write pieces for others to play, that maybe a college group would play a piece here and there. So the idea that I could have my own band was kind of beyond me. I'm not the most dominant type of personality.

"At twenty-nine I got to have the experience of leading my own band. Performing music, people seeming to like it, a year later making a first record, even under marginal circumstances— that was all validating enough for me to say, 'This is what's it's all about for me.' That's the thing I've been trying to do off and on. The thing that I really love the most is writing music and then taking a band and putting the music together in the best possible way, and afterward taking some performances to a recording studio. I like this more introverted part of it; I don't really enjoy playing for people, not that much. It's fun, but I never felt like this is what it's about. Maybe if I were going to Europe every year like a lot of people I know, it would have been very different.

"I abhor the stage. There's an interesting contradiction about myself. I want attention, but I hate attention. I want to do everything to make it happen, but once it comes to the moment to be there I don't want any of it, I shrink away from it. That's part of the reason I like to work with large

groups of people, I can just be part of a large mass of talent on stage, and it's not about me, I really diminish my role. It took me a long time to do a record where I featured myself as a soloist. I just didn't want to shine in that way."

Nash earns a modest amount of money from his music, but certainly not enough to sustain himself without the added income he receives as a grant writer and consultant. He explained how the balance between his work life and his art evolved over the years. "In a very modest way I was able to support myself through music until about the age of thirty-two. But there were just too many disruptions. I kept moving around. I was confronted at a certain point with the necessity of doing something else. It was liberating and frightening, because I thought my options were so narrow for making a living. I had many terrifying months when I wasn't able to support myself. Through a family connection I was able to get a job, a government job, an interesting job, and that sort of opened the door to the straight world. I felt like part of the regular, normal existence.

"I worked nine-to-five for most of ten years, on and off. I have been working as a consultant for only three years, and I find it a much better balance, although I don't make as much money. As a matter of fact, I just finalized an agreement to work on a part time basis with a local school district, to work three days a week as a consultant for $250 a day. It means I don't have to go nuts trying to patch together work. They wanted to hire me full-time, but I refused. Things are blossoming for me too much at this point for me to do that.

"I have to say that my work with grants evolved out of trying to make things happen for myself as an artist, evolved out of helping my own cause as an artist and the causes of other artists with whom I was involved, and then stepping out little by little into other areas where I could function in a broader arena.

"For most of the last ten years, I've been a grants developer as either a staff person in an organization, or as I have been for the last three years, as a consultant. I evaluate educational programs as well as write grants to support them. So I'm sort of a specialist in education. At this stage I'm not doing pure research but trying to determine if the organization did what they set out to do.

"The grants I'm mostly involved with are federal grants, which are fairly insulated from political influence; you are being judged in an objective way that can't be tampered with by who you know. But on the other hand, when you are trying to address things that you know that the agency or funder are concerned about, you know that there are certain buttons to be pushed and things to be said that reflect the funder's concerns. Also, I like to think of myself as someone who can market an idea, give it an identity

that's palatable, and present it in a lively way, which I think many people fail to do.

"It's strange how comfortable I am with it. I would make a terrible grants administrator, really, but I'm a wonderful proposal writer, because I've always been so future oriented; I'm always looking to see what I can make happen. Even when I have a job, I'm looking for a job. I'm more comfortable looking for a job than having a job. It sets that way of thinking—what if, what if? Not let's make all the details work now, but what are the possibilities?"

Although the grant work takes time away from Nash's work as a composer and musician, he does not view it as just a necessary evil to earn money. "I have a lot of feelings about it. There have been times when I've been able to integrate everything, and it makes sense since I've been working in arts and education. Then my identity can fit more comfortably together. There have been times when I thought I had found a happy marriage between the two. I had a job a few years ago, it didn't work out, working at Columbia University Teacher's College directing an arts-in-education program. When I was there, I thought, I can finally be an artist and an arts administrator or a grants administrator and it would be okay for me to be all those things because I'm finally housed in a place where it would be accepted.

"The other thing is, and I don't know to what extent it's a rationalization, because sure I would have been happy if I could have been doing music full-time and at a financial level that works, but I do think my other work feeds me in an intellectual way that gives me a broader way of thinking, working in an institutional environment, working with social issues, dealing with all the things that come up, and experiencing myself in different roles. Just the experience of putting together substantial grant proposals is an intellectual activity. It gives me a sense of satisfaction in myself that I wouldn't have gotten just from being a composer."

Although Nash usually lives comfortably within his own skin with the different aspects of his life, he finds it more difficult to reveal them to others. As he explained, "I'm not saying it's rational, but I don't like telling other artists what I do for a living in order not to diminish my professional image as an artist. On the other hand, I don't like telling some of the organizations that I work for that I'm an artist, because they'll think that I don't have a true commitment to this kind of work. I kind of get caught in that. It's sort of an identity problem. That's the way it is for me.

"The fear of letting other artists know what I do to make money is that I won't be taken seriously. Let's put it this way, if I'm trying to get people to join me in an artistic cause, if I appear to be somebody who's just doing this part time, I think it would be harder to get those individuals. Although

that's just my thinking, the reality of it is, they'll want to know if I can pay them and how much.

"Most of the people I've worked with are full-time musicians. Some are really struggling, but that's what they do— all they do. Not everybody though. There are some who make a lot of records, but they're proofreaders at night. Their incomes probably never top $20,000 in a good year. But on the other hand, I work with someone who makes $100,000 a year, and I'm very glad that he's been available to me, although he always complains about how much I can pay him."

Nash continues to live with this ambivalence, to be pulled back and forth between the practical and the enchanted. "Sometimes I think I can't really go after a particular idea, because it has to have a place in the world. I know that nothing is going to come of it, and it sort of poisons it. Artists have to struggle between just surrendering to a creative act and yet maintaining the business acumen of how to market what they do.

"For myself, the only reason I've kept going is because I've gotten something back. I think I would have been mentally deranged to keep on if I hadn't gotten good reviews, recordings, etcetera, if I hadn't gotten some reflection back from the real world that this is valued. But fortunately there is enough of a return, somebody thinks it's great, it goes somewhere. Just about everything that I've written has been performed in one way or another.

"When a piece of mine is performed or when I'm performing a composition of mine and I experience the audience's involvement, then I feel I've touched people. But that's so transitory, because I don't perform that much. It's not about that for me. For me, the creative process happens when I'm alone, and everything comes together, and there is a melding of things.

"I just turned fifty this year. I remember when I was approaching thirty, I said okay if it doesn't happen by thirty you've got to make a decision, and then, if it doesn't happen by forty you've got to make a decision, and I'm still here doing it. I can't help myself. There is a compulsion to make art, and it doesn't go away. Although it can be really debilitated by all these other things. When I get very, very involved in a project that's basically not paying me anything, it feels like everything is going to hell around me. I'm devoting all my time to this, I'm ignoring all my bills, and I'm thinking that I'm kind of crazy to do this, but I'm caught up in it, and I love it, but I also feel that I don't trust what I'm getting from it because it feels like the real world is going to hell for this magical thing that I'm trying to sustain in myself."

Bibliography

Apple, R. W., Jr., "Elected Bodies with Hardly a Cultured Bone." *New York Times*, July 26, 1998, pp. 2.1, 2.26.

"Artfront Presents New Sites." *Art Matters*, p. 2.

The Arts and the Public Purpose, The Ninety-Second American Assembly, Arden House, Harriman, New York, May 29–June 1, 1997.

Arts Wire. <http://www.artswire.org>.

Benedict, Stephen, ed., *Public Money and the Muse, Essays on Government Funding for the Arts*. New York: W. W. Norton, 1991.

Bolton, Richard, ed., *Culture Wars, Documents from the Recent Controversies in the Arts*. New York: New Press, 1992.

Colimore, Edward, "Funding Increases Have N.J. Arts Groups Off and Running. *Philadelphia Inquirer*, September 29, 1997, p. B3.

Creative Capital. <http://www.creative-capital.org>.

Dobrin, Peter, "How Mayoral Hopefuls Would Cultivate City's Arts." *Philadelphia Inquirer*, May 11, 1999, p. A6.

Doster, Stephanie, "An Old Farm Finds a New Haven for the Arts." *Philadelphia Inquirer*, October 19, 1999, p. B6.

Hutcheson, Ron, "From FDR's Day, Art Rift Lingers. *Philadelphia Inquirer*, August 11, 1997, pp. A1, A6.

Jenkins, Adrienne B., "City's Next Mayor Must Develop Ways to Support Arts and Culture." *Philadelphia Inquirer*, p. E7.

Larson, Gary O., *American Canvas, an Arts Legacy for Our Communities*. Washington, DC: National Endowment for the Arts, 1997.

Lowry, Glenn D., "The Dark Side." Letter to the editor, Arts Section. *New York Times*, December 20, 1998, p. 4.

Lowry, W. McNeil, ed., *The Arts and Public Policy in the United States*. Englewood Cliffs, NJ: Prentice-Hall, 1984.

Marquis, Alice Goldfarb, *Art Lessons, Learning from the Rise and Fall of Public Arts Funding*. New York: Basic Books, 1995.

Miller, Martin, "Entertainment Bug Sweeps America, Critic Writes." *Philadelphia Inquirer,* January 11, 1999, p. C7.

Morrone, John, ed., *Grants and Awards Available to American Writers.* 19th ed. New York: PEN American Center, 1996–1997.

Nesbitt, Caroline, "Farewell to Art." *American Theatre,* February 1998.

Recio, Maria, "House Bill to Cut NEA Funding Fails." *Philadelphia Inquirer,* July 15, 1999, p. A12.

Ridley, Clifford A., "You Can Look It Up: Artists Really Can Be Practical." *Philadephia Inquirer,* November 16, 1998, pp. C1, C6.

Salisbury, Stephan, "Court Backs 'Decency and Respect' Criteria for NEA Grants." *Philadelphia Inquirer,* June 26, 1998, p. A15.

_____, "The Death of Dance." *Philadelphia Inquirer,* July 1, 1998, pp. C1, C6.

_____, "NEA Was Spared, Yet Few in Arts Rejoice." *Philadelphia Inquirer,* November 6, 1997, pp. C1, C4–C5.

_____, "Pew Trusts to Sponsor Cultural Policy Research." *Philadelphia Inquirer* August 4, 1999, pp. D4–D6.

Seabrook, John, "The Big Sellout." *The New Yorker,* October 20 and 27, 1997.

Storr, Robert, "Nice Work If You Can Get It." *Civilization,* February/March 1999.

Ybarra-Frausto, Tómas, *Lo del Corazon: Heartbeat of a Culture.* San Francisco: The Mexican Museum, 1986.

Resources for Artists

BOOKS

Abbott, Robert J., *Art & Reality: The New Standard Reference Guide and Business Plan for Actively Developing Your Careers As an Artist.* Santa Ana, CA: Seven Locks Press, 1997.

Abbott, Susan and Barbara Webb, *Fine Art Publicity: The Complete Guide for Galleries and Artists.* New York: Allworth Press, 1996.

The Alliance of Artists' Communities, *Artists Communities: A Directory of Residencies in the United States that Offer Time and Space for Creativity,* 2nd ed., New York: Allworth Press, 2000.

Alterman, Glenn, *Promoting Your Acting Career,* New York: Allworth Press, 1998.

American Society of Media Photographers, *ASMP Professional Business Practices in Photography.* New York: Allworth Press, 1997.

Anderson Allen, Moira, *writing.com, Creative Internet Strategies to Advance Your Writing Career.* New York: Allworth Press, 1999.

Barbash, Llisa and Lucien Taylor, *Cross-Cultural Filmmaking: A Handbook for Making Documentary and Ethnographic Films and Videos.* Los Angeles: University of California Press, 1997.

Bowker's Complete Video Directory. New York: R.R. Bowker, 1998.

Bowser, Kathryn, *AIVF Guide to Film and Video Distributors.* New York: AIVF, 1996.

_____, *AIVF Guide to International Film and Video Festivals.* New York: AIVF, 1996.

Breimer, Stephen F., *The Screenwriter's Legal Guide,* 2nd ed. New York: Allworth Press, 1999.

Caplin, Lee Evan, Tom Power, and Livingston L. Biddle, eds. *The Business of Art,* Upper Saddle River, NJ: Prentice Hall, 1998.

Crawford, Tad, *Business and Legal Forms for Authors and Self-Publishers.* New York: Allworth Press, 1999.

_____, *Business and Legal Forms for Fine Artists*. New York: Allworth Press, 1995.

_____, *Business and Legal Forms for Photographers*.New York: Allworth Press, 1997.

_____, *Legal Guide for the Visual Artist*, 4th ed. New York: Allworth Press, 1999.

Crawford, Tad and Tony Lyons, *The Writer's Legal Guide*. New York: Allworth Press, 1998.

Crawford, Ted, Susan Mellon, Tad Crawford, and Daniel Grant (introduction), *The Artist-Gallery Partenership: A Practical Guide to Consigning Art*. New York: Allworth Press, 1998.

Curtis, Richard, *The Business of Publishing, An Insider's View of Current Trends and Tactics*. New York: Allworth Press, 1998.

Deivert, Bert and Dan Harries, *Film and Video on the Internet: The Top 500 Sites*. Studio City, CA: Micheal Wiese Productions, 1996.

DeLaney, Chuck, *Photography Your Way*. New York: Allworth Press, 2000.

des Pres, Josquin and Mark Landsman, *Creative Careers in Music*. New York: Allworth Press, 2000.

DuBoff, Leonard, *The Law (in Plain English) for Photographers*. New York: Allworth Press, 1995.

_____, *The Performing Arts Business Encyclopedia*. New York: Allworth Press, 1996.

Emblidge, David and Barbara Zheutlin, *Writer's Resource: The Watson-Guptill Guide to Workshops, Conferences, Artists' Colonies, Academic Programs (Getting Your Act Together) Any*. New York: Watson-Guptill, 1997.

Farace, Joe, *The Photographer's Internet Handbook*. New York: Allworth Press, 1997.

Garvy, Helen, *Before You Shoot: A Guide to Low Budget Film and Video Production*. Los Gatos, CA: Shire Press, 1995.

Gaspard, John and Dale Newton, *Persistence of Vision: An Impractical Guide to Producing a Feature Film for Under $30,000*. Studio City, CA: Micheal Wiese Productions, 1995.

Grant, Daniel, *The Artist's Resource Handbook*. New York: Allworth Press, 1997.

_____, *The Business of Being an Artist*. New York: Allworth Press, 2000.

_____, *The Fine Artist's Career Guide*. New York: Allworth Press, 1998.

_____, *How to Start and Succeed As an Artist*. New York: Allworth Press, 1997.

_____, *The Writer's Resource Handbook*. New York: Allworth Press, 1997.

Hadden, Peggy, *The Artist's Guide to New Markets: Opportunities to Show and Sell Art Beyond Galleries*. New York: Watson-Guptill, 1998.

Harmon, Renee and James Lawrence, *The Beginning Filmmaker's Guide to a Successful First Film*. New York: Walker and Co., 1997.

Heron, Michael, *Stock Photography Business Forms*. New York: Allworth Press, 1997.

Levison, Louise, *Filmmakers and Financing: Business Plans for Independents*. Woburn, MA: Focal Press, 1998.

Litwak, Mark, *Contracts for the Film and Television Industry*. Los Angeles: Silman James Press, 1999.

Loomis, Stacey, Robyn Middleton, Nicole Peterson, and Chad McCabe, *Artists and Writers Colonies: Retreats, Residencies, and Respites for the Creative Mind.* Portland, OR: Blue Heron Publishing, 2000.

Mackaman, Julie, *Filmmaker's Resource: The Watson-Guptill Guide to Workshops, Conferences and Markets, Academic Programs, Residential and Artist-in-Residence Programs.* New York: Watson-Guptill, 1997.

Malone, Eileen, *The Complete Guide to Writer's Groups, Conferences, and Workshops (Wiley Books for Writers Series).* New York: John Wiley and Sons, 1996.

Maloy, Timothy K., *The Writer's Internet Handbook.* New York: Allworth Press, 1997.

Michels, Caroll, *How to Survive and Prosper As an Artist: Selling Yourself Without Selling Your Soul.* New York: Henry Holt, 1997.

Monroe, Paula Ann, *Left-Brain Finance for Right-Brain People: A Money Guide for the Creatively Inclined.* Trabuco Canyon, CA: Sourcebooks, 1996.

Morgan, Robert C., *The End of the Art World.* New York: Allworth Press and the School of Visual Arts, 1998.

Morrone, John, ed., *Grants and Awards Available to American Writers,* 20th ed. New York: PEN American Center, 1998.

Nicholas, Michael Saint, *An Actor's Guide— Your First Year in Hollywood.* New York: Allworth Press, 1996.

Pierson, John, *Spike, Mike, Slackers & Dykes: A Guided Tour Across a Decade of American Independent Cinema.* New York: E.P. Dutton, 1996.

Piscopo, Maria, *The Photographer's Guide to Marketing and Self-Promotion,* 2nd ed. New York, Allworth Press, 1995.

Rich, B. Ruby, *Chick Flicks: Theories and Memories of the Feminist Film Movement.* Durham, NC: Duke University Press, 1998.

Rodriquez, Robert, *Rebel Without a Crew: Or How a 23-Year-Old Filmmaker With $7,000 Became a Hollywood Player.* New York: E.P. Dutton, 1996.

Ruskin, John, *Lectures on Art.* New York: Allworth Press, 1997.

Sedge, Michael, *The Writer's and Photographer's Guide to Global Markets.* New York: Allworth Press, 1998.

Shagan, Rena, *Booking and Tour Management for the Performing Arts.* New York: Allworth Press, 1996.

Shiva, V.A., *Arts and the Internet, A Guide to the Revolution.* New York: Allworth Press,1997.

Smith, Constance, ed., *Art Marketing Sourcebook for the Fine Artist: Where to Sell Your Artwork, 2000 New Listings.* Nevada City, CA: Art Network, 1998.

Smith, Constance, and Allen Hollingsworth, *Art Marketing 101: A Handbook for the Fine Artist.* Nevada City, CA: Art Network, 1997.

Snell, Tricia and David Biespiel, eds, Stanley Kunitz, (introduction), *Artists Communities; A Directory of Residencies in the United States Offering Time and Space for Creativity.* New York: Allworth Press, 1996.

Summers, Jodi, *The Interactive Music Handbook,* New York: Allworth Press, 1997.

_____, *Making and Marketing Music,* New York: Allworth Press, 1999.

Villani, John, *The 100 Best Small Art Towns in America: Discover Creative Communities, Fresh Air, and Affordable Living*. Santa Fe, NM: John Muir Publications, 1998.

Vitali, Julius, *The Fine Artist's Guide to Marketing and Self-Promotion: Innovative Techniques to Build Your Career As an Artist*. New York: Watson-Guptill, 1997.

Volunteer Lawyers for the Arts, *To Be or Not to Be: An Artist's Guide to Not-for-Profit Incorporation*. New York: Volunteer Lawyers for the Arts, 1986.

White, Virginia, *Grants and Grant Proposals that Have Succeeded*. New York: Plenum, 1993.

Wilson, Lee, *Making It in the Music Business: The Business and Legal Guide for Songwriters and Performers*. New York: Allworth Press, 1999.

WEB SITES

Academy of American Poets: www.poets.org
Alliance of Artists Communities: www.teleport.com/~aac/main.html
Allworth Press: www.allworth.com
American Arts Alliance: www.artswire.org/~aaa
American Federation of Musicians: www.afm.org
American Film Institute: www.afionline.org
American Guild of Musical Artists: www.agmanatl.com
American Symphony Orchestra League: www.symphony.org
A.N.E.W. Foundation for the Arts: www.introweb.com/anew
Artists' Health Insurance Resource Center: Arts.endow.gov/learn/Ivey2.html
ArtJob Online: www.artjob.org
Artsource: www.ilpi.com/artsource/artsourcehome.html
ArtsUSA-The American Council for the Arts: www.artusa.org/index.html
Arts Wire: www.artswire.org
Asian American Arts Alliance: www.aaartsalliance.org
Association of American Cultures: www.artswire.org/artswire/tacc/index.html
Association of Independent Video and Filmmakers: www.aivf.org
Association of Performing Arts Presenters: www.artspresenters.org
Cadence Arts Network: www.leonardo.net/dance.90210/cadence.html
Corporation for Public Broadcasting (CPB) Guide to Grant Proposal Preparation
 and Writing: www.cpb.org/grants/grantwriting.html
The Council on Foundations: www.cof.org
Creative Capital: www.creative-capital.org
Dance/USA: www.danceusa.com
The Donna Reed Foundation for the Performing Arts:
 www.frii.com/~fujiii/home.html
Electronic Poetry Center: wings.buffalo.edu/epc
Film Festivals Server: www.filmfestivals.com
Filmmaker: www.filmmag.com
Ford Foundation: www.fordfound.org
Foundation Center: www.fdn.center.org
Foundations On Line: www.foundations.org

Grant Lady: www.grantlady.com
Grantscape: www.grantscape.com
International Film Financing Conference: www.iffcon.com
Jobs 4 the Arts: www.jobs4thearts.com/about.html
The John Simon Guggenheim Foundation:
 www.islandnet.com/~naimiroy/anvil/gugg-gen.htm
MacArthur Foundation: www.macfdn.org/index.htm
Morrie Warshawski (consultant and writer on the arts and grants):
 www.warshawski.com
National Assembly of State Arts Agencies: www.artswire.org/ArtsWire/nasaa
National Association of Women Artists: www.anny.org/orgs/0231/000f0231.htm
National Endowment for the Arts: arts.endow.gov
National Endowment for the Arts Art Forms-Arts Management:
 www.arts.endow.gov/artforms/Manage/Manage5.html
National Endowment for the Humanities: www.neh.fed.us/whatsnew.html
National Latino Communications Center: clnet.ucr.edu/community/nlcc
National Opera Association: www.watamu.edu/academic/fah/mus/noa.htm
National Video Resources: www.nvr.org
OPERA America: www.operaam.org
The Pew Fellowships for the Arts: www.pewarts.org
Poetry Café: www.poetry.com
Poetry Magazine: www.poetrymagazine.org
Poetry Society of America: www.poetrysociety.org
The Pollock-Krasner Foundation: www.pkf.org
Rockefeller Foundation: www.rockfound.org
Theatre Communications Group: www.tcg.org
Volunteer Lawyers for the Arts: www.artswire.org/artlaw/info.html
Working Today: www.workingtoday.org

Index

About the Author

GLORIA KLAIMAN is a writer and printmaker. She received an honorable mention from the 1995 Leeway Foundation Grants in the Arts for Excellence in Fiction.